GORGES, WATERFALLS & WILDFLOWERS

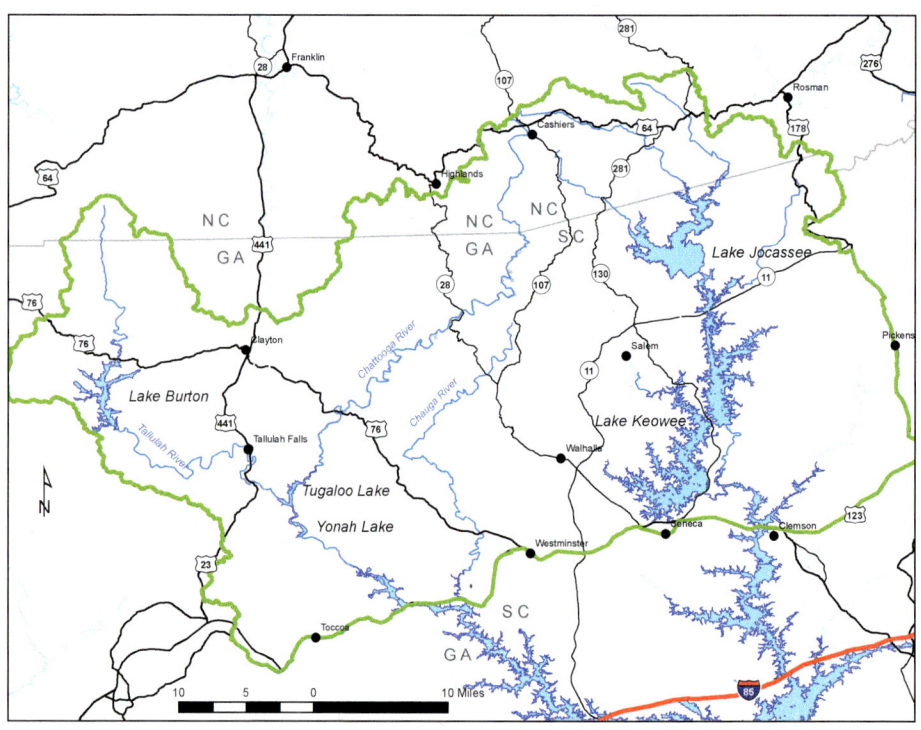

Southern Blue Ridge Front of NC, SC, and GA: green line indicates study area

GORGES, WATERFALLS & WILDFLOWERS

Images of the Southern Blue Ridge Front

L. L. Gaddy

terra incognita books
© 2025

ISBN 978-1-63804-194-8

www.tibooks.org

Published by terra incognita books in partnership with
Clemson University Press, Clemson, SC.

dedicated to
HEYWARD DOUGLASS
Pilot, Trail Keeper, Naturalist

and
Mountain Companions
Holly, Pat, Birgitte, Rebecca, Rudy, Edmund, Butch, Chuck, Perry, Jill, Lewis, Sherrie, Theodore, Juniper, Jeff, Bill N., Billy C., Hu Ye, Ye Lin, Lana, Stan Sr., Stan Jr., Allison, Karin, Robert, John, Clare, Scott, Mark, Richard, Harriet, Jenna, Samantha, and Leon

CONTENTS

PREFACE	vii
INTRODUCTION	1
KEOWEE, EASTATOE, AND CANE CREEK	8
LAKE JOCASSEE AND THE ESCARPMENT GORGES	18
GRANITIC-GNEISSIC DOMES, HIGH ELEVATION PEAKS	36
BLUE RIDGE FRONT/CHAUGA BELT	40
THE CHATTOOGA	56
TUGALO RIVER AND TOCCOA (GA) AREA	78
TALLULAH GORGE	89
TALLULAH RIVER ABOVE TALLULAH GORGE	98
NOTEWORTHY PLANTS AND ANIMALS: GALLERY	105
SELECTED REFERENCES	137
INDEX—Common Names, Scientific Names	141

Preface

The headwaters of the Savannah River along the southern Blue Ridge Front have long been the epitome of my definition of paradise. I bought a few acres here in the early 1970s and have been hanging around since then on and off between making a living and exploring other earthly paradises (the Little Pee Dee River, the Lesser Antilles, Guatemala, the mountains of southern China, north Vietnam, the country of Georgia, and the Ryukyu Islands). The headwaters are herein defined as the Savannah River drainage from its meeting with the French Broad drainage in North Carolina (at over 5000 feet) and Georgia south to about Interstate 85 or around elevation 1000 feet.

The Blue Ridge Front here is truly a land of gorges, waterfalls, and wildflowers. Twenty-five years ago I did a little guidebook called *A Naturalist's Guide to the Blue Ridge Front* with maps and directions of how to find most of the gorges and waterfalls (it is now available as an ebook from the University of South Carolina Press). This book is a follow-up picture book (25 years later) with my photographs and images of the region. I took these pictures ("captured these images") from the mid-1970s to the present during my walks through these mountains and gorges alone and with many friends.

Enjoy.

L. L. Gaddy/Walhalla, 2025

INTRODUCTION

Hydrology/Drainage

The southern Blue Ridge Front, as defined here, includes the headwaters of the Savannah River drainage. Found in the Mountain and Piedmont provinces of North and South Carolina and Georgia, this region includes the drainages of numerous rivers (east to west) the Eastatoe, the Toxaway, the Horsepasture, the Thompson, the Whitewater, the Chauga, the Chattooga, and, finally, the Tallulah River. All of these rivers drain into the Keowee or the Tugalo Rivers, both dramatically shortened by downstream dams and man-made lakes. All of the above rivers could be classified as rocky, whitewater rivers. Table 1 gives the approximate mileage of each river.

Table 1. Major rivers of the southern Blue Ridge front (Savannah River drainage), estimated mileage in length, and species richness.

GORGE/RIVER	STATE(S)	MILEAGE	VASCULAR PLANT SPECIES
Eastatoe	NC-SC	22	700+
Toxaway	NC-SC	22	437
Horsepasture	NC-SC	18	580
Thompson	NC-SC	8	547
Whitewater	NC-SC	15	268*
Chattooga	NC-SC-GA	57	502
Chauga	SC	31	568
Tallulah	GA	48	400?

+Includes Wadakoe Mountain and environs.
*Mosses only (Whitewater Gorge is one of the richest moss sites in temperate North America)..

The Eastatoe flows into the Keowee; the Horsepasture and the Toxaway come together under the waters of Lake Jocassee, as do the Whitewater and the Thompson. The Whitewater/Thompson, then called the Whitewater joins the Toxaway (with the Horsepasture's waters) at Jocassee Dam. The Chauga flows into Lake Hartwell, and, finally, the Chattooga and the Tallulah join just below Tallulah Gorge on the SC-GA state line to form the Tugalo(o). Finally, the Keowee and Twelve Mile Creek come together to form the Seneca River, which flows into the Savannah/Lake Hartwell south of Clemson. The gorge area above Lake Jocassee is sometimes called the Blue Ridge "Embayment," but this term does not include the Chattooga, Tallulah, and Chauga drainages, all of which are included in this book.

Geology, Landforms, and Elevations

The southern Blue Ridge front, as defined herein, ranges in elevation from around 1000 feet to 5400 feet. The highest point in the region is Standing Indian Mountain at 5400 feet where the Tallulah River begins and flows southward (and the Nantahala flows north toward the Little Tennessee). The top of Whiteside Mountain, just east of Highlands, in North Carolina, is the highest point in the Chattooga drainage at just over 5000 feet. To the east, Toxaway Mountain on the headwaters of the Horsepasture is nearly 4800 feet. Finally, on the headwaters of Rocky Bottom Creek, the eastern fork of the Eastatoe drainage, is Sassafras Mountain, at over 3500 feet, the highest peak in South Carolina.

The geomorphology of the region includes weathered granite-gneiss domes (Whiteside Mountain, Chimneytop, Black Rock Mountain, the Fodderstacks, and Satulah Mountain), sheer cliffs (Tallulah Gorge, Laurel Knob, Rock Gorge, Whiteside Mountain), sandy/gravelly rocky ridges with granite-gneiss boulders (Narrow Rock Ridge above the Horsepasture), deep gorges (e.g., , Toxaway, Horsepasture, Whitewater, Tallulah), ravines (Glade Fern Ravine on Jocassee), colluvial "coves" (Station Cove, Dark Bottom, Brasstown and Panther Creek Coves), and spectacular waterfalls (Whitewater Falls, Laurel Fork Falls, Twin Falls, Tamassee Falls,). [King (2008) lists over eighty waterfalls from Oconee and Pickens Counties, SC.]

Much of the gorge region is dominated by acidic soils weather from granitic and gneissic rocks; however, rocks of the Tallulah Dome in northeastern Georgia included sandstone and Tallulah Quartzite, which makes up the walls of the deep Tallulah Gorge. Running northeast-southwest through the region, a narrow belt of metasedimentary rock called the Brevard or Chauga Belt cuts across upper Lake Jocassee (outcropping in Glade Fern Ravine, Tamassee Cove, Station Cove, Issaqueena Falls in South Carolina), then passing through the Chauga River area, Brasstown and Panther Creeks, and Cedar Creek in Georgia. This geological belt contains calcareous rock, which supports rich wildflower coves and small areas of marble (on and around Poor Mountain, SC).

Climate

The gorge region of the southern Blue Ridge front gets 80-125 inches of precipitation annually and is close to being a "temperate rain forest" climate. The Coweeta hydrological station in northeastern Georgia and Whitewater Gorge on the NC-SC state line (Billings and Anderson, 1966) are two of the wettest places in eastern North America. In summer, updrafts from humid air from the Gulf of Mexico create daily thunderheads on the Blue Ridge front. Temperatures are temperate, usually ranging from the 30s to the low 90s; however, extreme winter events often push the lows down into single digits.

Vegetation and Flora

The region is dominated by diverse deciduous forests with shortleaf, pitch, and, rarely, Table Mountain pines on the ridges and rockier slopes. White pine and hemlock are found on cooler slopes and in gorges and coves. A southern mixed mesophytic forest (Braun, 1950) consisting of basswood, beech, white walnut, tulip poplar, white oak, Canada hemlock, red oak, slippery elm, silverbell, and white ash is found in the richest coves. On the upper Tallulah River in the Southern Nantahala Wilderness Area, sugar maple is also present in this forest type. A few small colonies of Carolina hemlock are present on north-facing rocky cliffs.

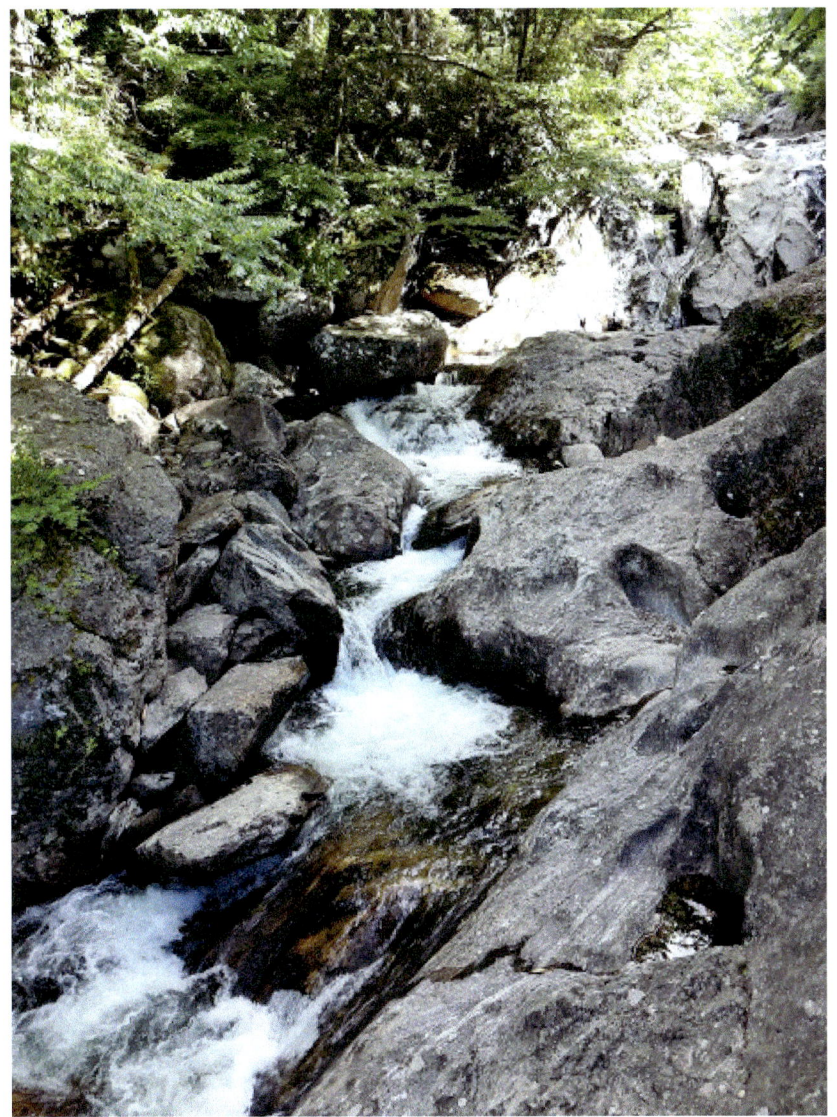
Potholes on the Chattooga River in North Carolina at Bull Pen Road Bridge.

Rare and Noteworthy Flora

Federally-listed plant species known from the region include small whorled pogonia, smooth coneflower, and persistent trillium (all pictured herein). Tunbridge fern's only North American location is in Eastatoe Gorge, and several plant species found in the study area are endemics (found only in one small area): persistent trillium is found only in Tallulah Gorge and surround ravines; Oconee bells is found only in tributaries leading into Lake Jocassee and

Lake Keowee in North and South Carolina; and faded trillium is endemic to the upper Savannah River drainage.

Other rare vascular plant species known to occur along the southern Blue Ridge front are: mountain stewartia, white fringeless orchid, dwarf filmy fern, single-sorus spleenwort, black-stemmed spleenwort, purple cliffbrake (a fern), yellow lady's-slipper, tripartite violet, Fraser's loosestrife, barren strawberry (locally common along the Chauga River), Georgia aster, and whorled horsebalm (locally common in the area).

Several rare mosses and liverworts and one rare (federally-listed as endangered) lichen—the rock gnome lichen—are also found in the southern Blue Ridge front region. Whitewater Gorge is especially rich in mosses. Gorge moss, now thought to be extirpated from the southern Blue Ridge gorges, was collected from Whitewater, Thompson, Horsepasture, and Toxaway River gorges in North and South Carolina. It is listed as "critically imperiled" by www.natureserve.org. Carolina gorgemoss, a species of *Plagiomnium,* was described from Whitewater Gorge by Lewis Anderson and is also very rare in GA, NC, and SC on wet gorge walls. Recently, a population of Carolina gorgemoss was found in the Dominican Republic in a gorge near Salto de Aguas Blancas (loosely translated as "Whitewater Falls").

Rare and Noteworthy Fauna

Black Bear

The American black bear is known from the Blue Ridge front region of all three states and is generally more common above 2000 feet in elevation than at lower elevations. Bear, however, have been recently cited in lower elevations in all three states, including a late-night sighting on Main Street, Walhalla, SC, in which police briefly saw a bear pass through town. Bear are nocturnal omnivores who try to avoid humans.

Spotted Skunk

The spotted skunk, also nocturnal, is known from the southern Blue Ridge front region, where it is considered rare and uncommon.

Bald Eagle

The bald eagle nests on Lake Jocassee and is often seen there and on Lake Keowee in winter months.

Copperhead

Copperheads are common in the southern Blue Ridge front region, especially along the rivers and tributaries entering Lake Jocassee. Here, small copperheads seem unusually abundant and forage for food on lower slopes and along streams. Bearcamp Creek, a tributary of the Horsepasture, and several other small tributaries on the lake seem to have large populations of small, non-aggressive copperheads. To the east, the Eastatoe, especially the upper gorge, has abundant copperheads. The so-called "copperheads" of the Chattooga and Tallulah Gorges usually turn out to be the look-alike Northern water snake, an early-season snake very tolerant of cold water.

Rattlesnakes

Strangely enough, the timber rattler is rare at higher elevations in the Blue Ridge front area. I have never seen a rattlesnake in the gorges above Jocassee or in Tallulah Gorge. Rattlesnakes in the region seem to be more common at the base of the mountains around Lake Keowee and along the Chauga River in South Carolina, where they appear to be most common in the Poor Mountain-Rich Mountain area.

Salamanders/Lizards

The southern Appalachians are well-known as one of the global centers of salamander diversity (Petranka, 2010). The rare green salamander is known from Thompson River gorge, the Eastatoe (where it breeds), and Tallulah Gorge. Jordan's salamander is common in the Whitewater area of Lake Jocassee. Finally, the green anole is quite common along the edge of the Blue Ridge front and ranges up to around 3000 feet in the mountains.

The Piedmont from the Blue Ridge Front in South Carolina.

KEOWEE, EASTATOE, AND CANE CREEK

The two eastern tributaries of the Savannah River flow into Lake Keowee (formerly the Keowee River). The Eastatoe (which has been called a river and a creek), forms the easternmost drainage of the headwaters of the Savannah River. "Eastatoe" is a Cherokee name denoting the former abundance of the Carolina Parrakeet (or Parroquet) in its valley. Eastatoe's water comes from springs just north of the NC-SC boundary on US Highway 178 at just over 2600 feet (on the Eastern Continental Divide) and from water originating on Sassafras Mountain at 3554 feet, the highest point in South Carolina. The Upper Eastatoe consists of a complex of deep ravines (or gorges) with narrow passages and seepage cliffs with rare ferns—the rare Appalachian bristle fern is found here along beside the even rarer Tunbridge filmy fern. The filmy fern, found nowhere else in North America, is locally common at the "Narrows," the deepest portions of Eastatoe Gorge (a few other locations in the gorge).. Several noteworthy falls are found on the tributaries of the upper Eastatoe—Reedy Cove Falls (or Twin Falls), a large double falls entering the Eastatoe from the west, outshines them all.

The Middle Eastatoe is farmed bottomlands bounded by rich tributaries like Cane Creek, which parallels the Eastatoe as it flows toward Lake Keowee, and diverse, wildflower-rich slopes like those of Wadakoe Mountain. Farther downstream are waterfalls, more rich wildflower coves like those of Peach Orchard Branch, and good fishing spots above where the river pours into the backwaters of Lake Keowee.

The late Leland Rodgers found 670 species of plants in the Eastatoe drainage; other botanists (Robert Siler, Patrick McMillan, Layla Waldrop, and the author) have added to this flora, pushing the Eastatoe's known flora past 700 species, making it one of the richest sub-drainages in the state. The Eastatoe and its tributaries harbor an array of rare and interesting plants and animals: American ginseng, single-sorus spleenwort (Cane Creek), great Indian plantain (Cane Creek), bent trillium (Wadakoe Mountain), the Allegheny spurge (Peach Orchard Branch), Oconee bells (Cane Creek), faded trillium (Cane Creek and Eastatoe Gorge), an abundance of box turtles (Sassafras Mountain), black bear, the northern copperhead (abundant in the upper gorges near the Narrows), and the rare green salamander (which breeds on the lower stretches of the Eastatoe).

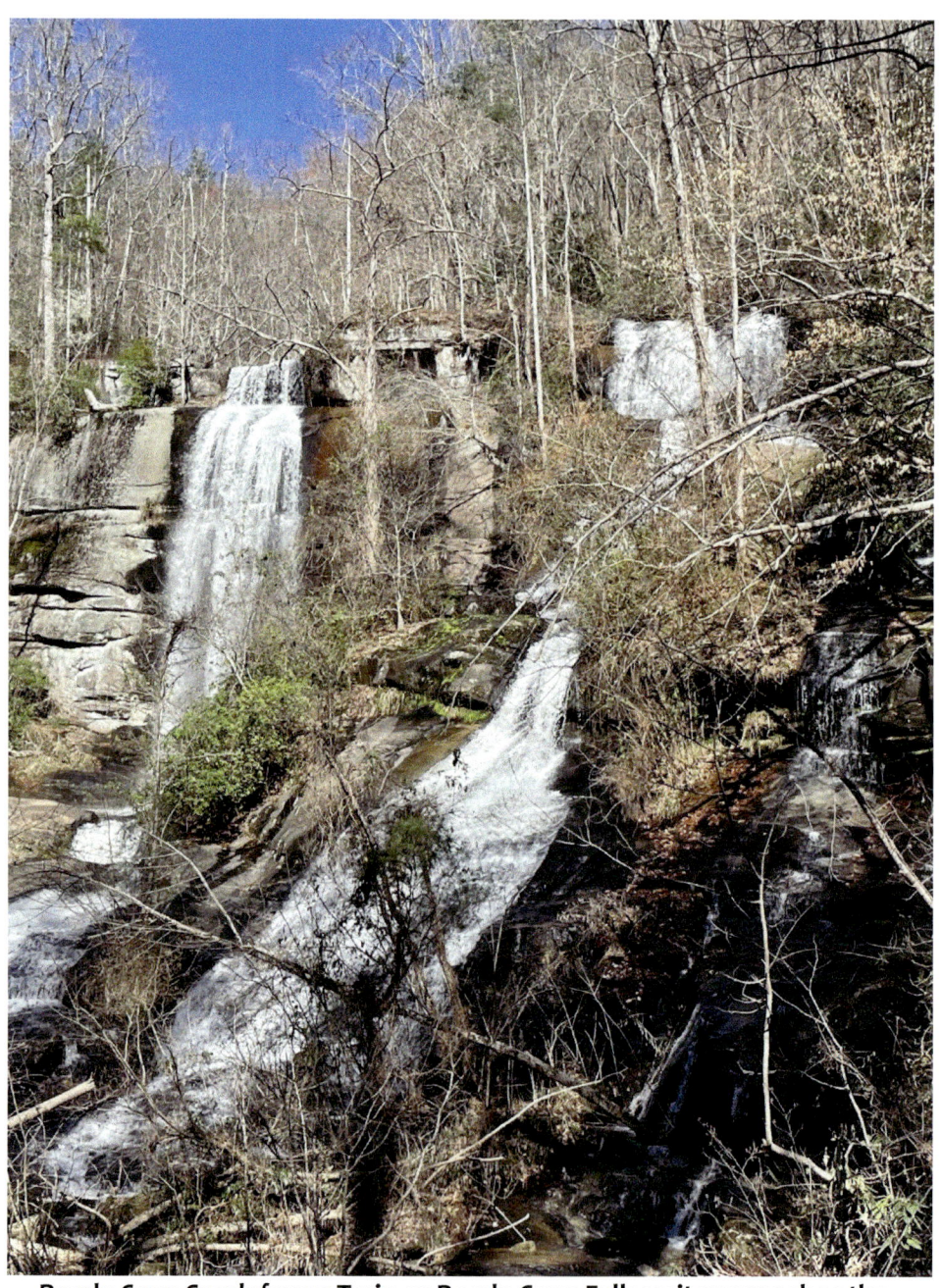
Reedy Cove Creek forms Twin or Reedy Cove Falls as it approaches the Eastatoe.

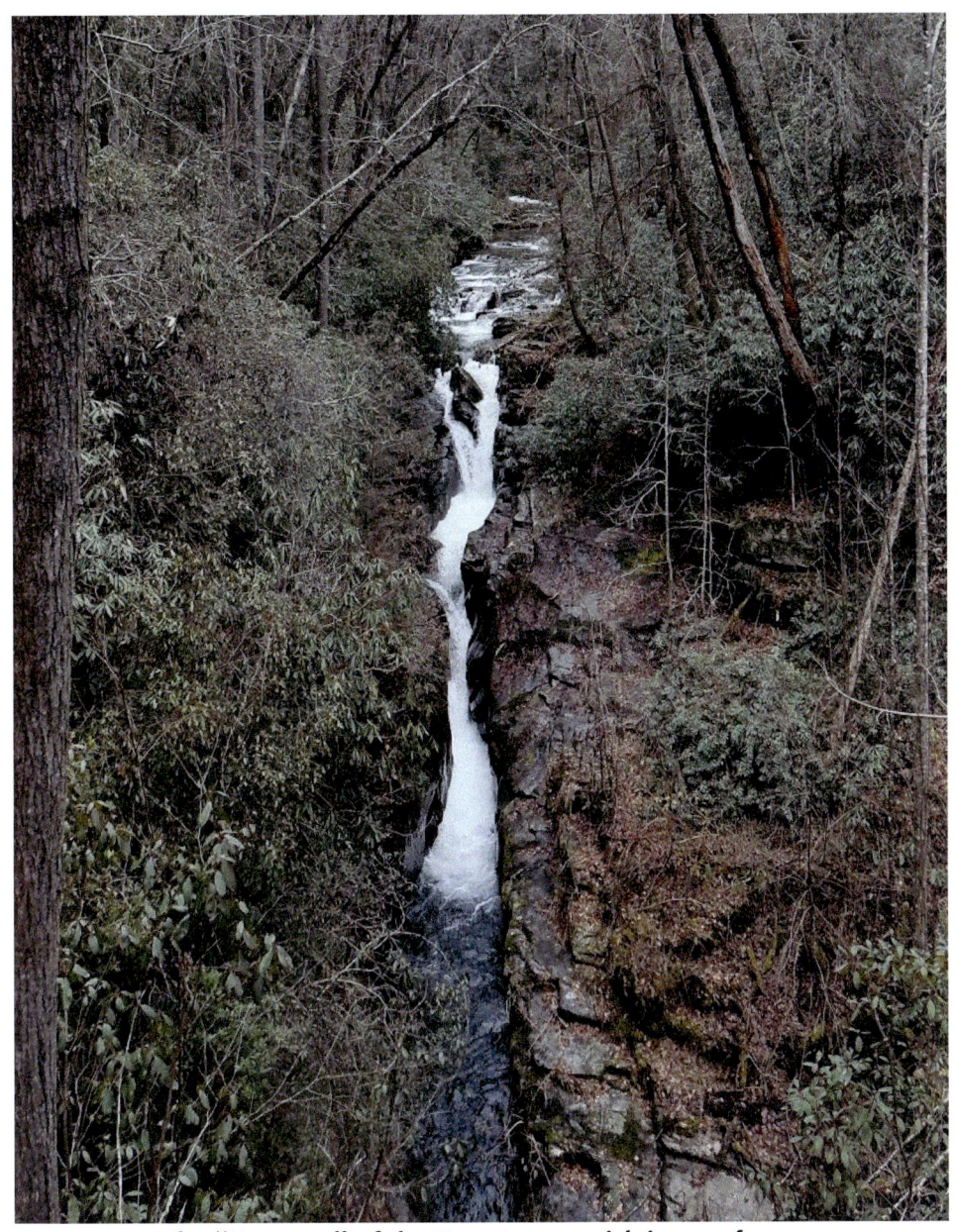
The "Narrows" of the Eastatoe are rich in rare ferns.

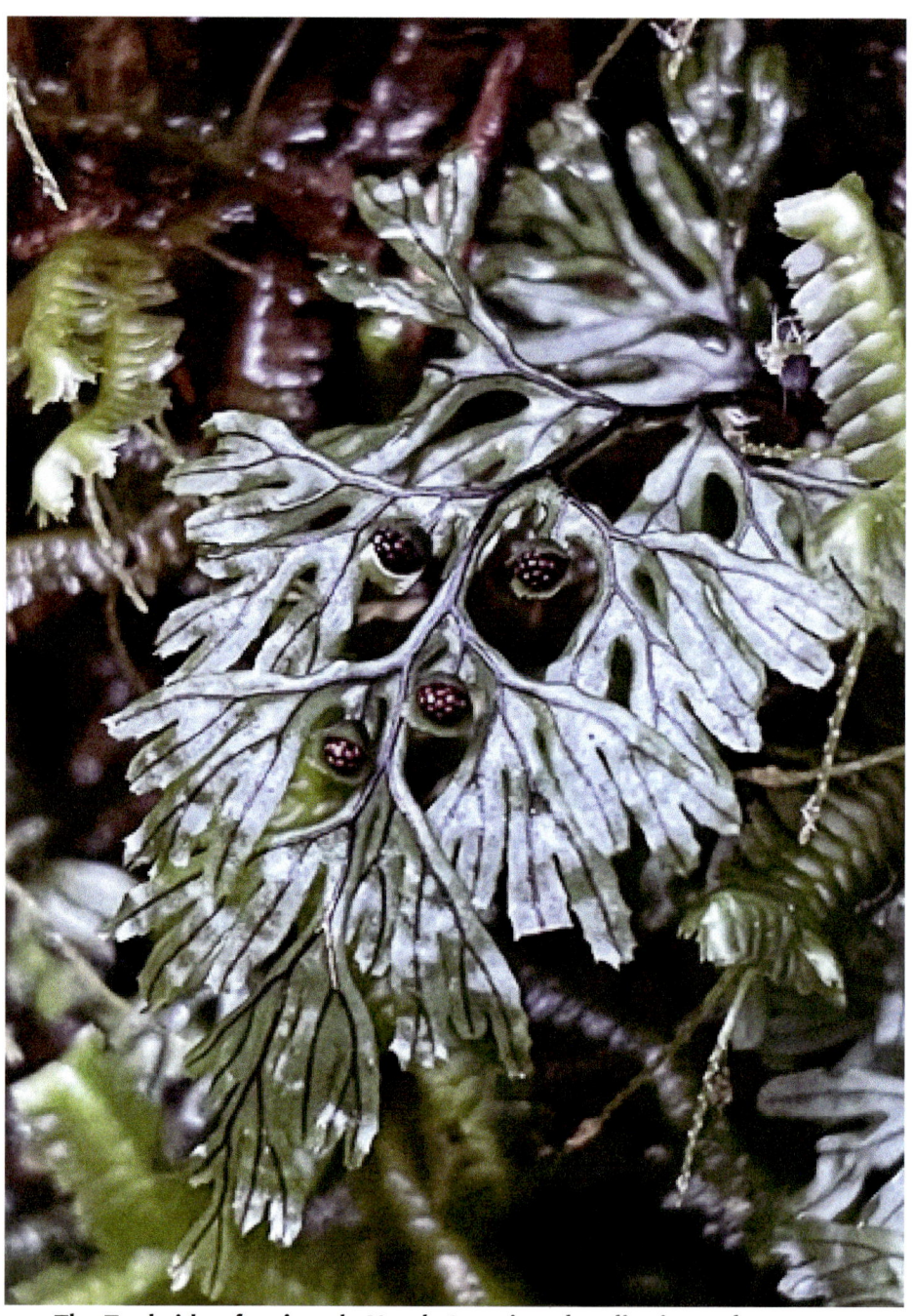
The Tunbridge fern's only North American locality is on the Eastatoe (Samantha Tessel).

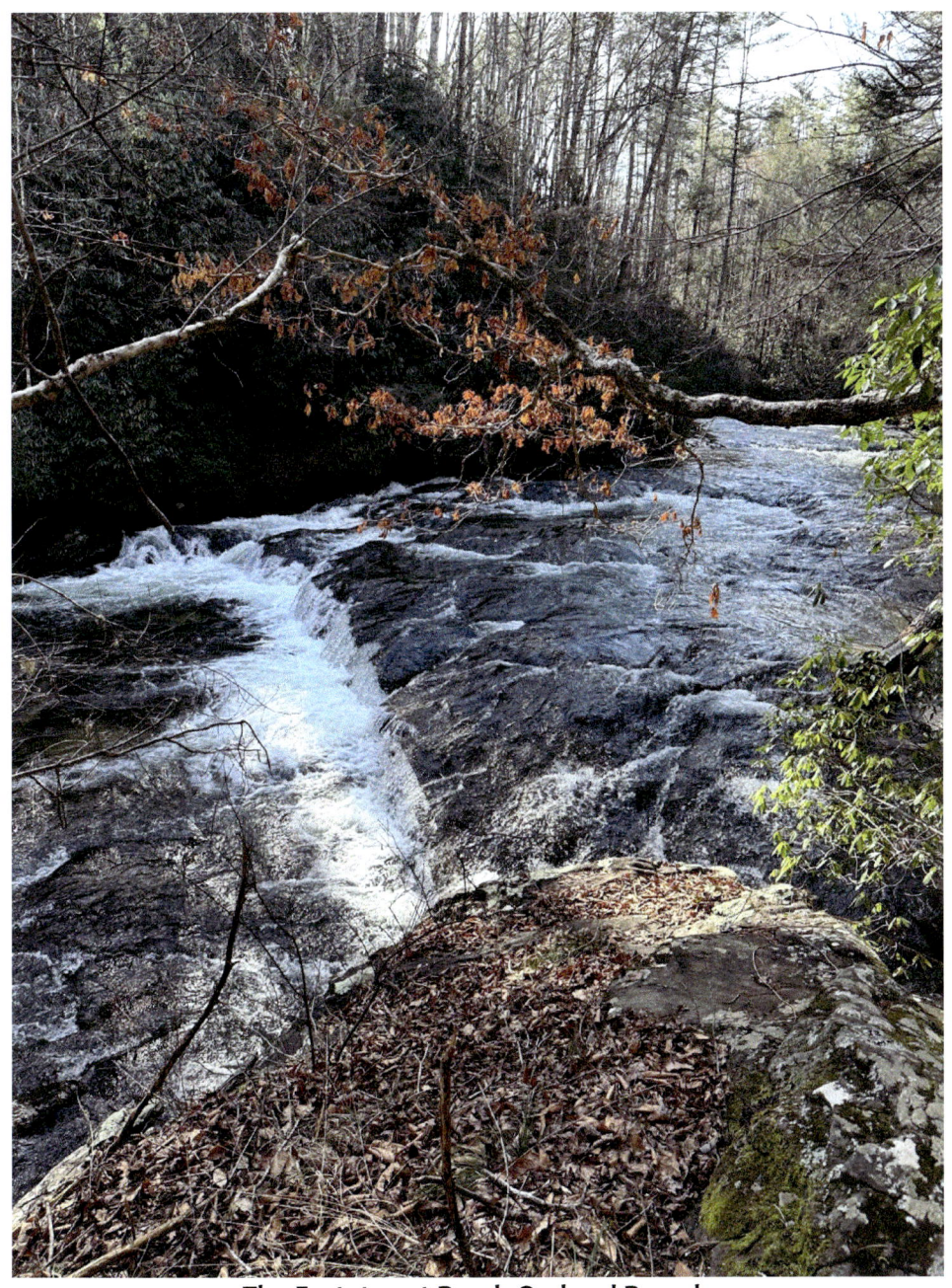
The Eastatoe at Peach Orchard Branch.

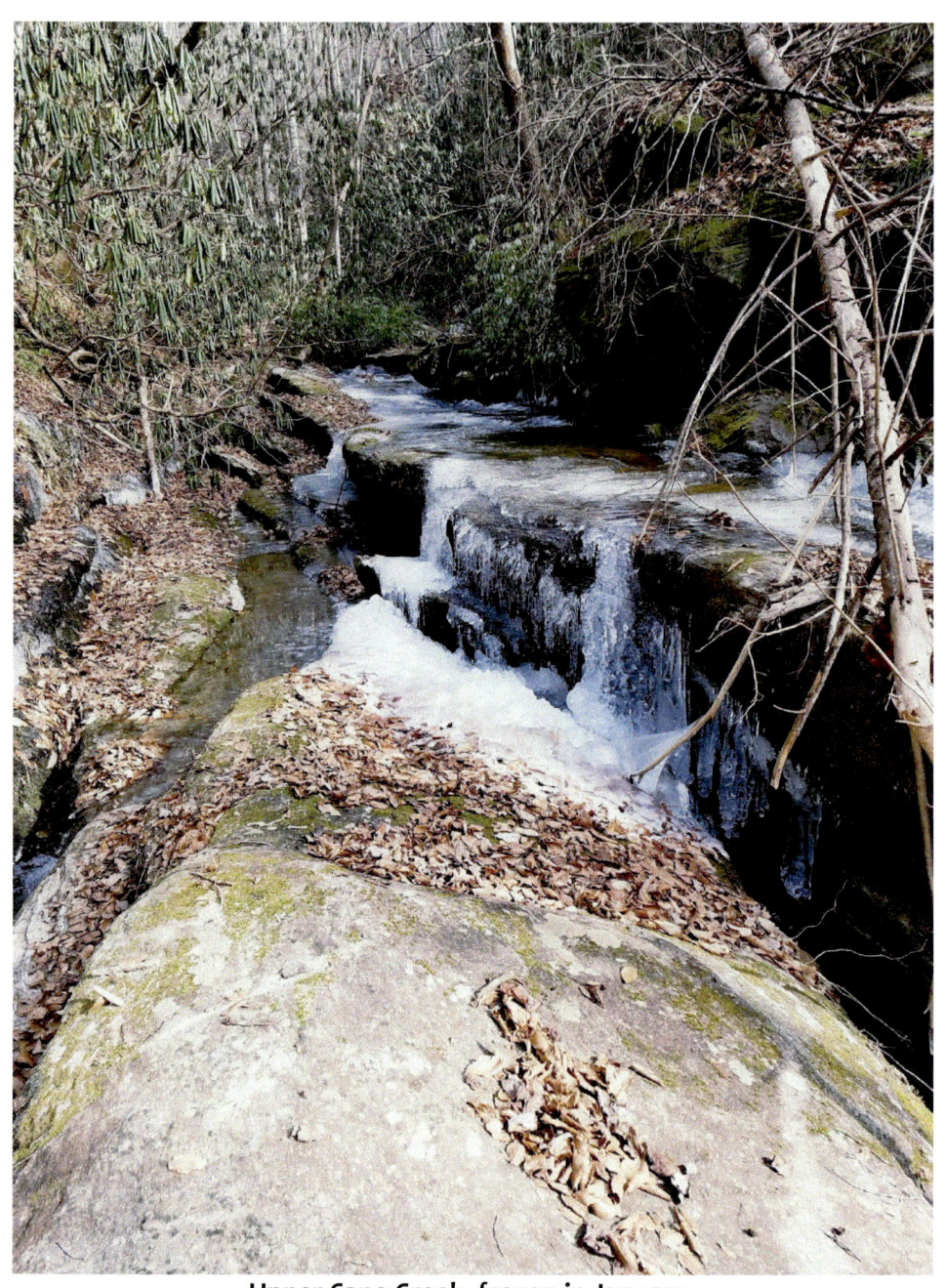
Upper Cane Creek, frozen in January.

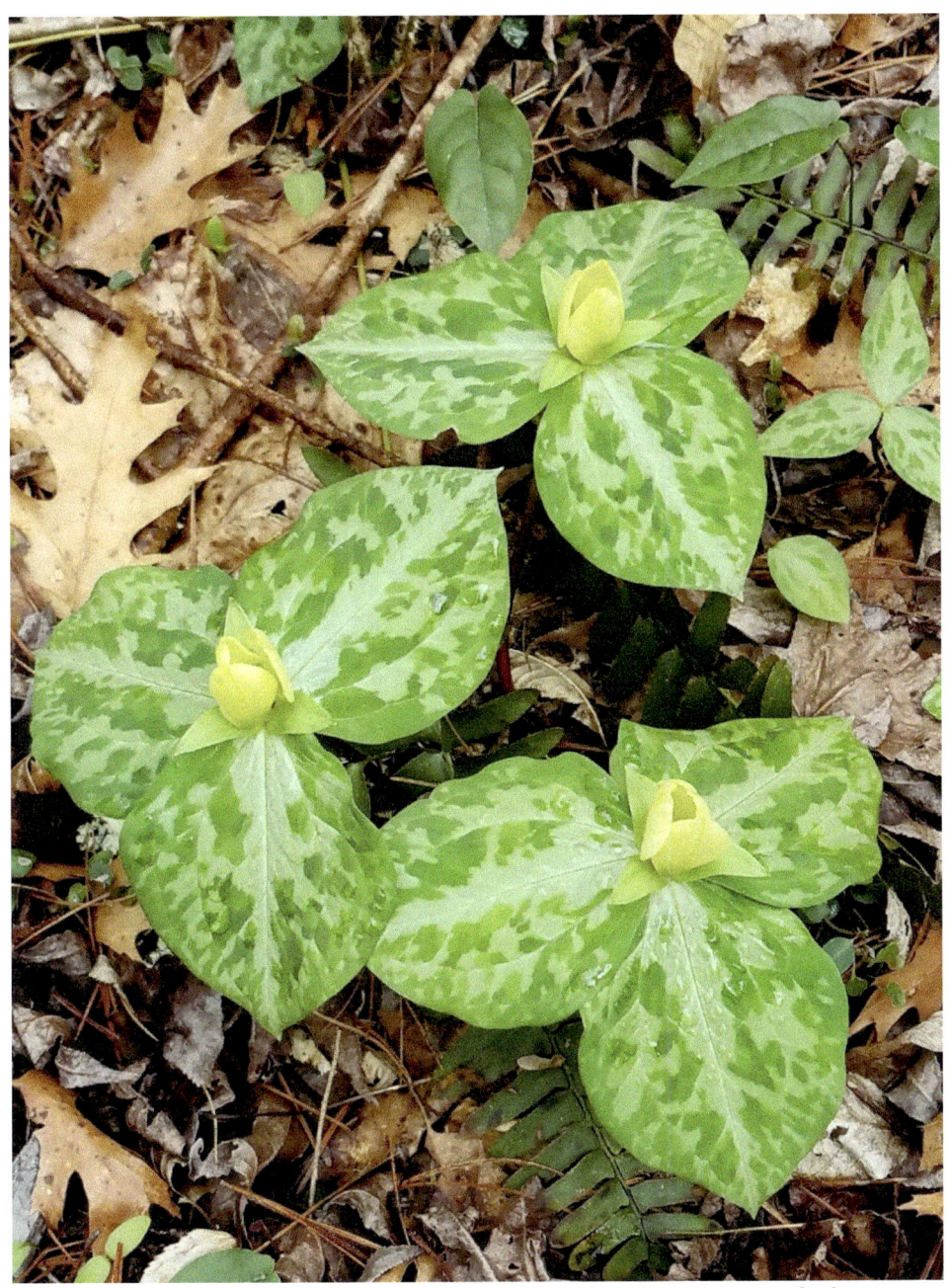

Faded trillium is common on Cane Creek and in the Eastatoe drainage.

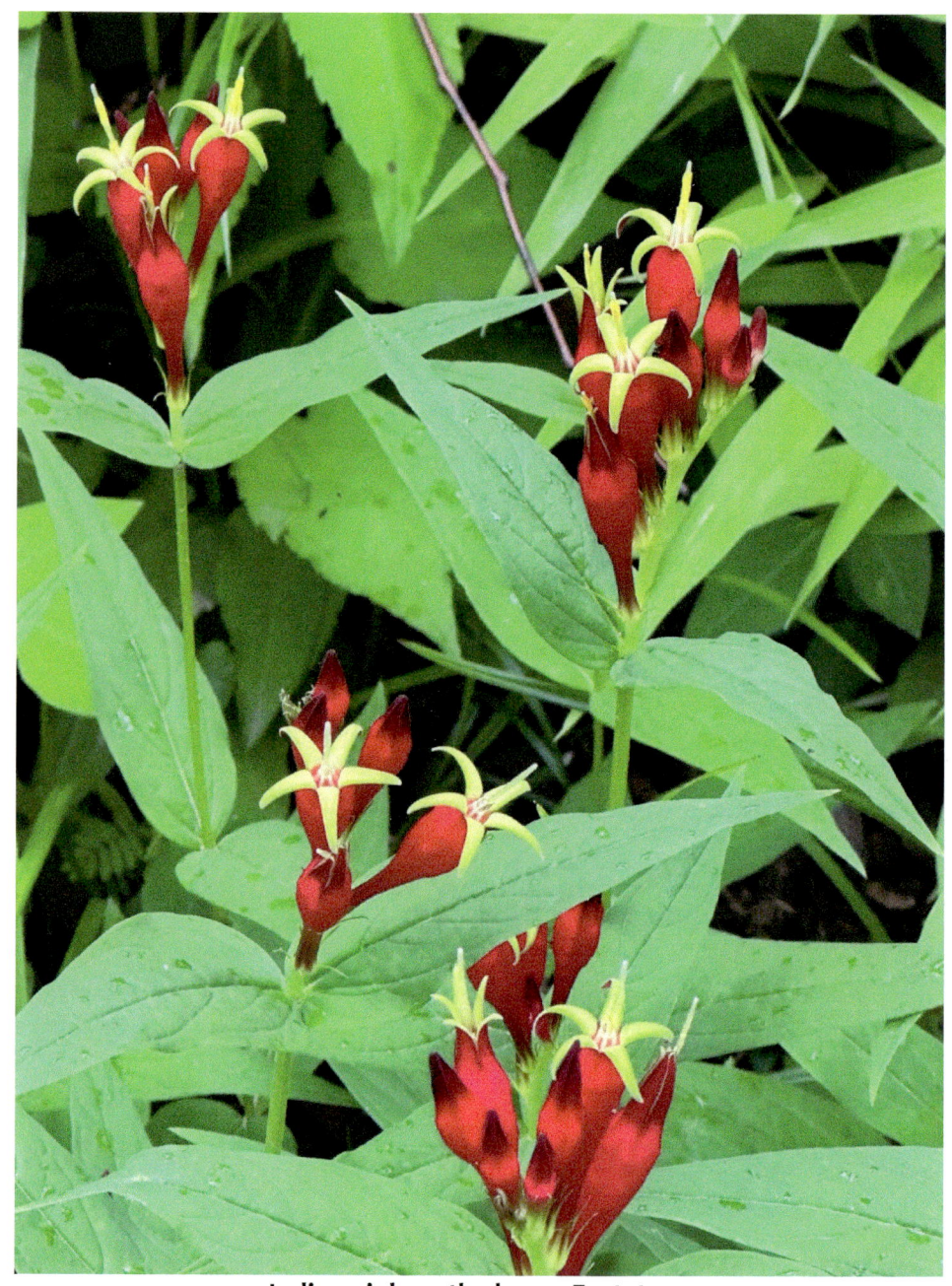
Indian pink on the lower Eastatoe.

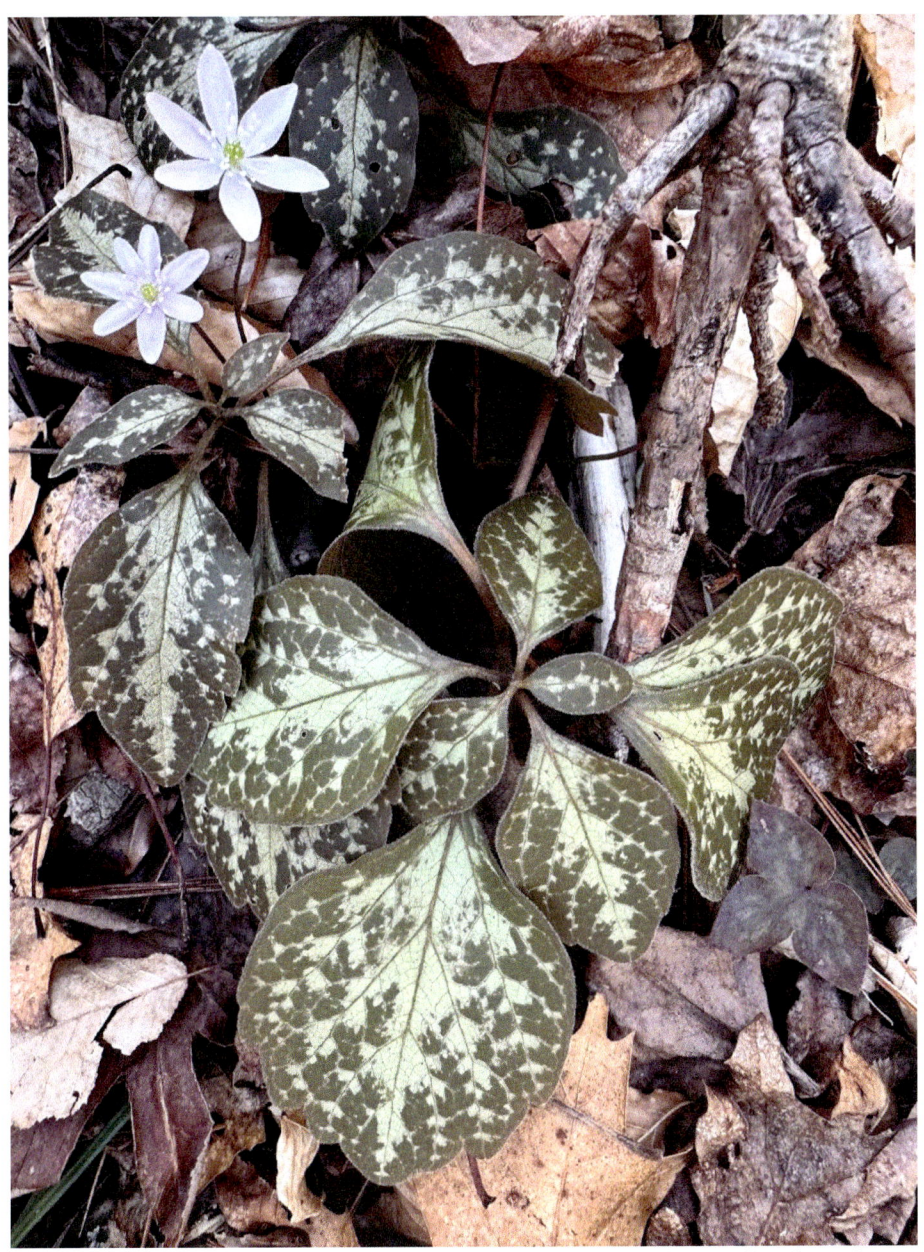

Pachysandra, famously variegated, has only one South Carolina location—Peach Orchard Branch, a tributary of the Eastatoe (here with acute-lobed hepatica).

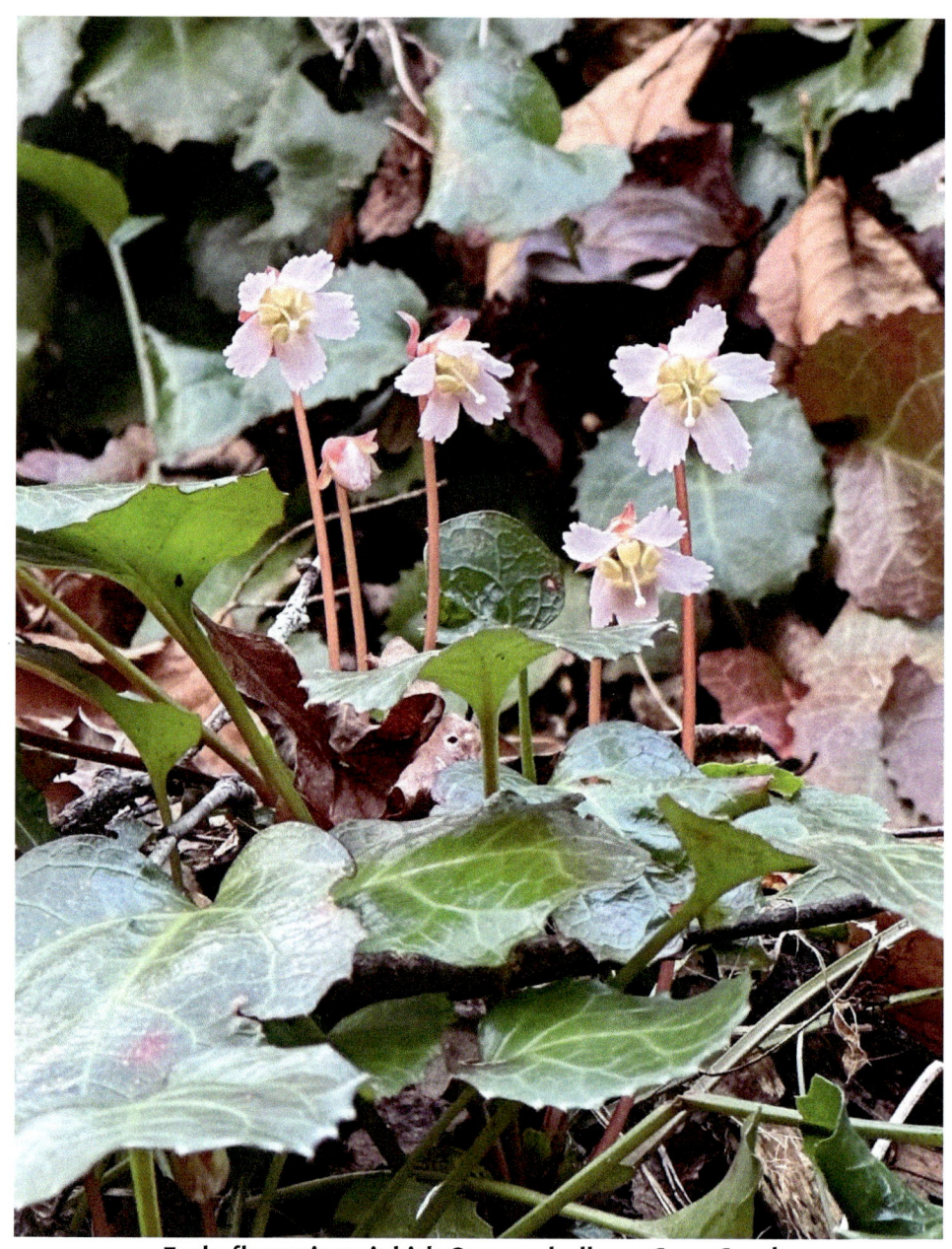
Early-flowering pinkish Oconee bells on Cane Creek.

LAKE JOCASSEE AND THE ESCARPMENT GORGES

Created by Duke Power in 1973, Lake Jocassee inundated much of what was once called the Keowee-Toxaway valley. Duke had planned to build multiple hydroelectric power stations in the whitewater of the gorges above the lake. To date, only the Jocassee Station (at the dam) and the Bad Creek Station (a pump-storage station on Bad Creek, a tributary of the Whitewater River) were constructed. Above Lake Jocassee in South and North Carolina lie the "Escarpment" or "Embayment" Gorges. Here, the Toxaway, the Horsepasture, the Thompson, and the Whitewater Rivers and their tributaries have, over geologic time, have progressively cut back into the Blue Ridge front creating an embayment of deep ravines and gorges. Toxaway, which begins at Toxaway Mountain above Lake Toxaway, has carved Toxaway Falls on U. S. Highway 64 and a deep gorge below that extends all the way to Lake Jocassee in South Carolina. The Horsepasture River begins just north of U. S. 64 in Dillard Canyon and flows into central Jocassee, leaving behind the picturesque Rainbow Falls and the spectacular Windy Falls, as well as the steep, rocky Narrow Rock Ridge to the west of the river. The lesser-known, although quite rugged Thompson River, has carved two noteworthy falls and numerous nearly inaccessible water slides on its way down to Jocassee. With its origins among the granitic domes just south of Cashiers, the Whitewater flows into the western portions of Lake Jocassee, having sculpted two mighty falls—the Upper in North Carolina and the lower in South Carolina on its way out of the mountains. These montane rivers and their tributaries pour water into the crystal-clear waters of the 300-foot deep Lake Jocassee. The lake and its gorges are famous nationally and regionally for their spectacular waterfalls (too numerous to list), rare plants (including the endemic and well-known Oconee bells), and their pristine waters.

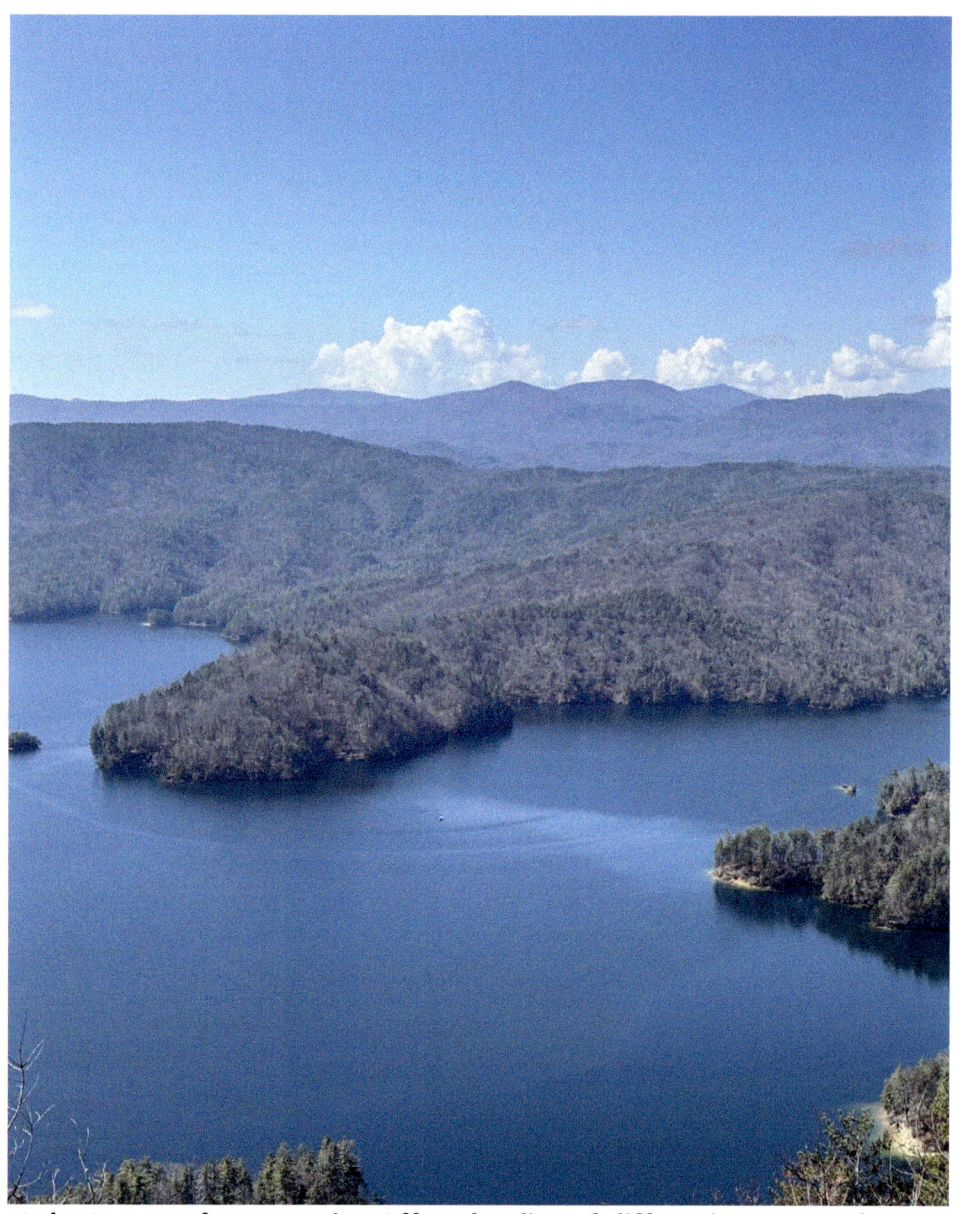
Lake Jocassee from Jumping Off Rock, a line of cliffs on its eastern shores.

View north across Jocassee on a summer's day.

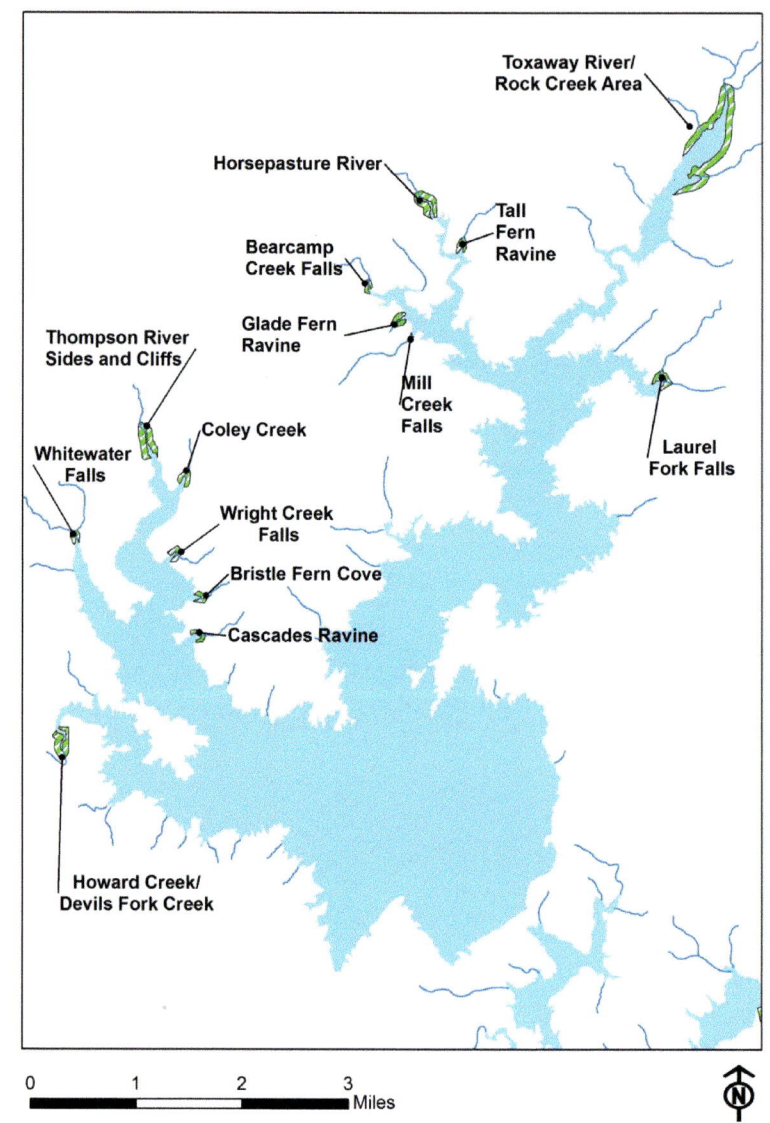

Location of major natural areas on Lake Jocassee.

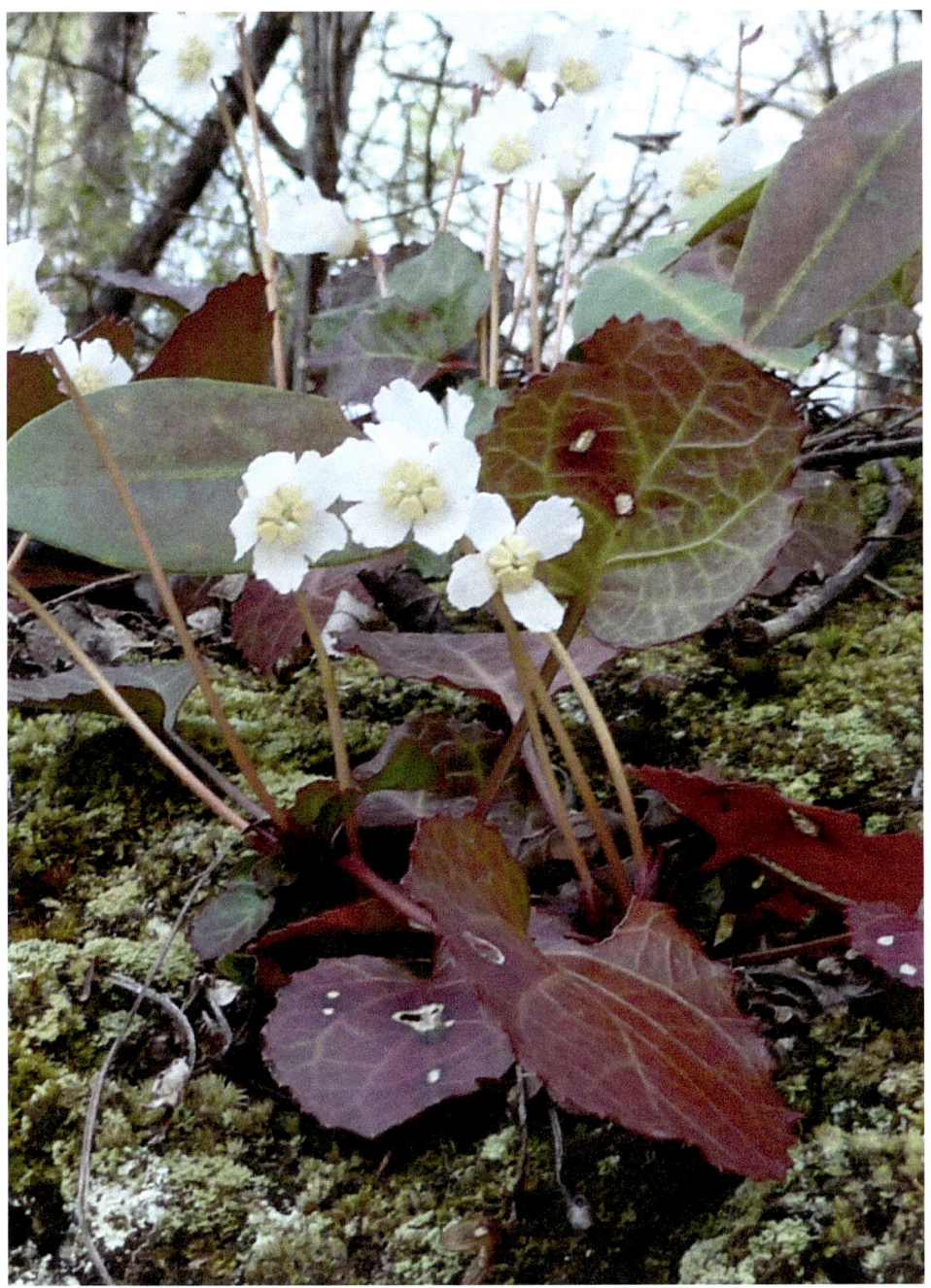
Reddish leaves on Oconee bells found in full sun on margin of Lake Jocassee.

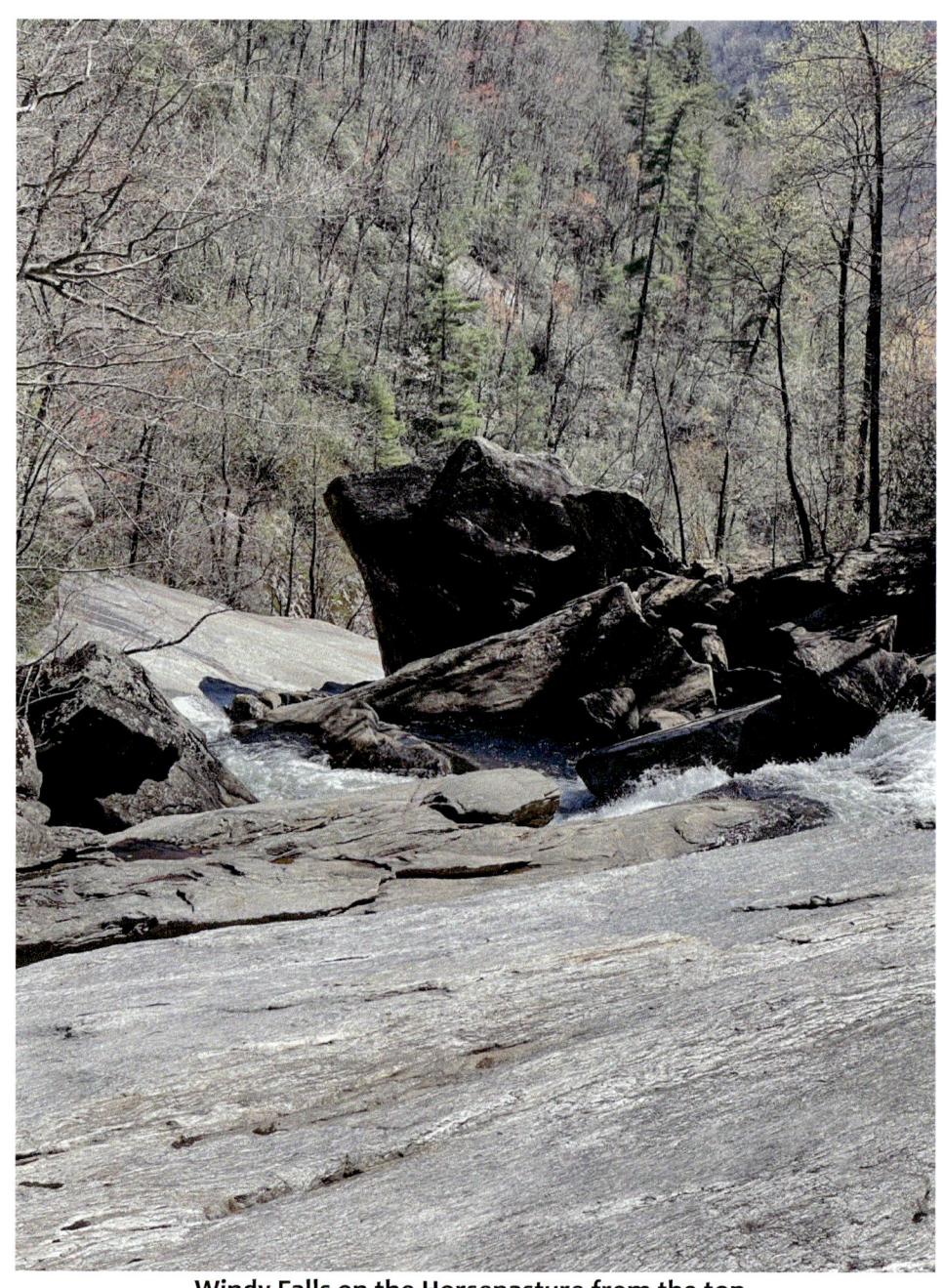
Windy Falls on the Horsepasture from the top.

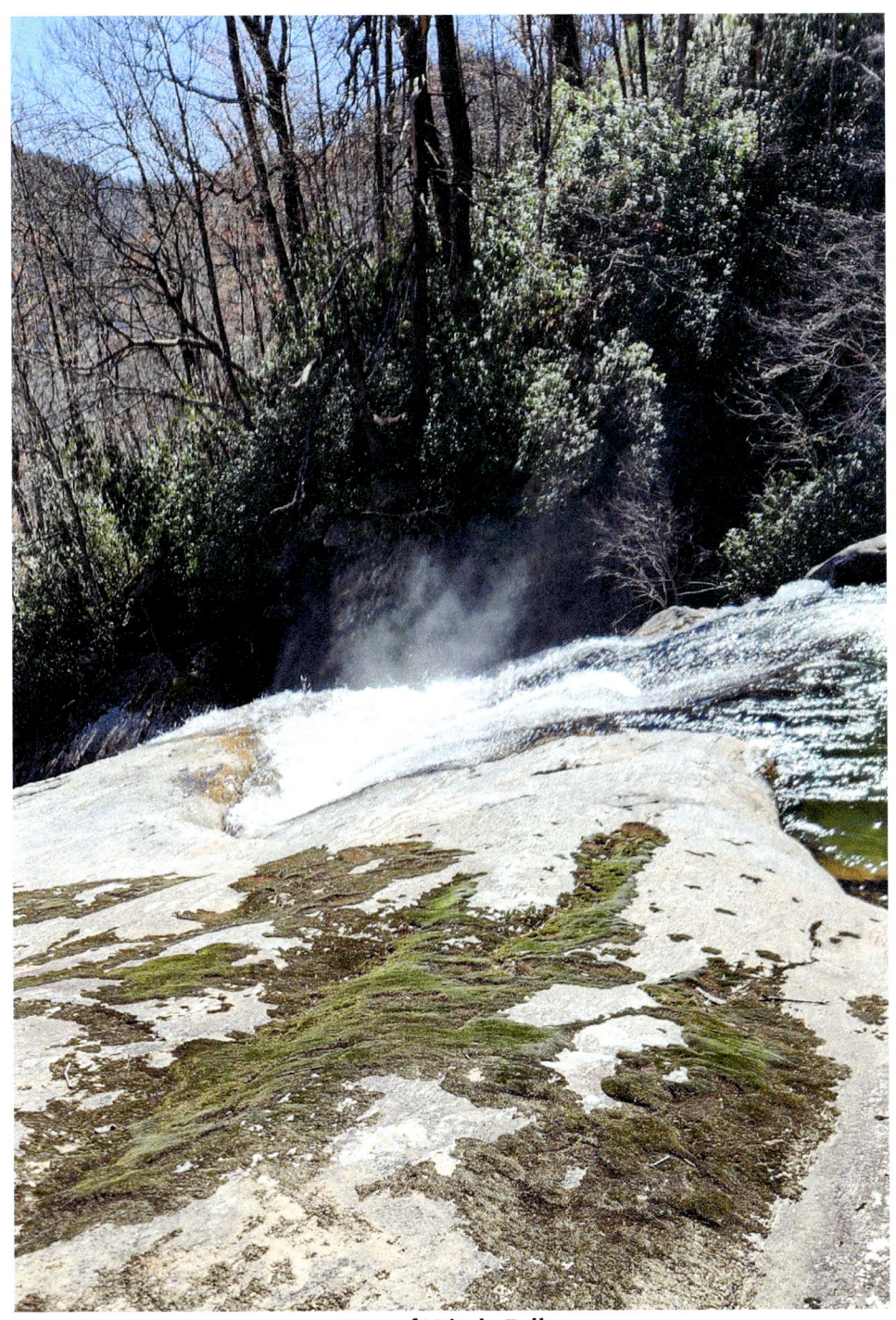
Top of Windy Falls.

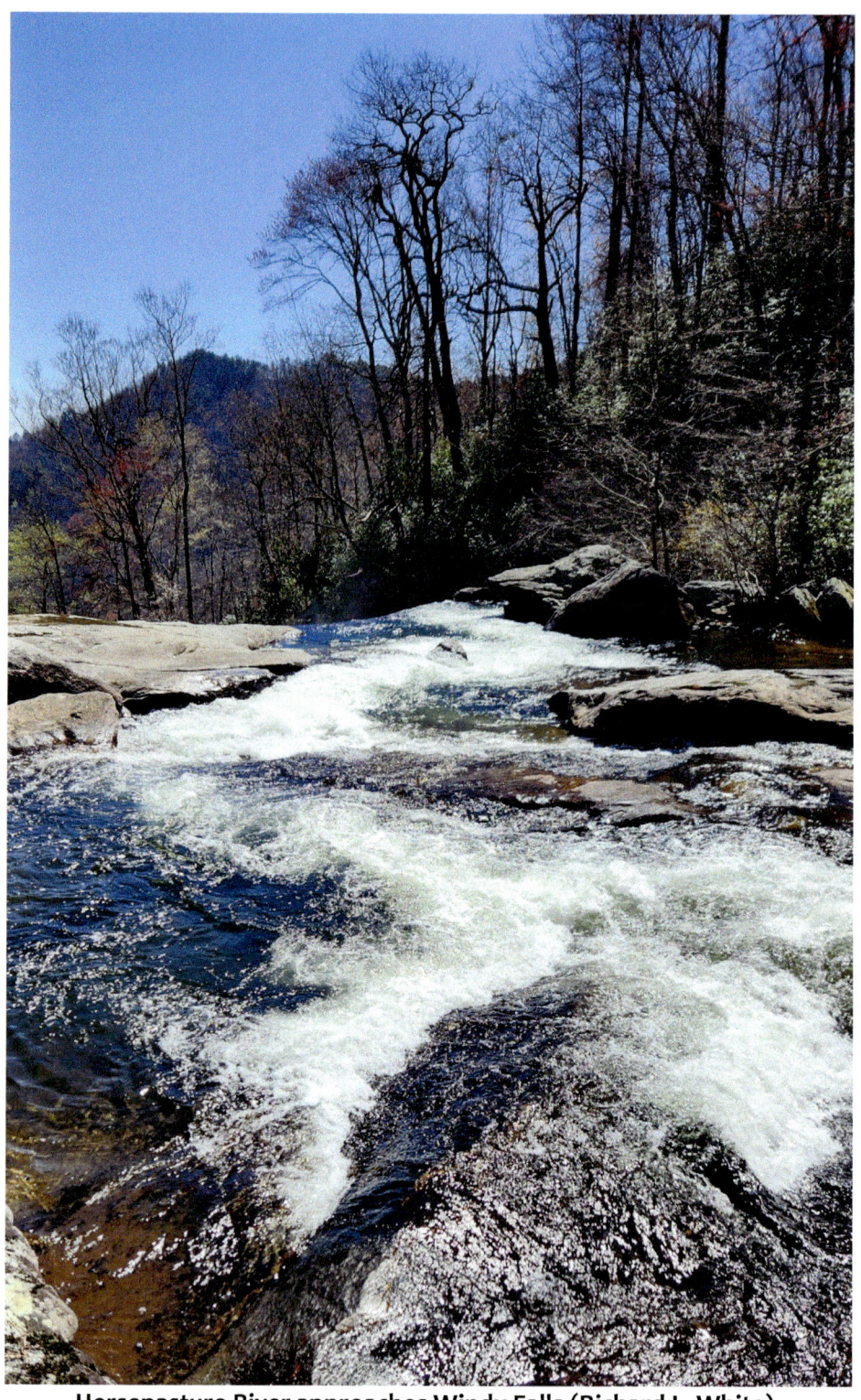
Horsepasture River approaches Windy Falls (Richard L. White).

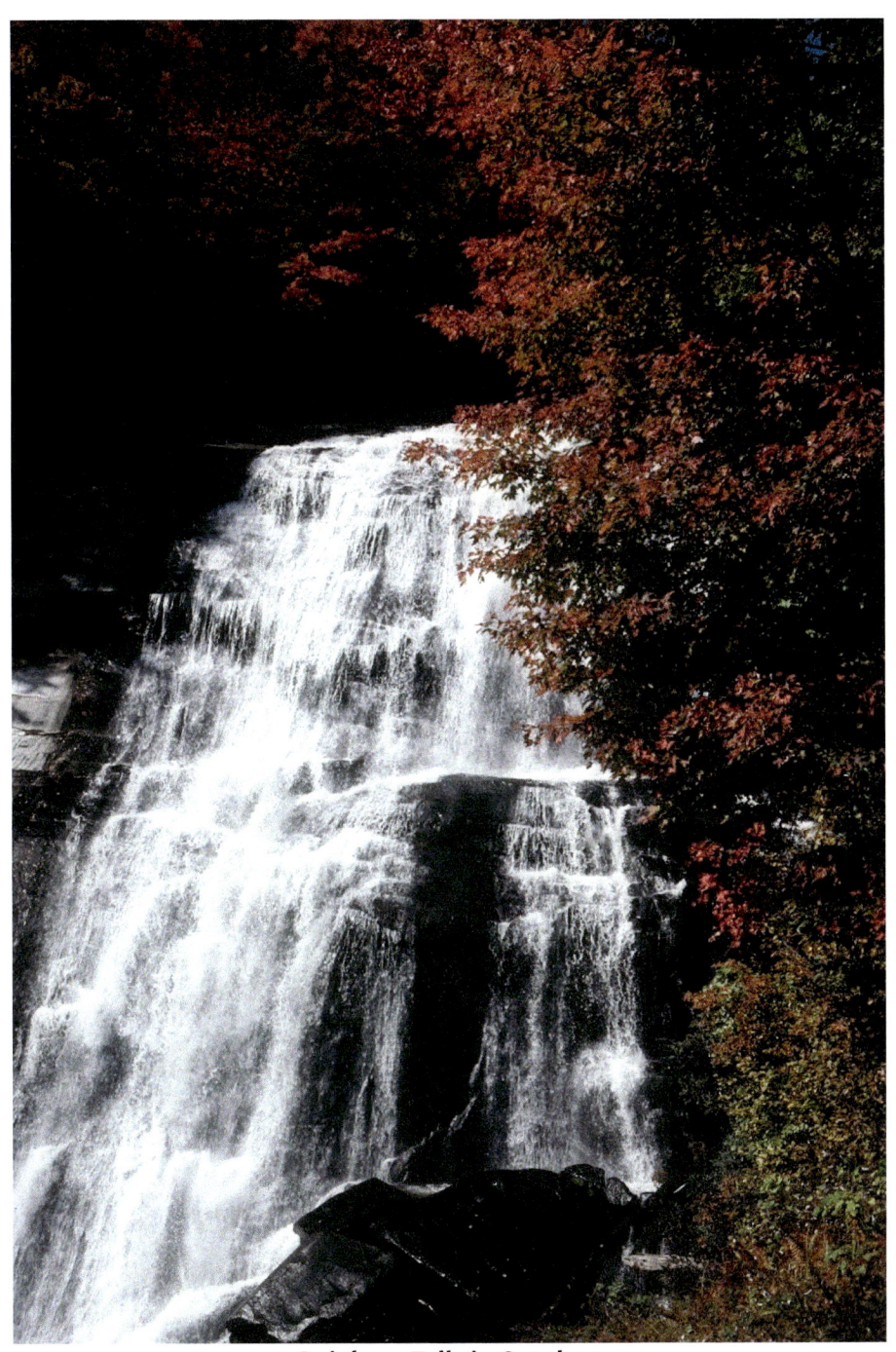
Rainbow Falls in October.

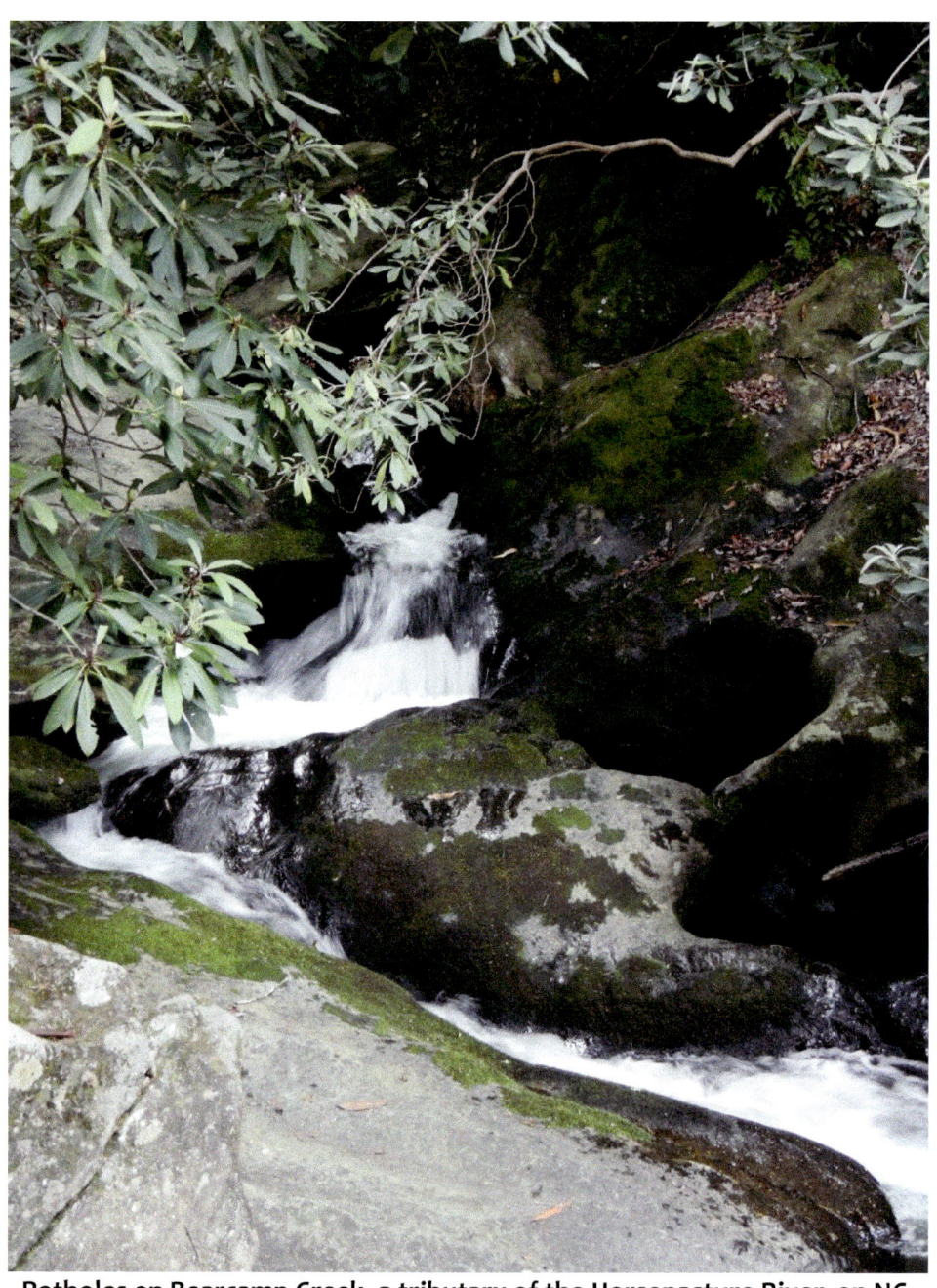
Potholes on Bearcamp Creek, a tributary of the Horsepasture River, on NC-SC state line.

Large narrow-leaved glade fern at Glade Fern Ravine, home of 16 species of ferns, in the Horsepasture area on Jocassee in SC.

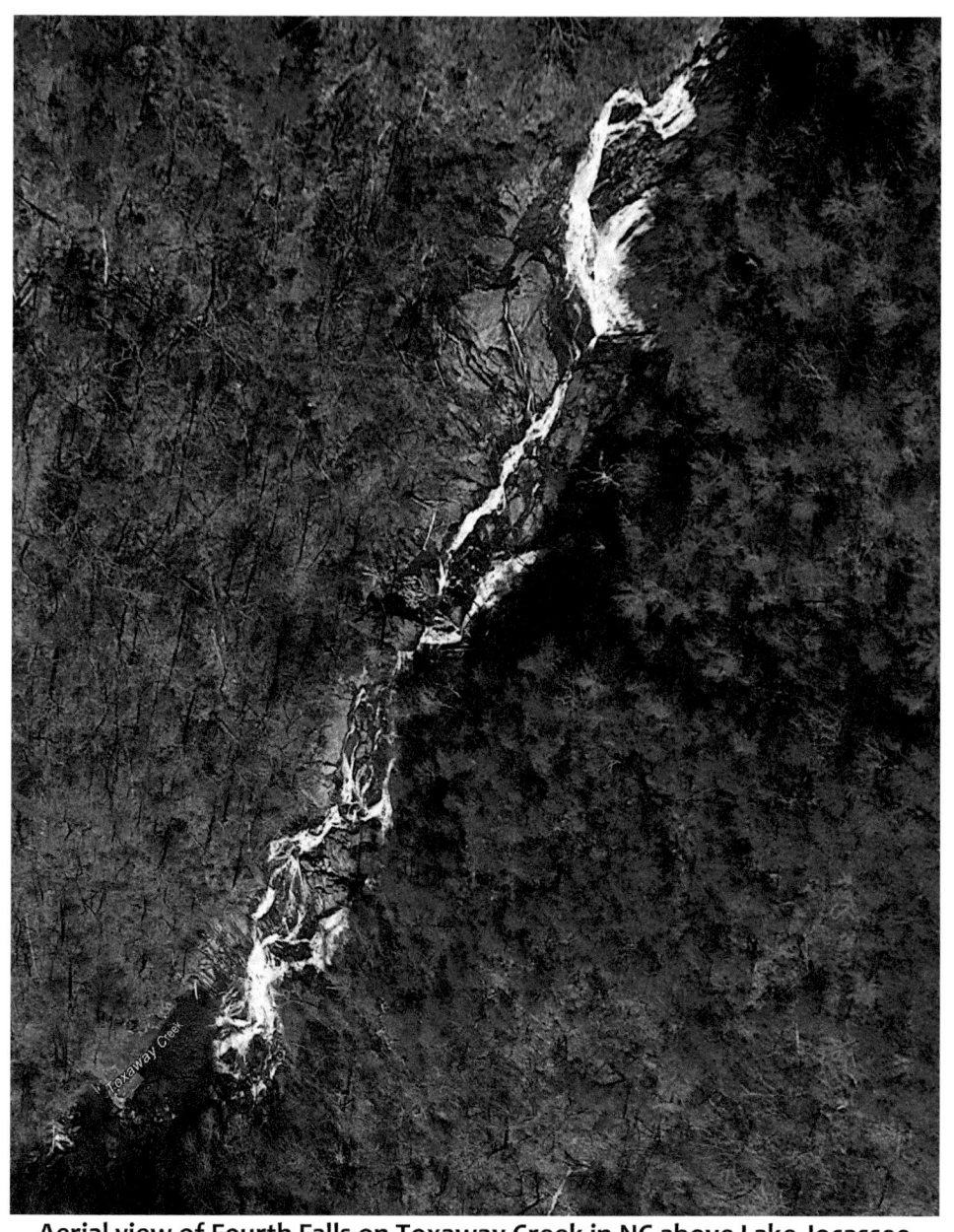
Aerial view of Fourth Falls on Toxaway Creek in NC above Lake Jocassee (note pool at bottom of image) (Google Earth).

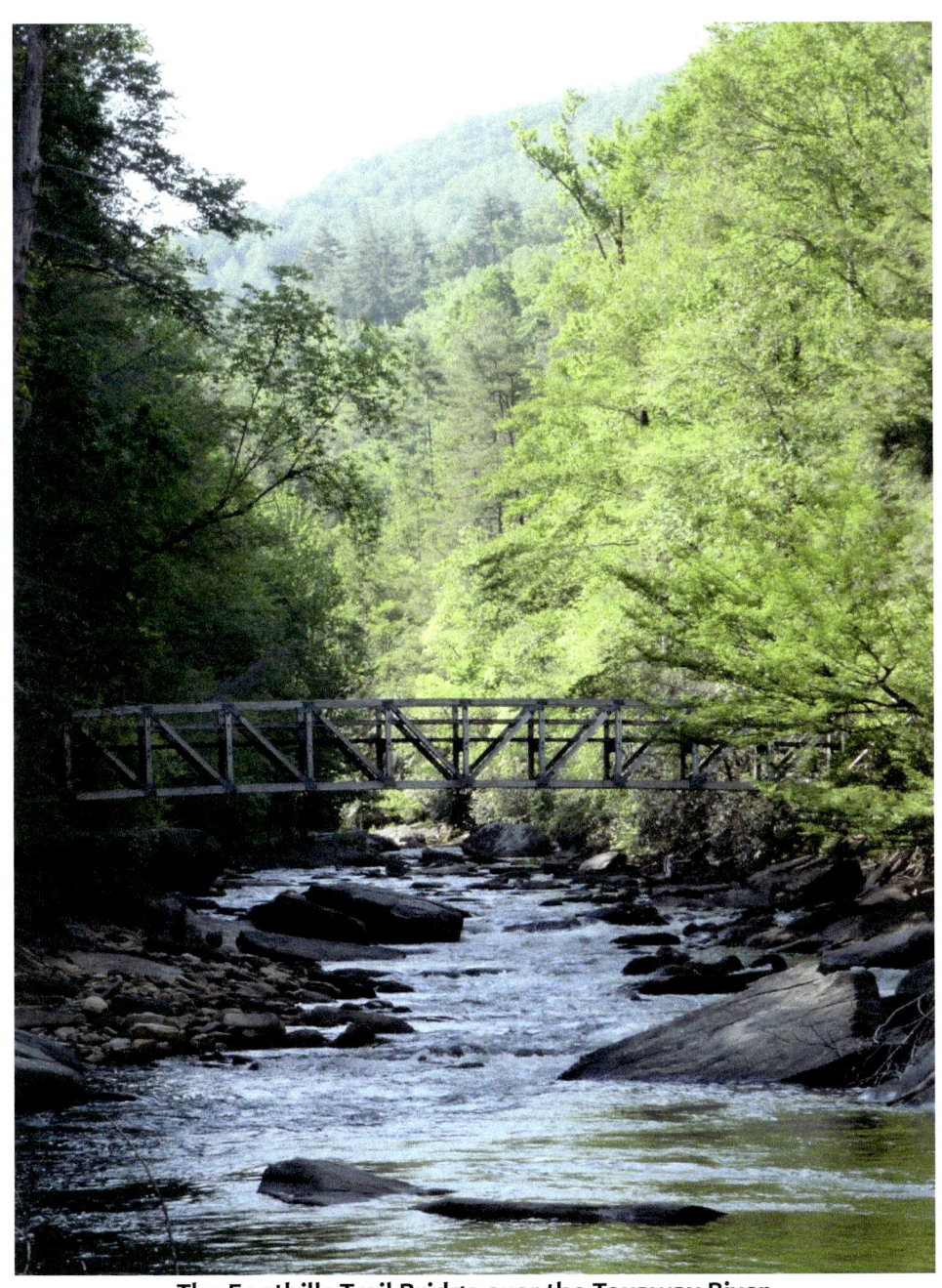
The Foothills Trail Bridge over the Toxaway River.

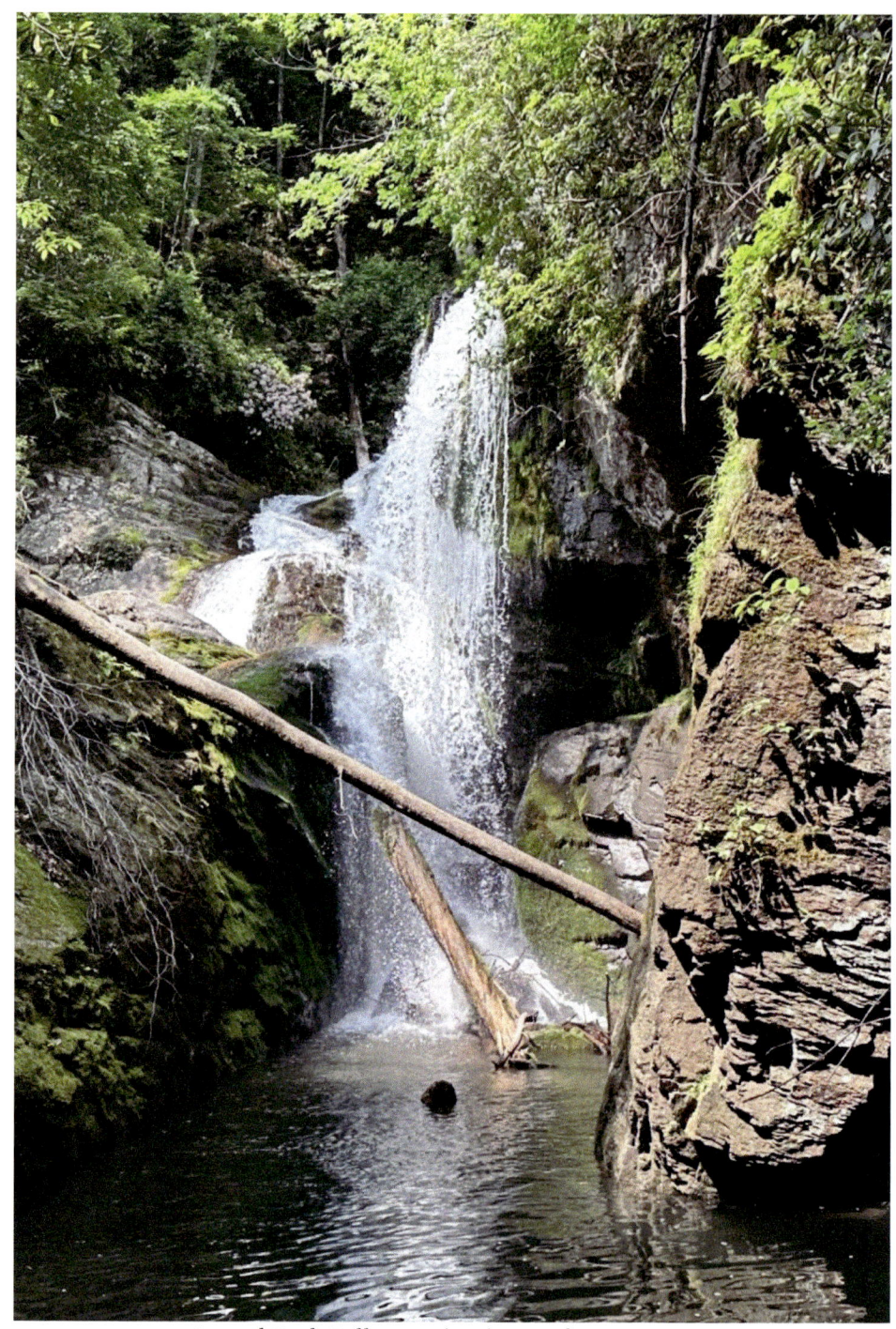

Laurel Fork Falls pouring into Lake Jocassee.

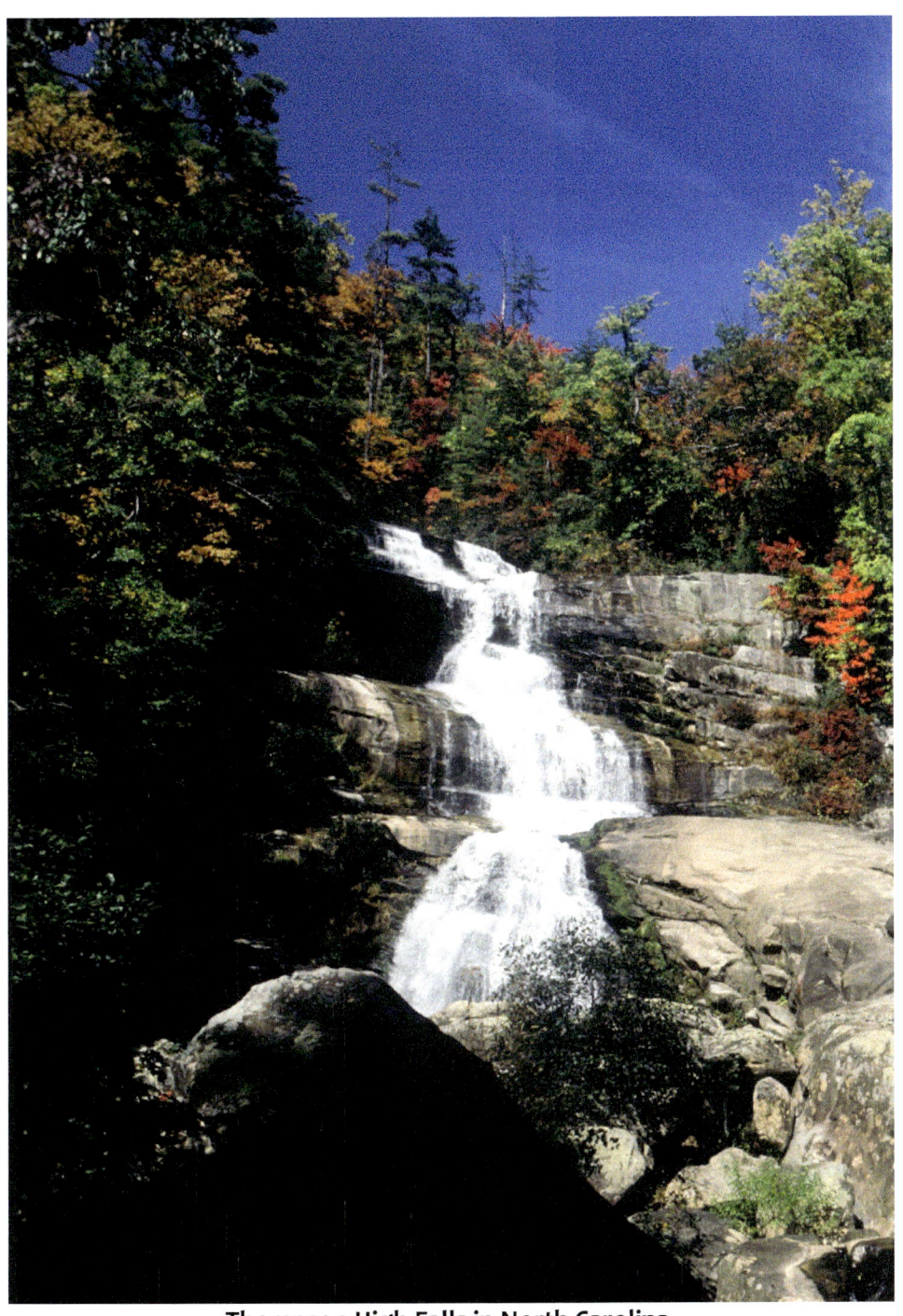
Thompson High Falls in North Carolina.

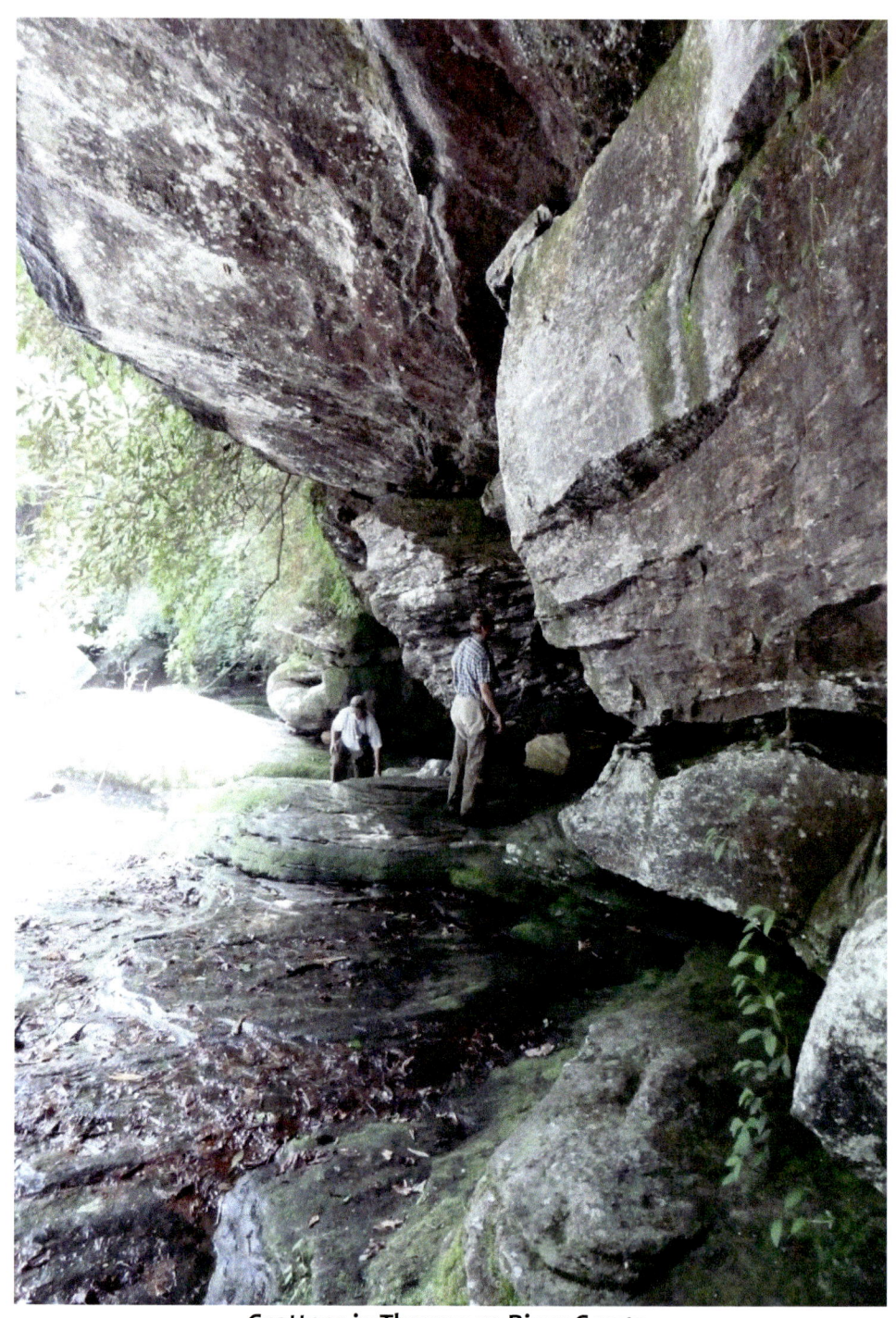
Grottoes in Thompson River Gorge.

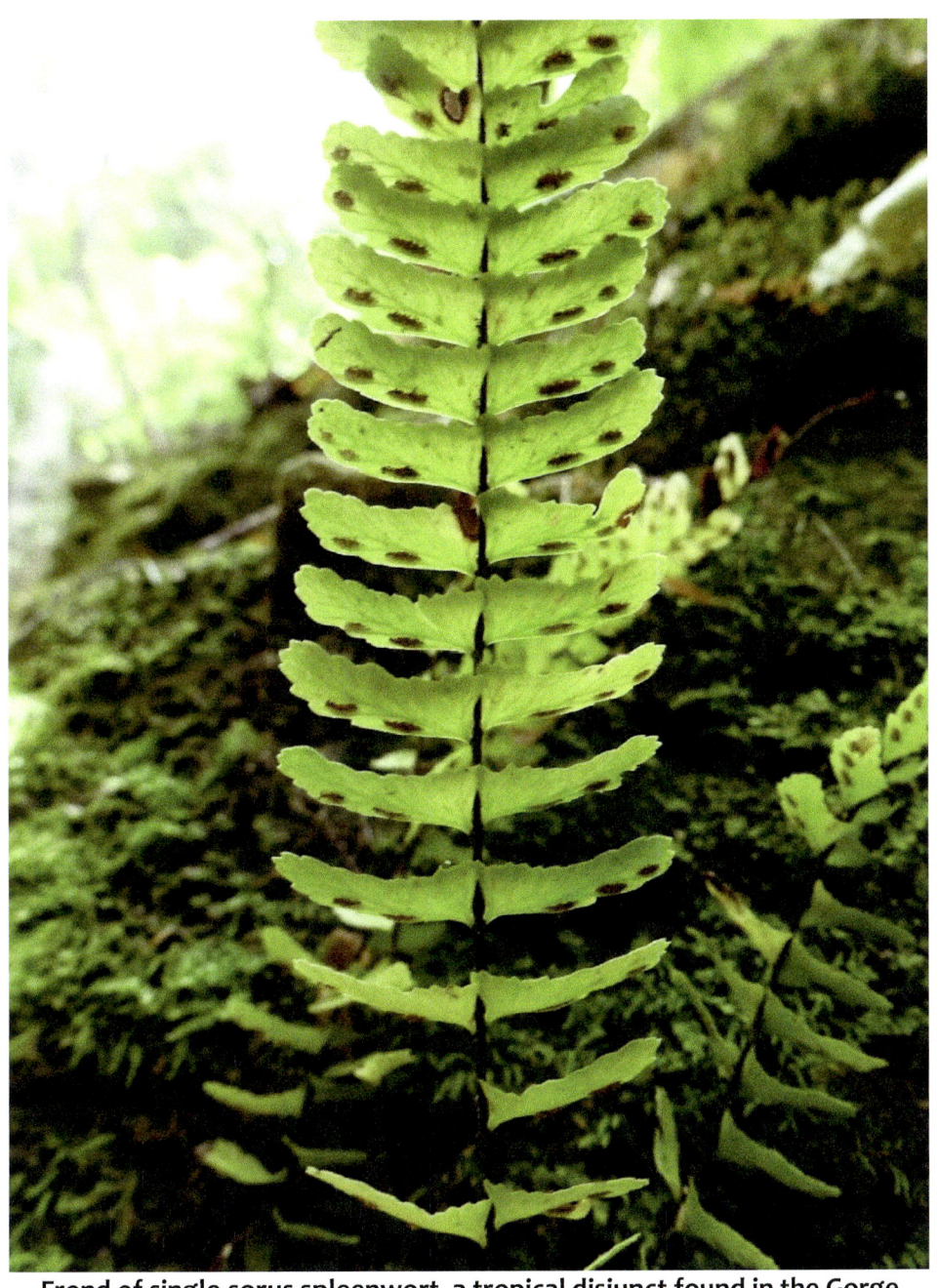
Frond of single-sorus spleenwort, a tropical disjunct found in the Gorge Region.

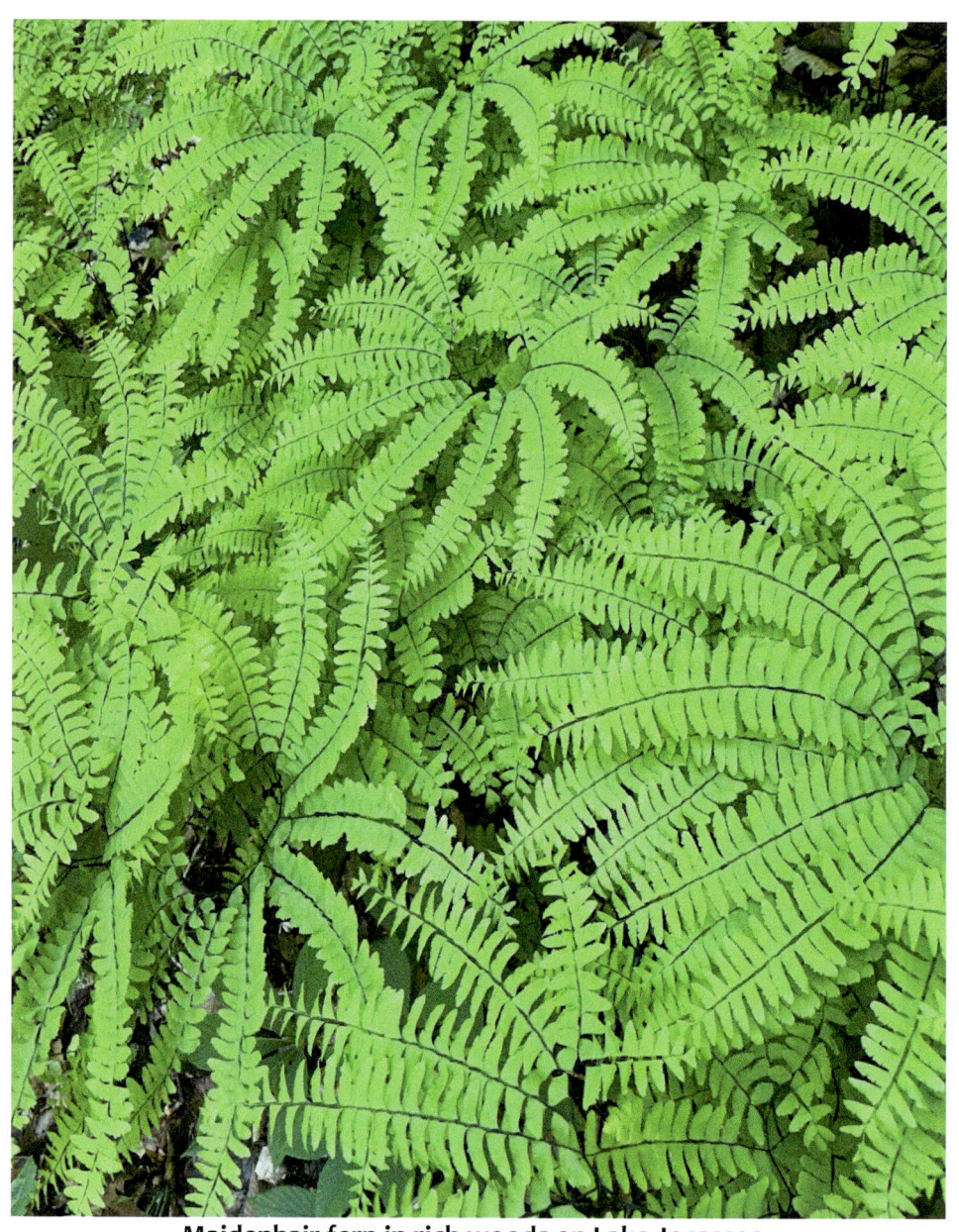
Maidenhair fern in rich woods on Lake Jocassee.

GRANITE-GNEISS DOMES, HIGH ELEVATION PEAKS

North of the gorges, demarcating the margins of the Savannah River drainage, are mountaintops ranging from 3,000-4,000 feet. Some are peaks, while many are eroded granitic-gneissic domes. These domes are especially common in the Highlands-Cashiers area of the gorge region. Whiteside Mountain, the grandest of these, tops out at just over 5000 feet and has spectacular sheer cliffs around 1000 feet in height. Surrounding the town of Highlands, Satulah Mountain, the Fodderstacks, Black Rock Mountain, and Whiteside are all domes with slightly different interesting flora. Around Cashiers and toward Sapphire Valley, one finds Chimneytop, Rock Mountain, Terrapin Mountain, Cow Rock, and Laurel Knob. Closer exploration of these domes reveals a fascinating rock flora. The Fodderstacks are pine-covered rock domes with fire-maintained, dwarfed 400-year old pitch pines. Nestled in rock cracks near the top of Chimneytop is the diminutive wine-leaved cinquefoil, an herb found from Newfoundland to Georgia. On the rocky cliffs of Satulah, one finds the type locality of the Biltmore sedge, originally collected by T. G. Harbison of Highlands and deposited in the Biltmore Herbarium in Asheville (thus its name). On the high ridges of Rabun Bald in extreme northwestern Georgia (4,656 feet), high elevation plant species are found. (See also Tallulah River Above Tallulah Gorge for a discussion of Standing Indian Mountain.)

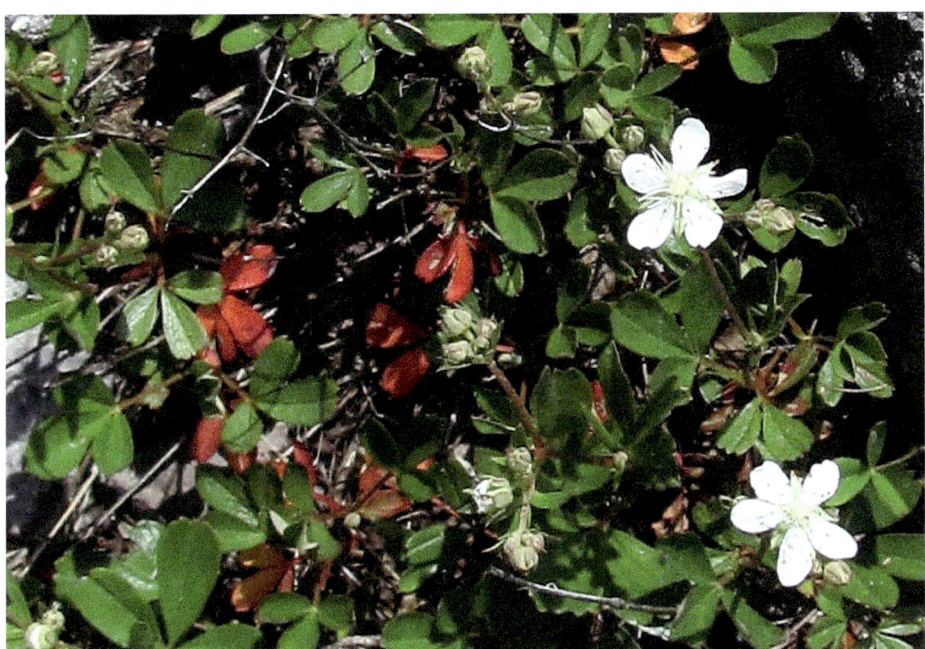

Wine-leaved cinquefoil is found in rock crevices on Chimneytop, a granitic peak near Cashiers, NC—it ranges north to Nova Scotia and Greenland!

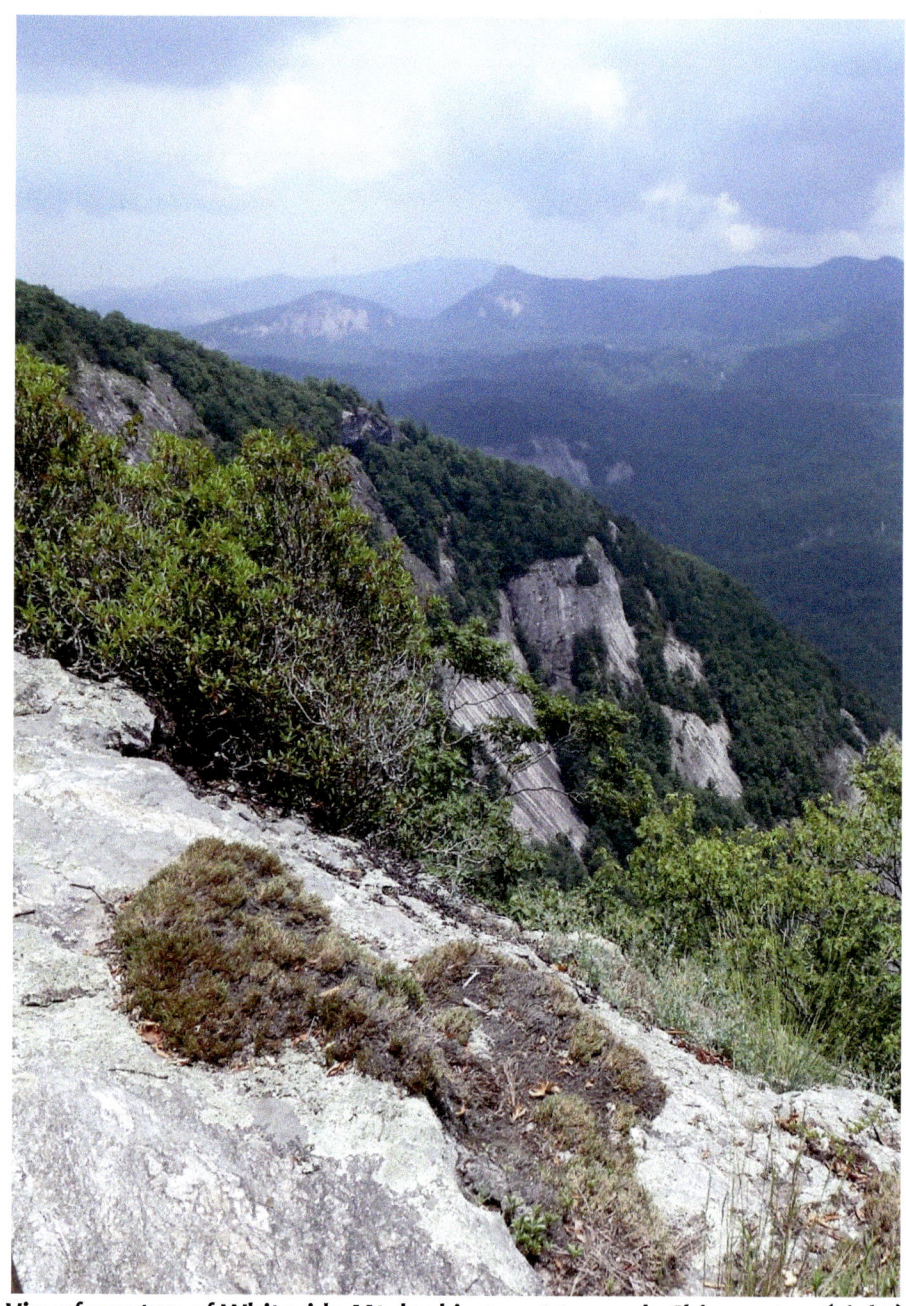

View from top of Whiteside Mt. looking east towards Chimneytop (right) and Rock Mountain in Cashiers, NC.

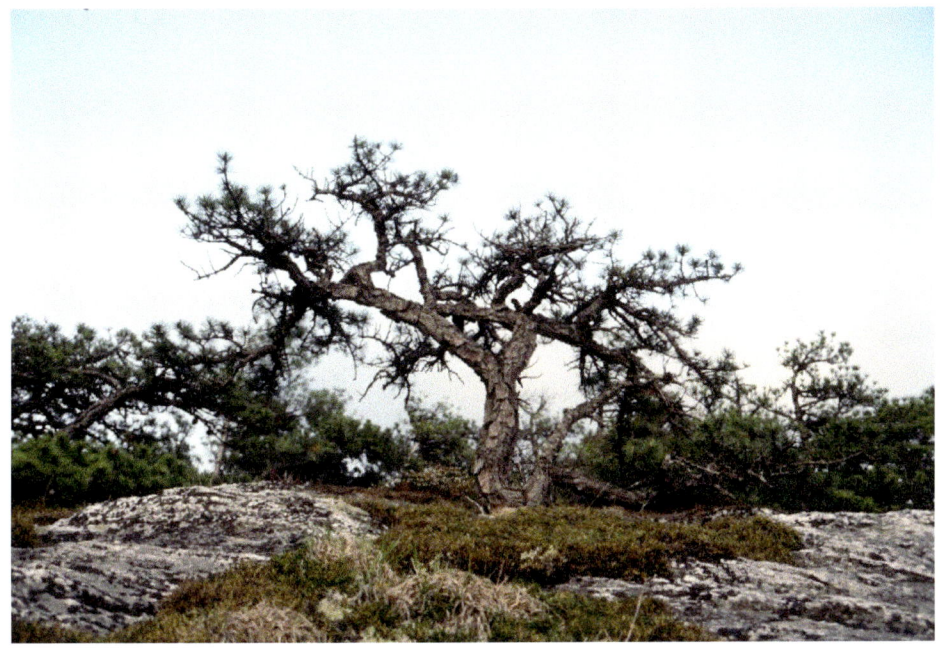
Old-growth, dwarf pitch pine on Big Fodderstack is thought to be nearly 400 years old.

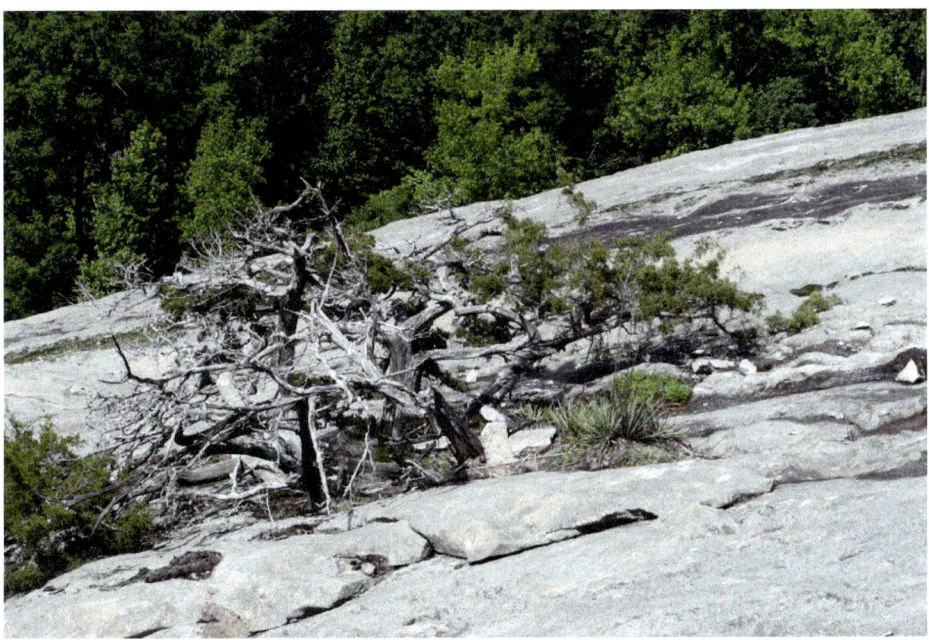
A few steep, granitic domes have scattered old-growth gnarled eastern red cedar on their crests and upper slopes.

The high elevation pink shell azalea, normally found only along the Blue Ridge Parkway, is known from Rabun Bald west of the Chattooga River at over 4000 feet in elevation.

BLUE RIDGE FRONT/CHAUGA BELT

The Blue Ridge front actually extends from Maryland to Georgia, but in the Gorge Region, it is most pronounced in Oconee County, South Carolina, where the Blue Ridge abruptly drops 1200 feet from SC Highway 107 into the Cheohee and Tamassee Valleys. The only road that scales the escarpment here is the Forest Service's Tamassee Road (also called Winding Stairs Road). This road winds and switches back over and over from the top of the Blue Ridge front down to the Piedmont. Just north and roughly paralleling Tamassee Road is Winding Stairs Trail, which begins just south of Cherry Hill Campground on SC Highway 107 and travels 3.5 miles downward to the lower reaches of Tamassee Road. The trail follows old logging roads, which follow what was once a Native American trail from the Blue Ridge down to two Cherokee towns—Cheohee and Tamassee (it may have existed before the Cherokees).

The Chauga (or Brevard) Belt begins in North Carolina and extends from Brevard into northern Georgia. According to geologists, this belt was formed when the African geologic plate collided with the North American geological plate and smashed a volcanic island arc off the coast of the Carolinas into the Blue Ridge. Here, metasedimentary rocks such as schists, slates, and even marble are found. These rocks are rich in calcium and magnesium and have formed some of the richest coves in the area. Glade Fern Ravine, Station Cove, Tamassee Falls, Issaqueena Falls, the Chauga River, Brasstown Creek, and Panther Creek in Georgia are all found in the Chauga Belt. Most showy southern Appalachian wildflowers prefer soils rich in calcium and magnesium; the Chauga Belt, therefore, is a good place to find spring wildflowers.

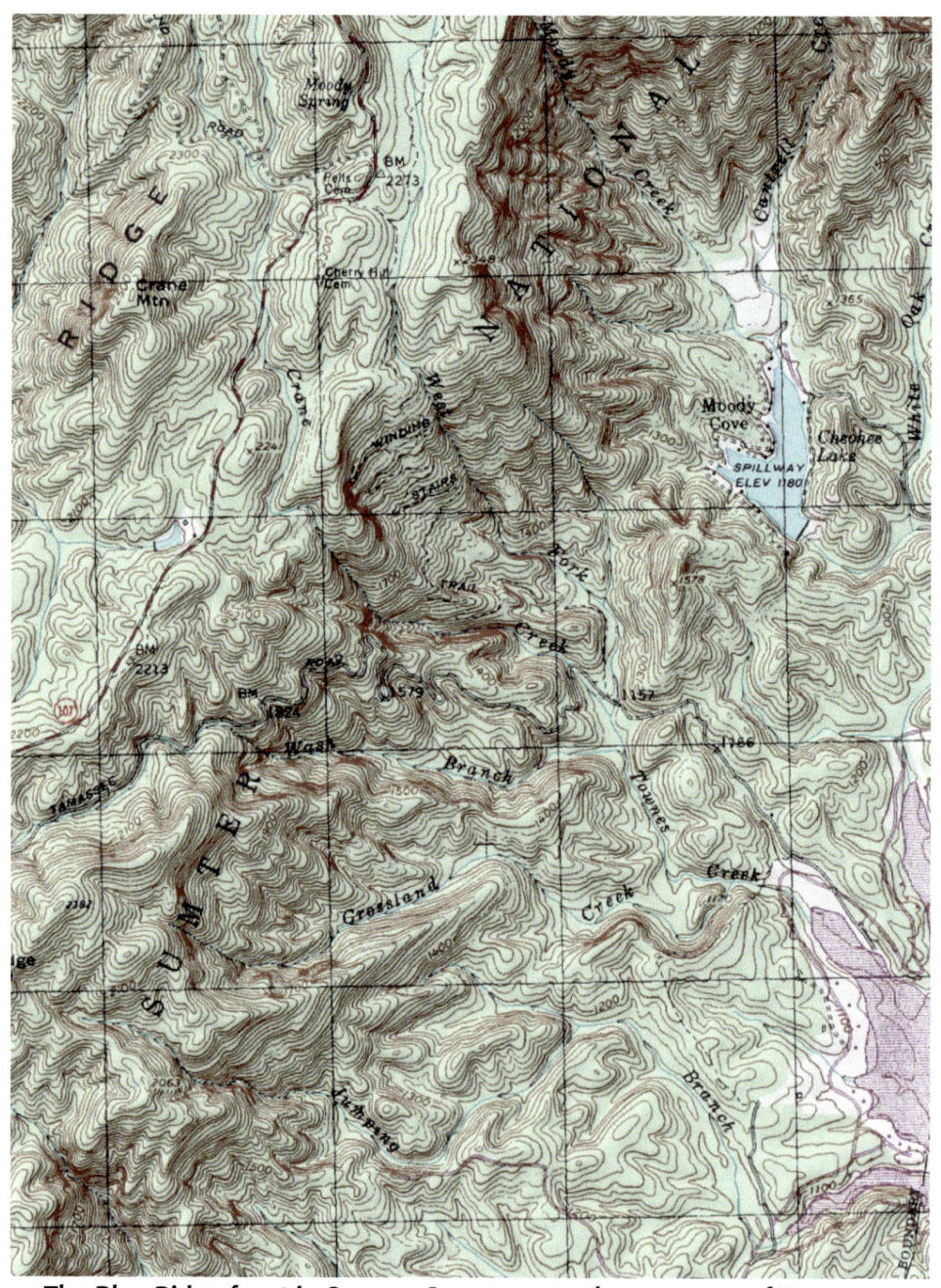

The Blue Ridge front in Oconee County: note the presence of Tamassee Road and the Winding Stairs Trail.

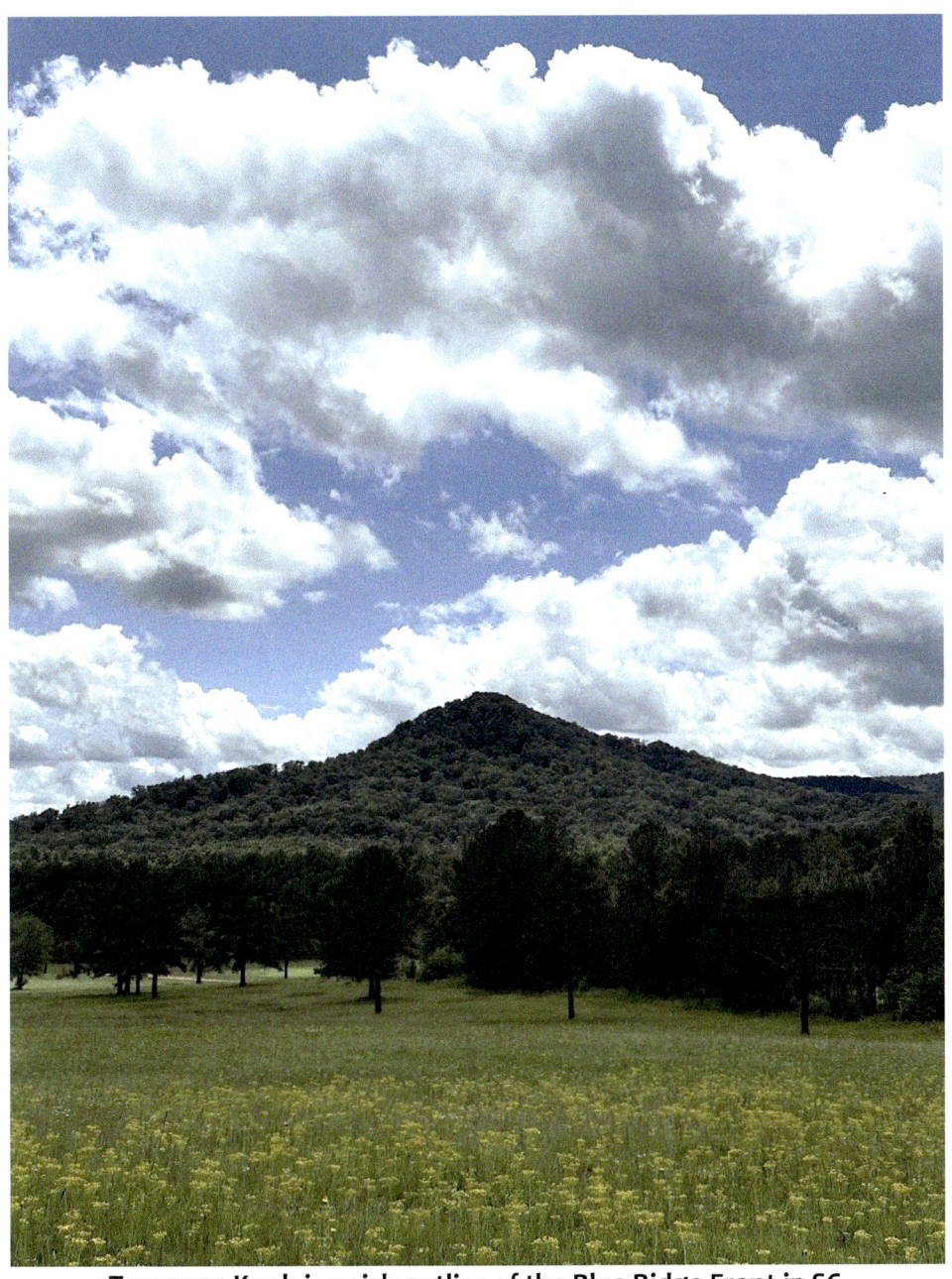
Tamassee Knob is a rich outlier of the Blue Ridge Front in SC.

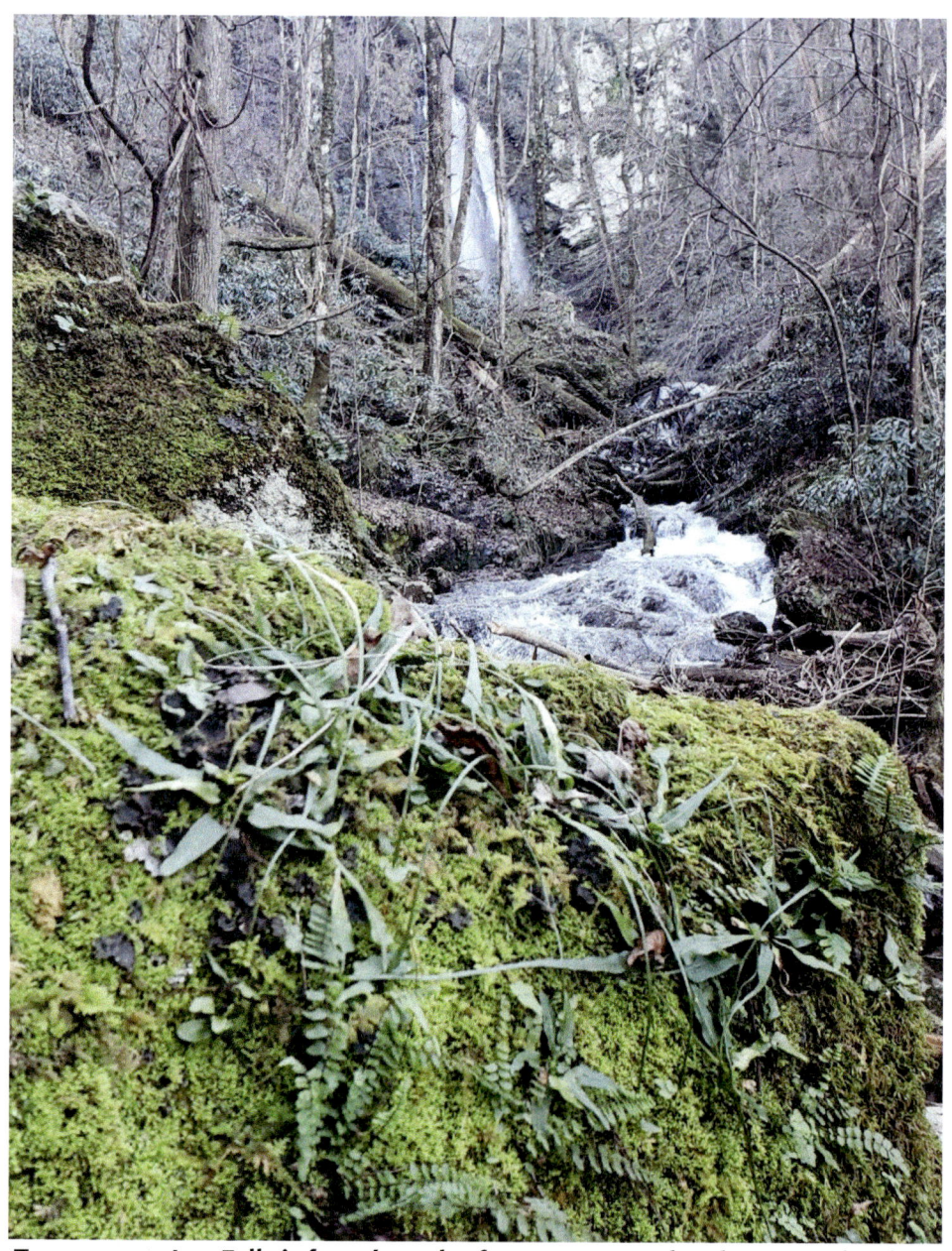
Tamassee or Lee Falls is found north of Tamassee Knob. The mossy boulder above is covered with walking fern and black-stemmed spleenwort, both rare in SC.

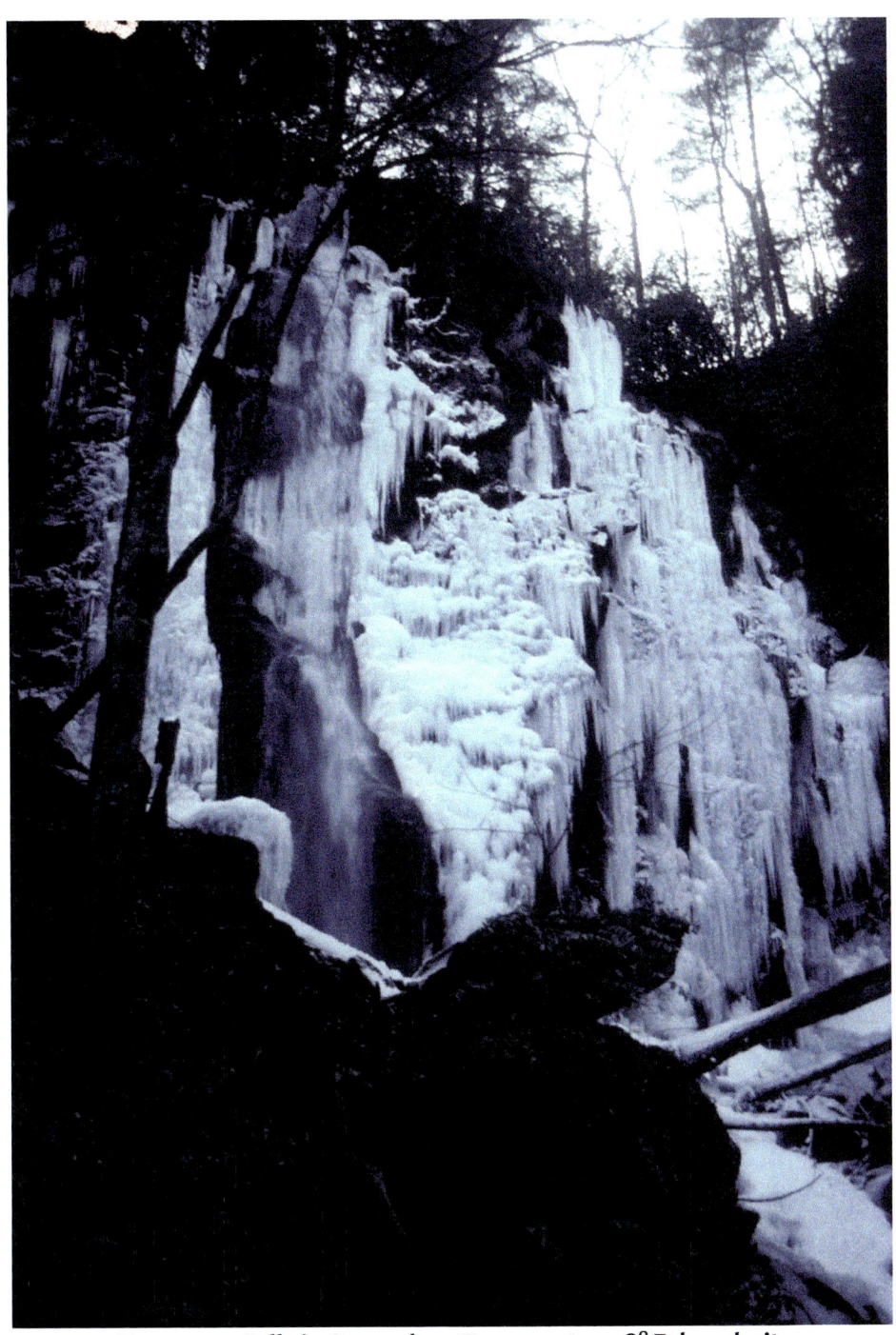
Tamassee Falls in December. Temperature 8° Fahrenheit.

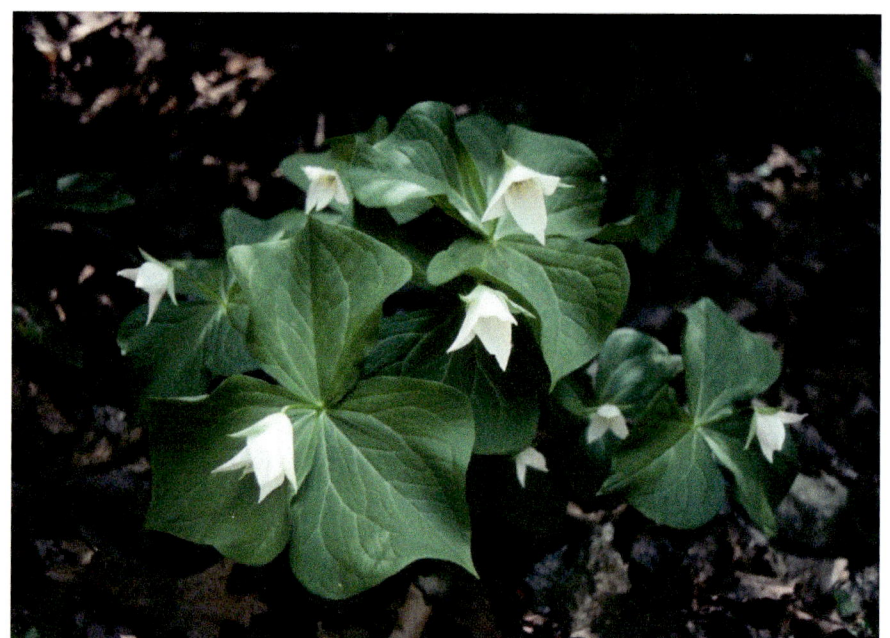
Sweet white trillium is found in rich coves below Station Cove and Tamassee Knob.

American ginseng grows on rich soils in coves in the study area.

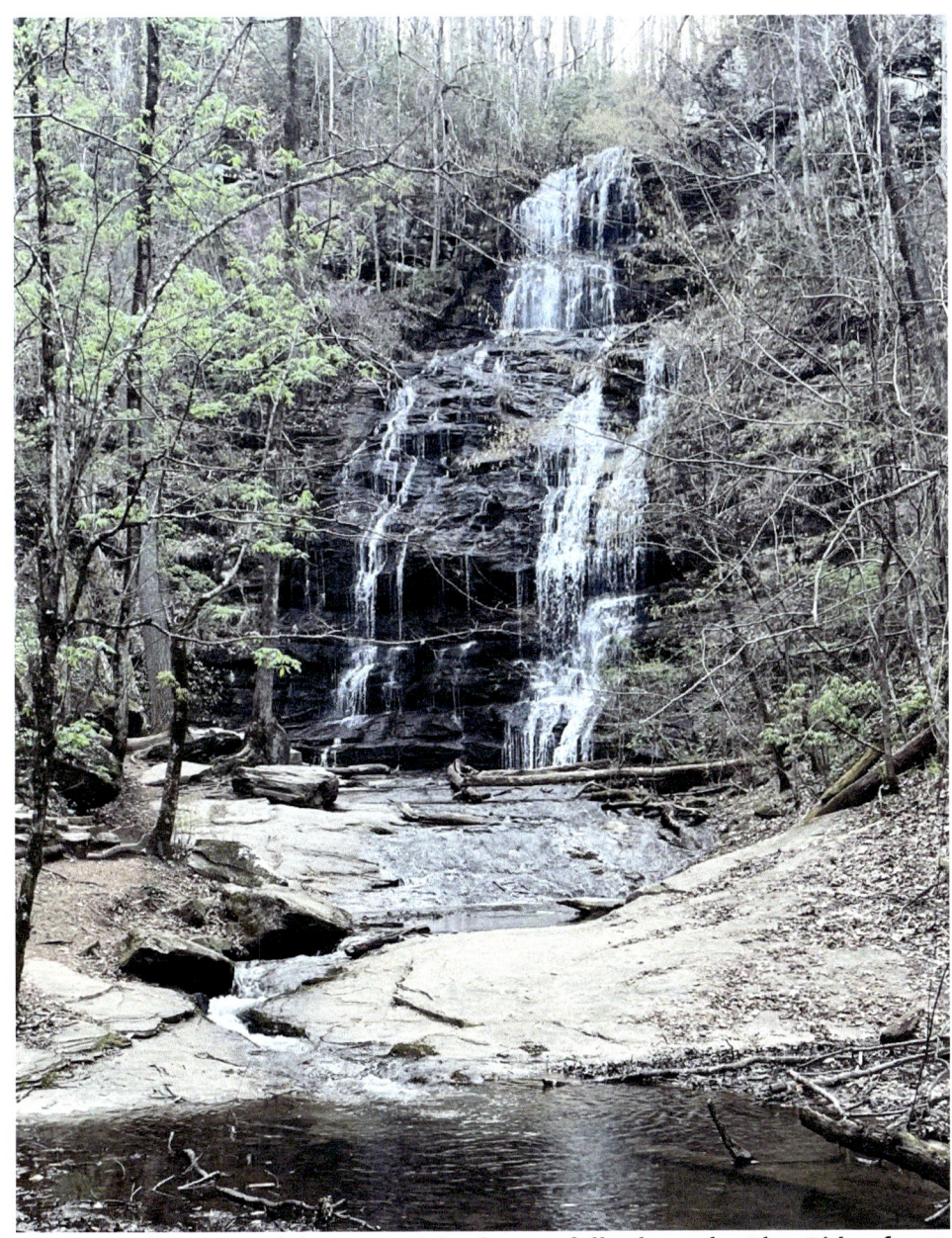
Station Falls is one of the most-visited waterfalls along the Blue Ridge front in SC.

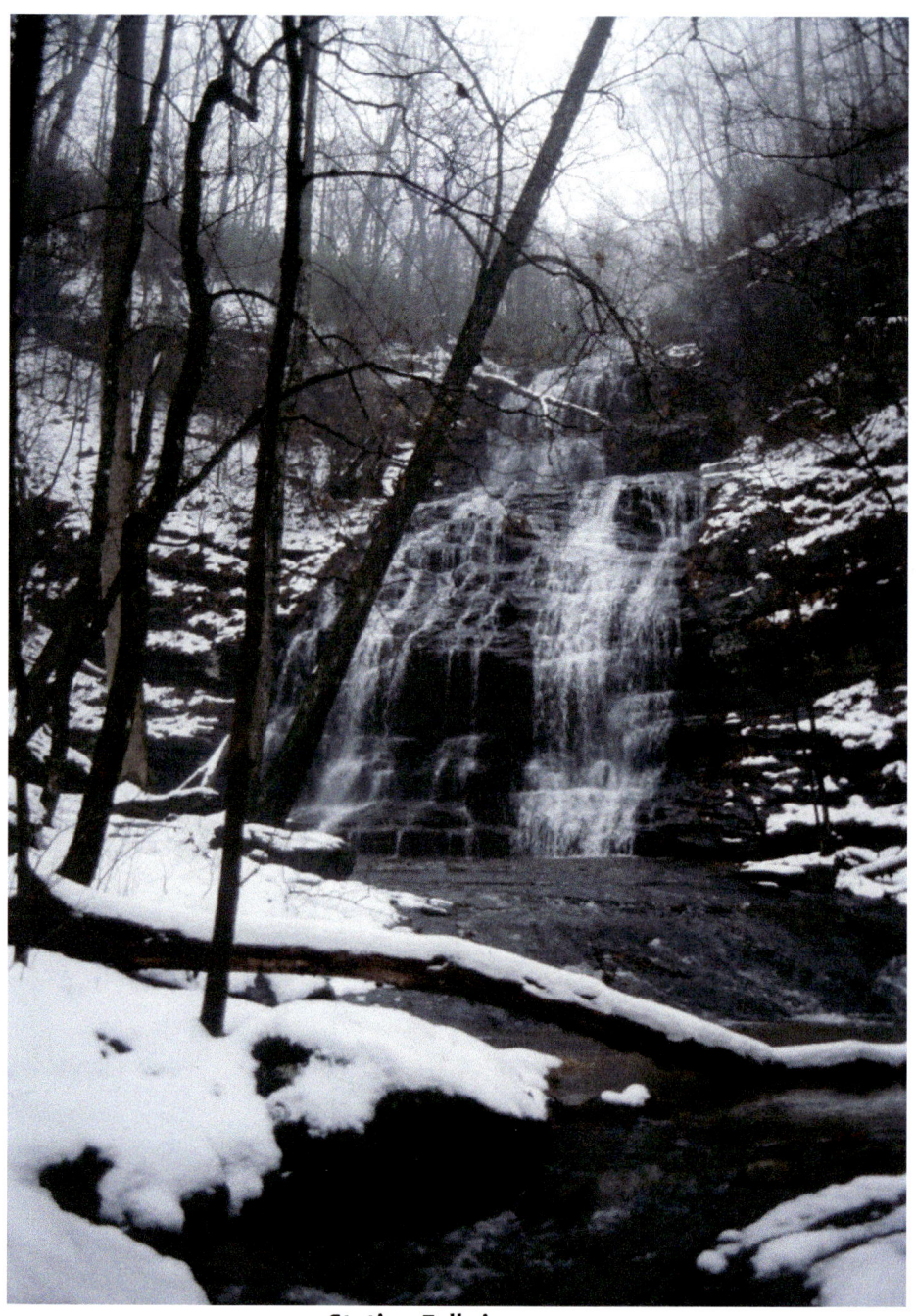
Station Falls in snow.

Old-growth beech and slippery elm in Station Cove just below the falls.

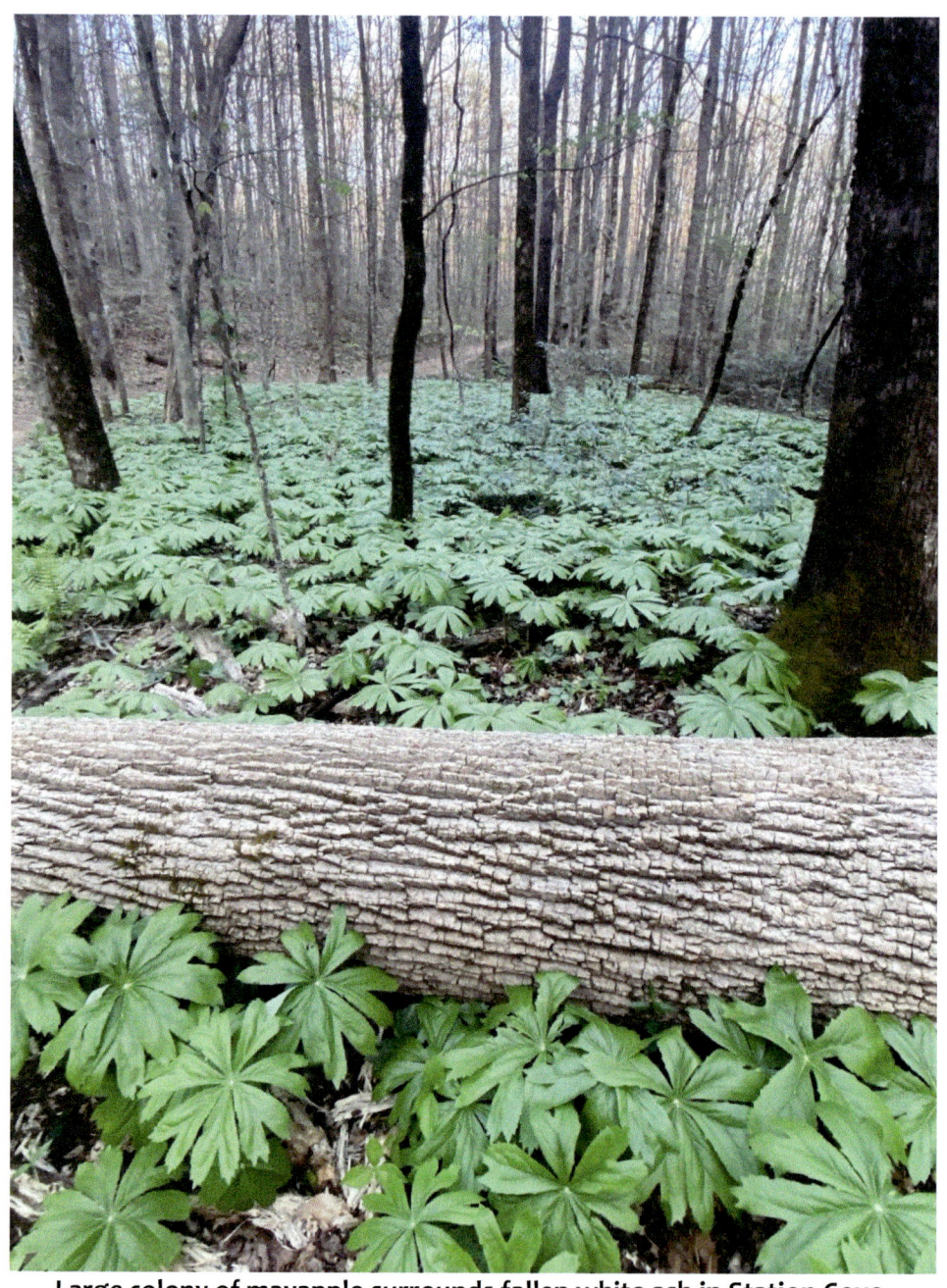
Large colony of mayapple surrounds fallen white ash in Station Cove.

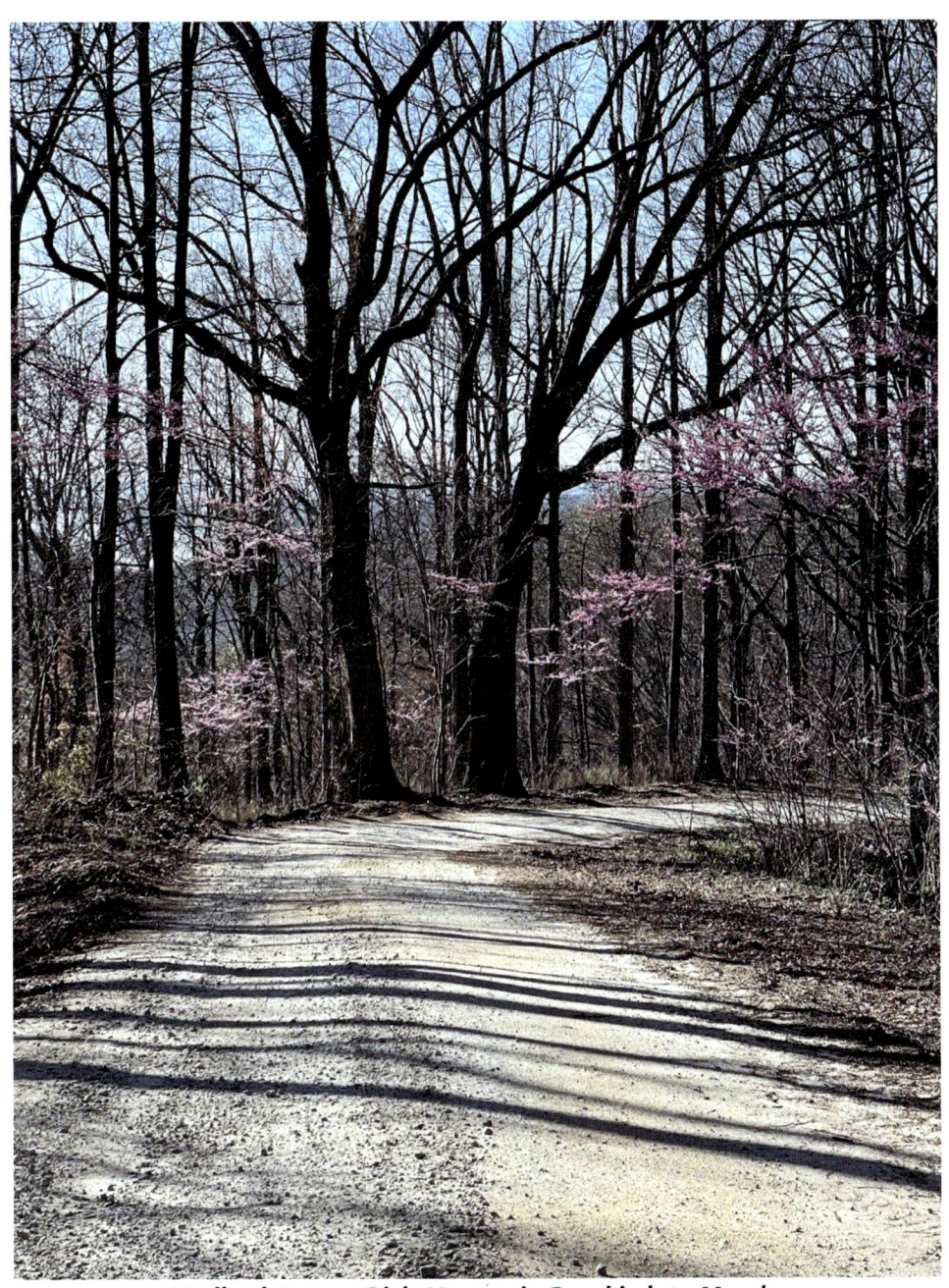
Redbud Gap on Rich Mountain Road in late March.

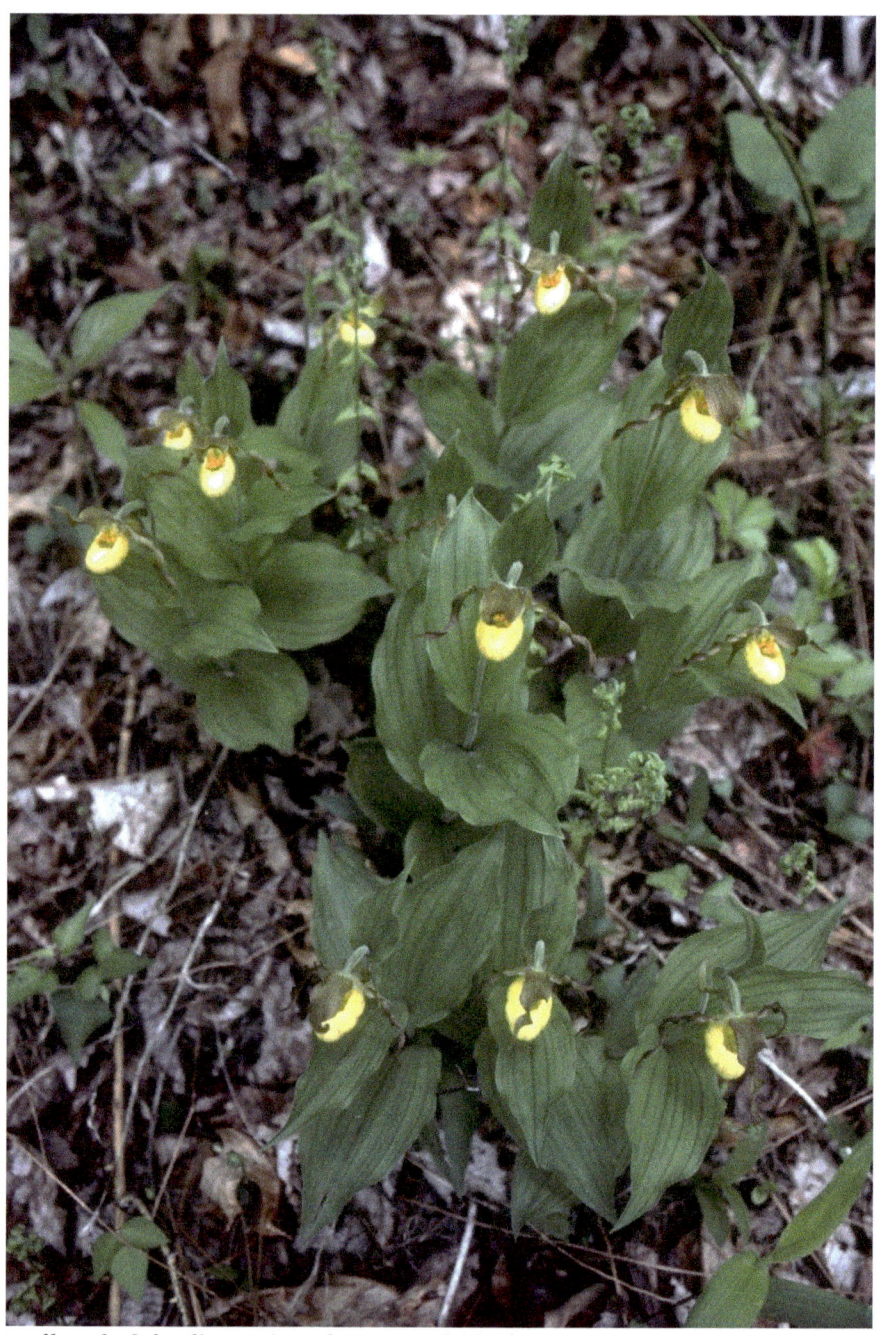
Yellow lady's-slipper is a showy orchid often seen in rich coves on the Chauga River.

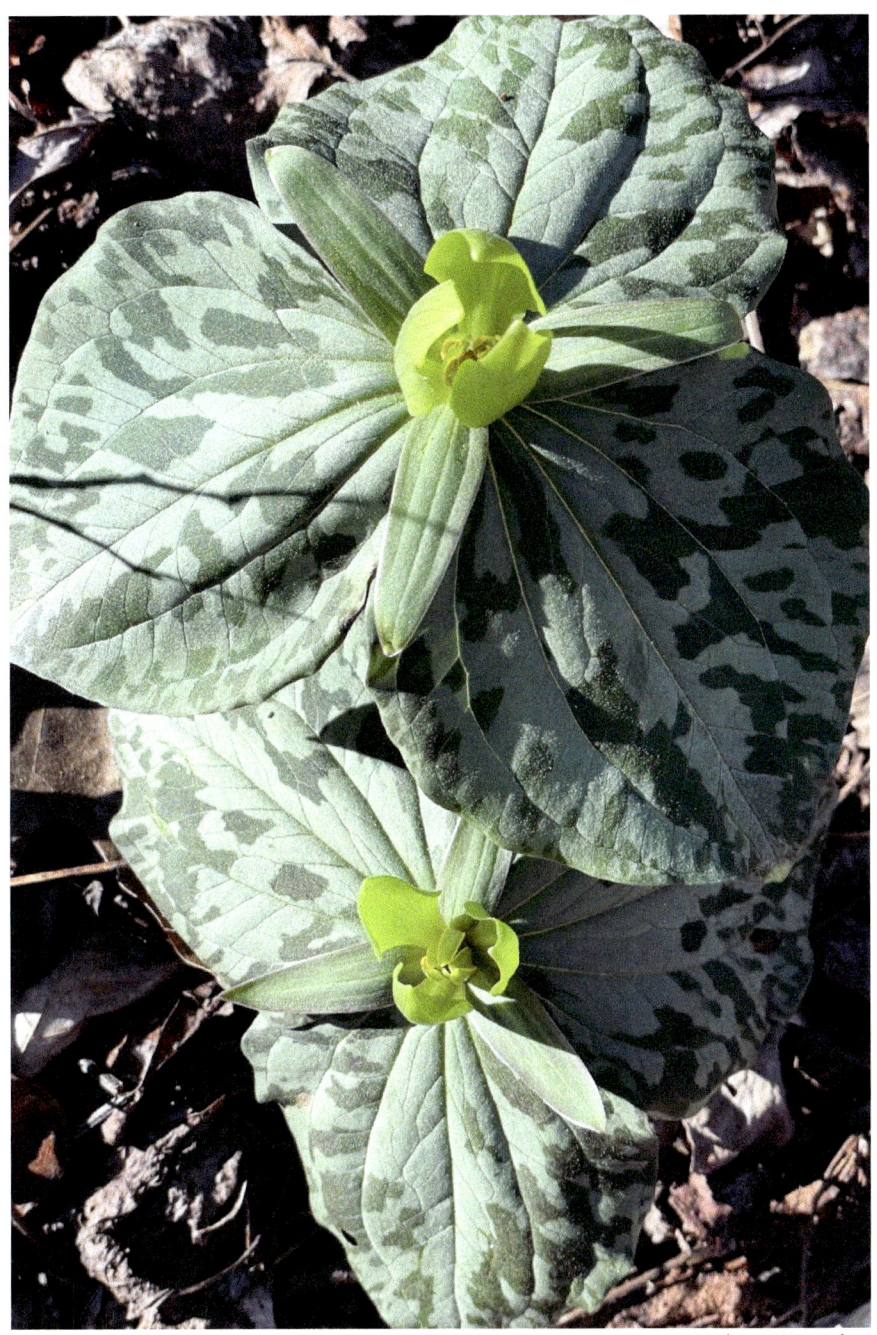
Greenish-yellow flowers of a variety of cuneate toadshade (a trillium) on Rich Mountain.

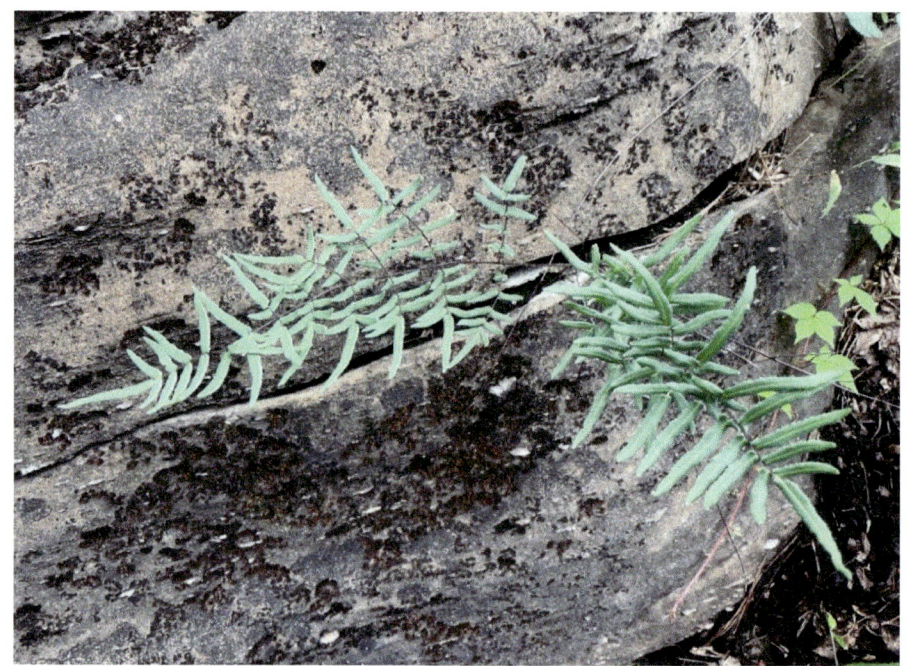
Purple cliffbrake fern growing on marble on Poor Mountain.

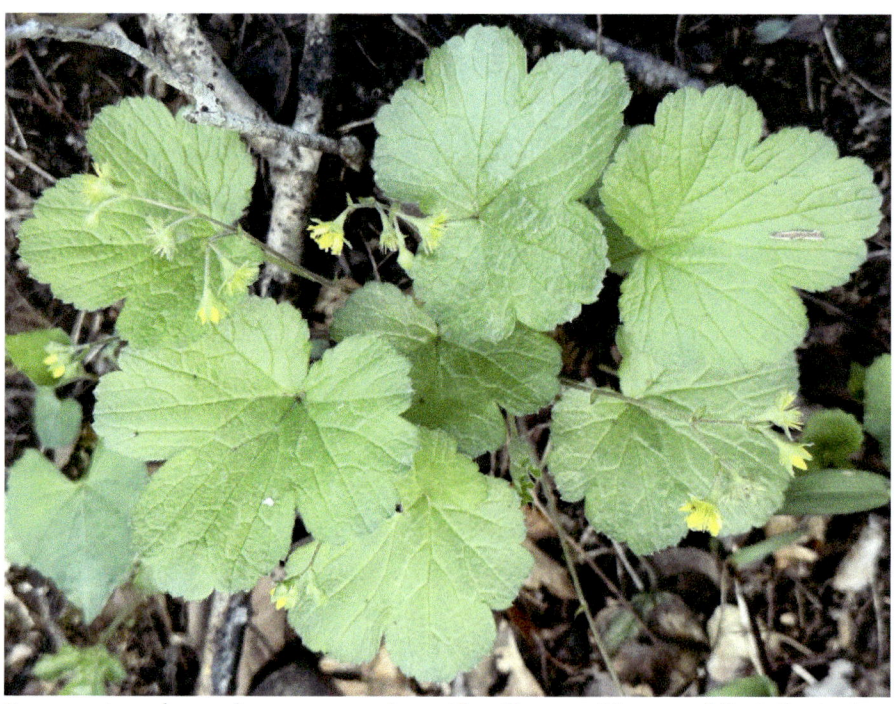
Barren strawberry is common along the Chauga River and its tributaries.

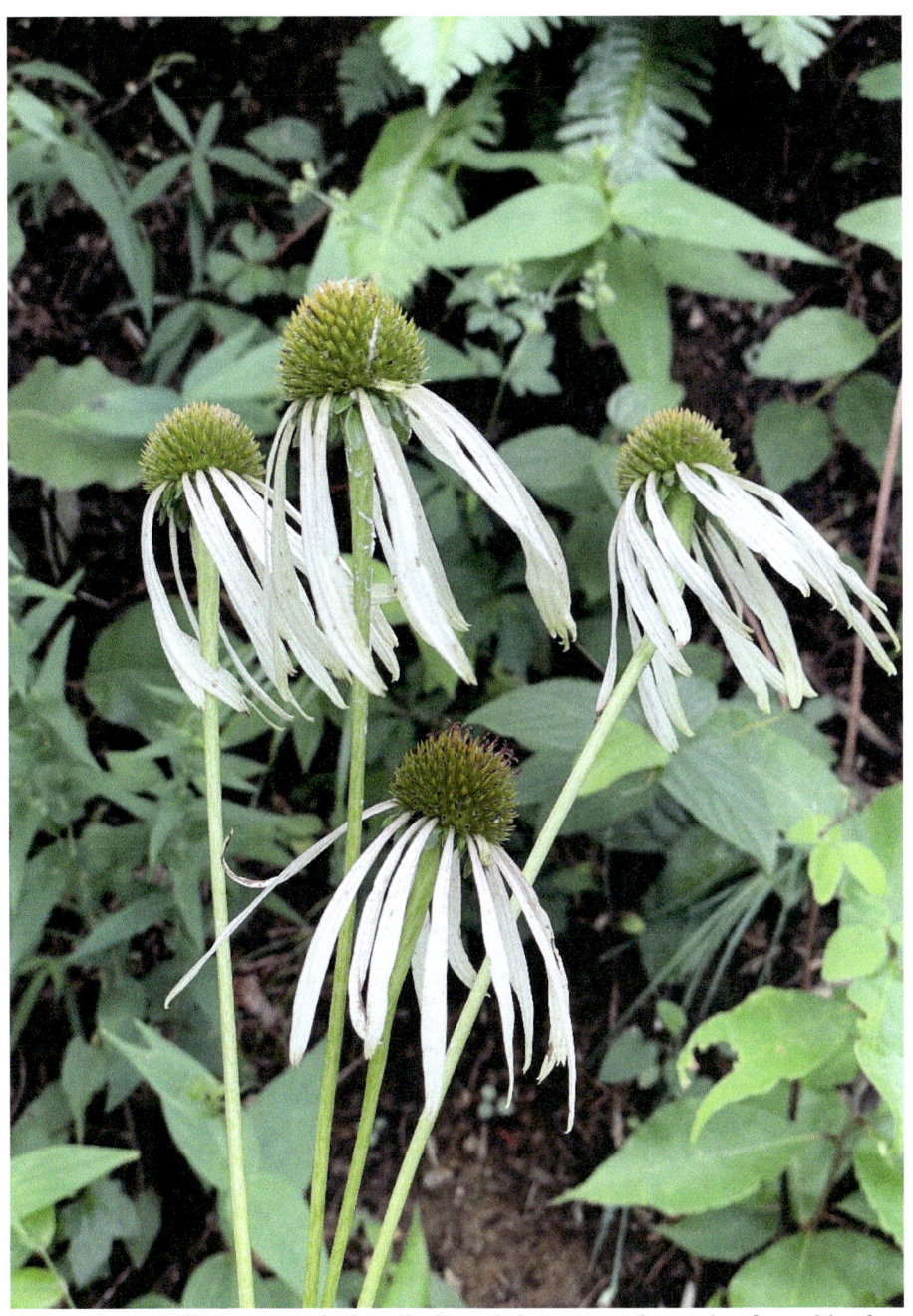
Smooth coneflower is a federally-listed threatened species found in the Chauga River drainage.

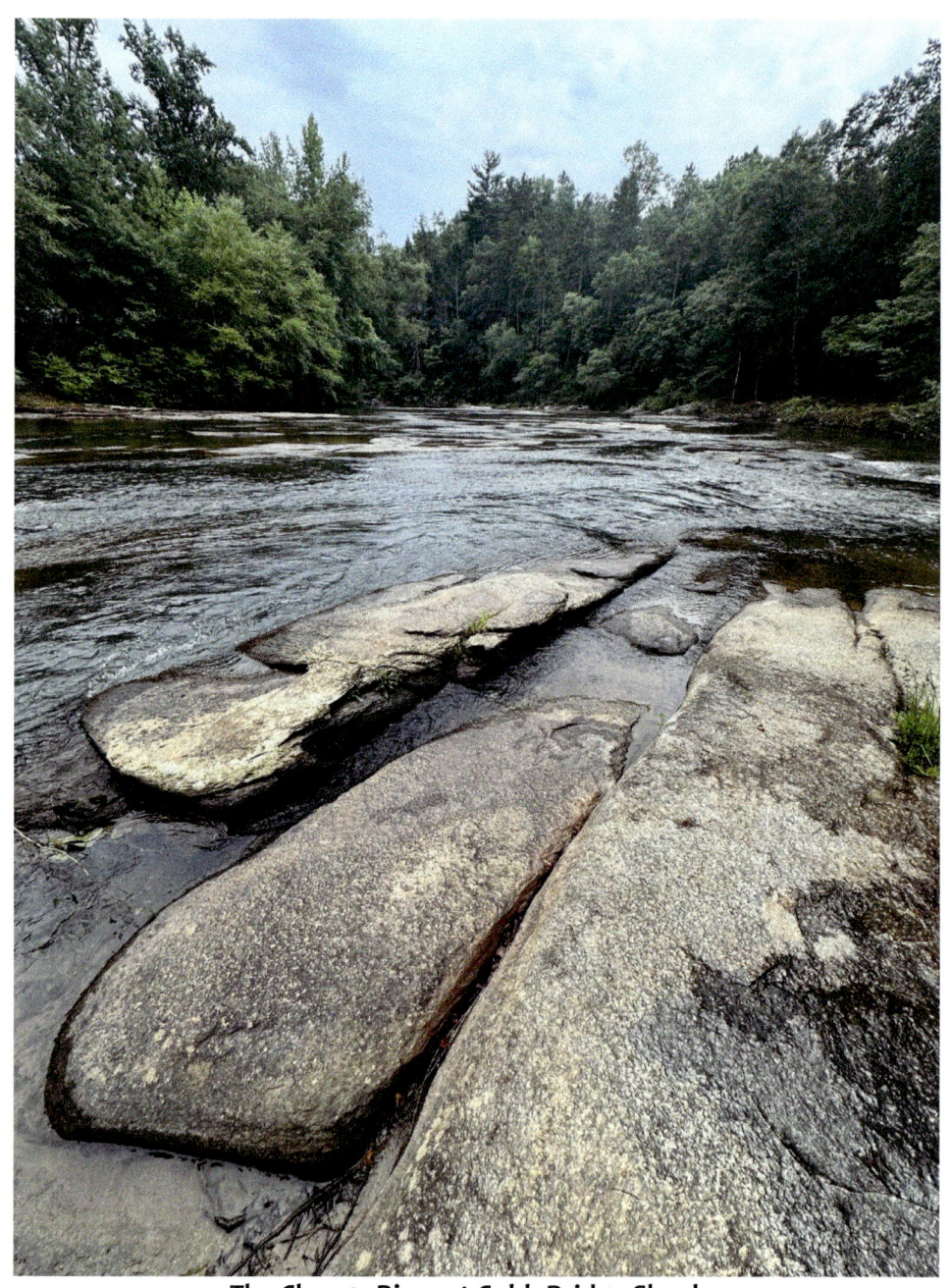
The Chauga River at Cobb Bridge Shoals.

THE CHATTOOGA

The Chattooga River is the longest river in the region. It arises from springs on the north face of Whiteside Mountain in North Carolina and winds its way through two sets of narrows and several small gorges down to where it meets the Tallulah to form the Tugalo, which flows into the backwaters of Lake Hartwell, where it meets the Seneca River, also under Lake Hartwell and eventually becomes the Savannah River. The Chattooga is a National Wild and Scenic River well known for its whitewater rapids.

The Chattooga has two main branches—the East Fork (in SC and NC) and the West Fork (in GA). The East Fork flows along NC Highway 107 into SC through the SCDNR Fish Hatchery and into the main Chattooga in SC. It harbors excellent trails and old-growth woods (at one time the state record Canada hemlock, white pine, and pitch pine were known from its drainage) and the large-flowered trillium, umbrella-leaf, mountain camellia, and Wood's sedge, all rare plants in South Carolina. The five-mile round trip from the Fish Hatchery to the Chattooga and back is an interesting hike any time of the year.

The West Fork begins where Holcomb, Secret, and Overflow Creeks meet in northeastern Georgia (called "Three Forks." three creeks meeting at one point is an anomaly in dendritic drainage systems). Here the "West Fork" officially begins; it ends flowing into the Chattooga just below Highway 28 Bridge. The area around Three Forks, relatively inaccessible to the casual hiker, is frequented by fly fishers, waterfall watchers (there are numerous interesting falls in a half-mile radius of the junction), and wildflower and mushroom hunters.

Just below Big Bend Falls, the Chattooga has carved a steep-walled gorge called Rock Gorge. In upper Rock Gorge lies the second "Narrows" of the Chattooga (the first are just above the Bull Pen Road Bridge below "Chattooga Cliffs" in North Carolina). At both Narrows, the Chattooga is only 20-30 feet wide. The rare Biltmore sedge and gorge clubmoss can both be seen on the granitic walls of Rock Gorge and Chattooga Cliffs.

The lower Chattooga is most famous for whitewater. Between the US Highway 76 bridge and Tugalo Lake numerous rapids and chutes are found. Noteworthy waterfalls here include Long Creek Falls and Opossum Creek Falls. Oconee residents such as Butch (W. C.) Clay, W. C. Lesan, and Buzz Williams have spent much of their lives floating, studying, and protecting this beautiful river. Both Clay and Lesan are authors of guides to the myriad interesting sites in the river drainage. The online interactive **Hiker's Guide to the Chattooga River** by Lesan and others at the Chattooga Native Plant Society (https://decastongrene.com) is outstanding and is free.

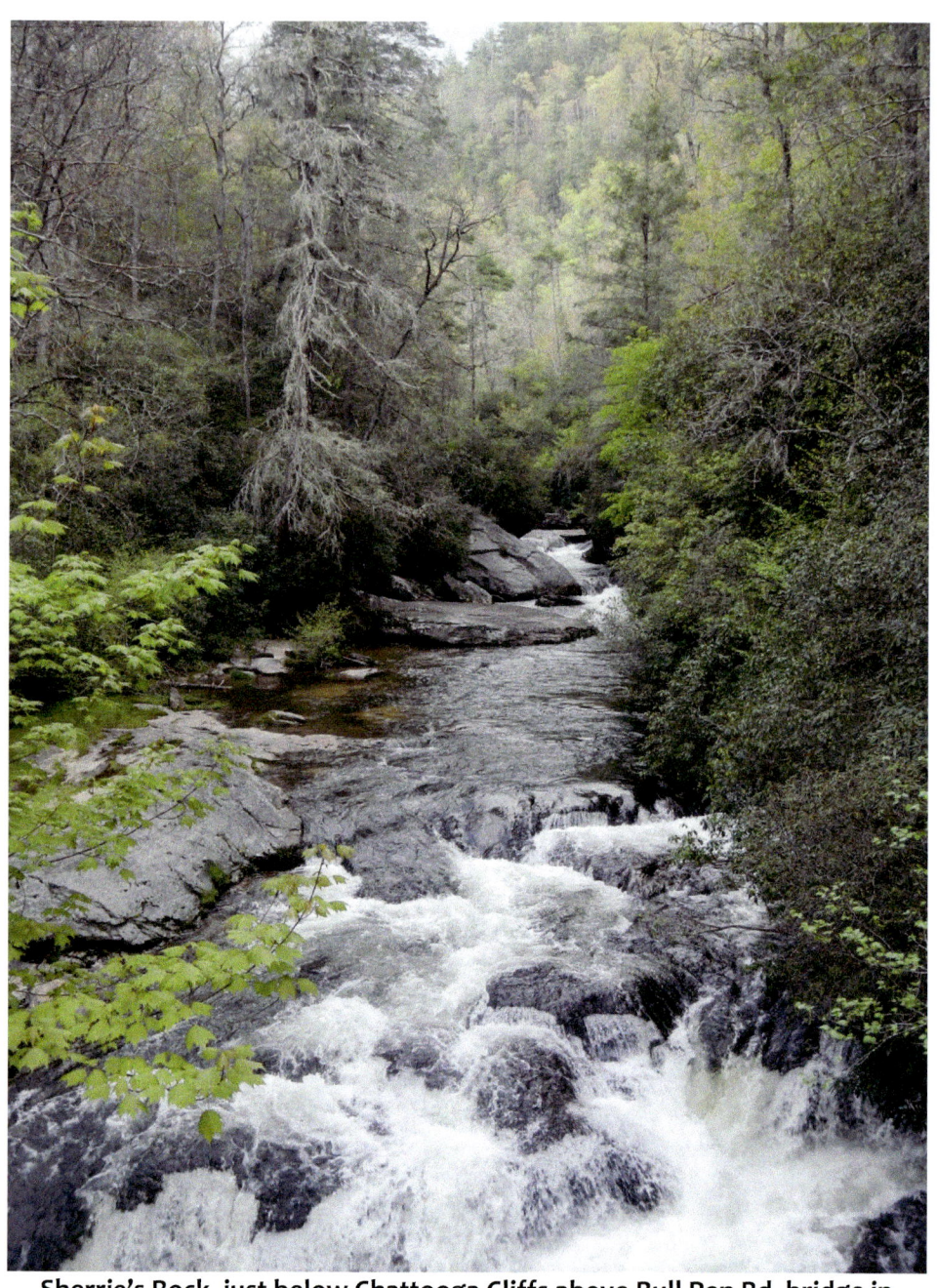
Sherrie's Rock, just below Chattooga Cliffs above Bull Pen Rd. bridge in North Carolina overlooking "the Narrows."

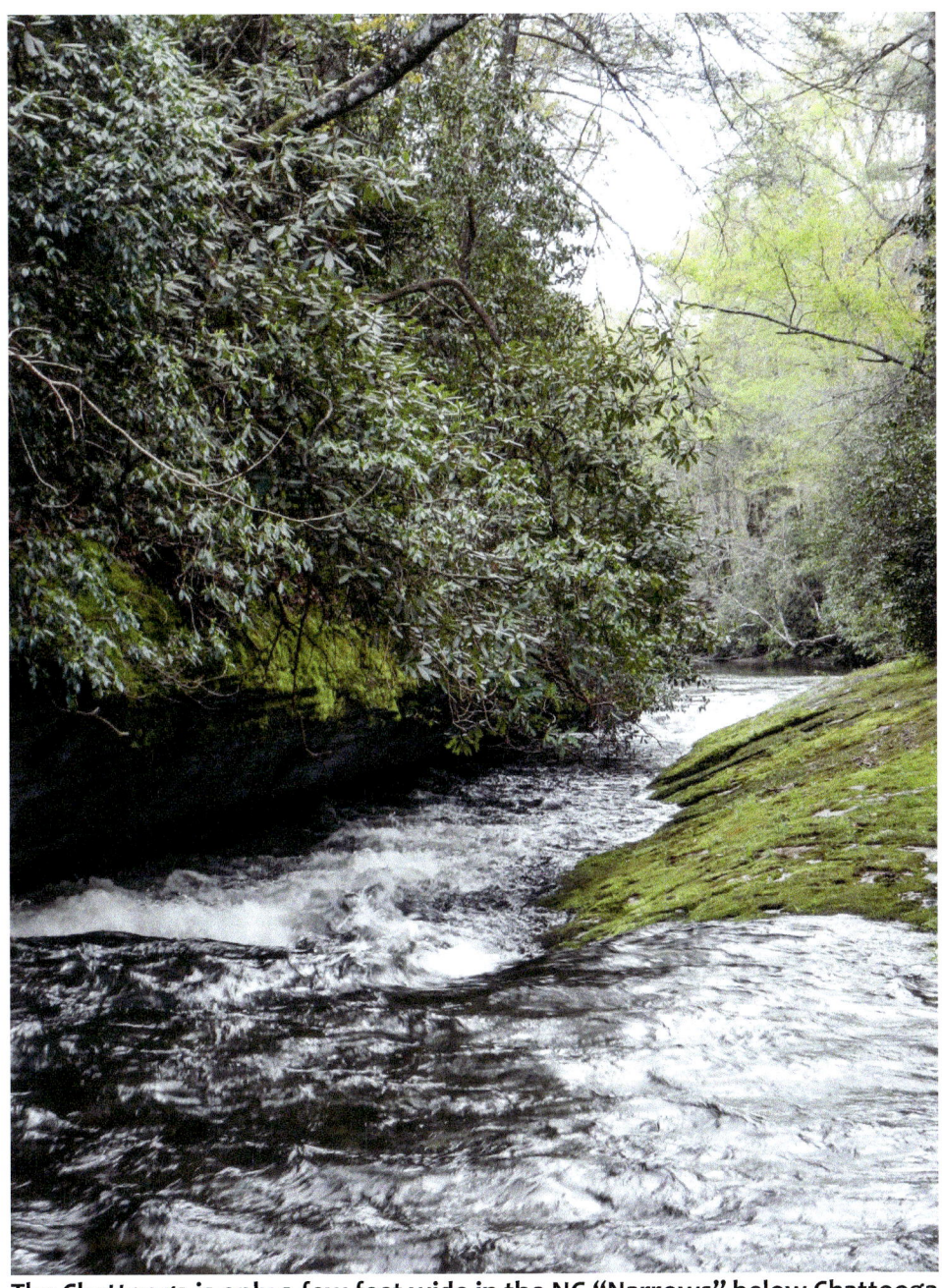
The Chattooga is only a few feet wide in the NC "Narrows" below Chattooga Cliffs.

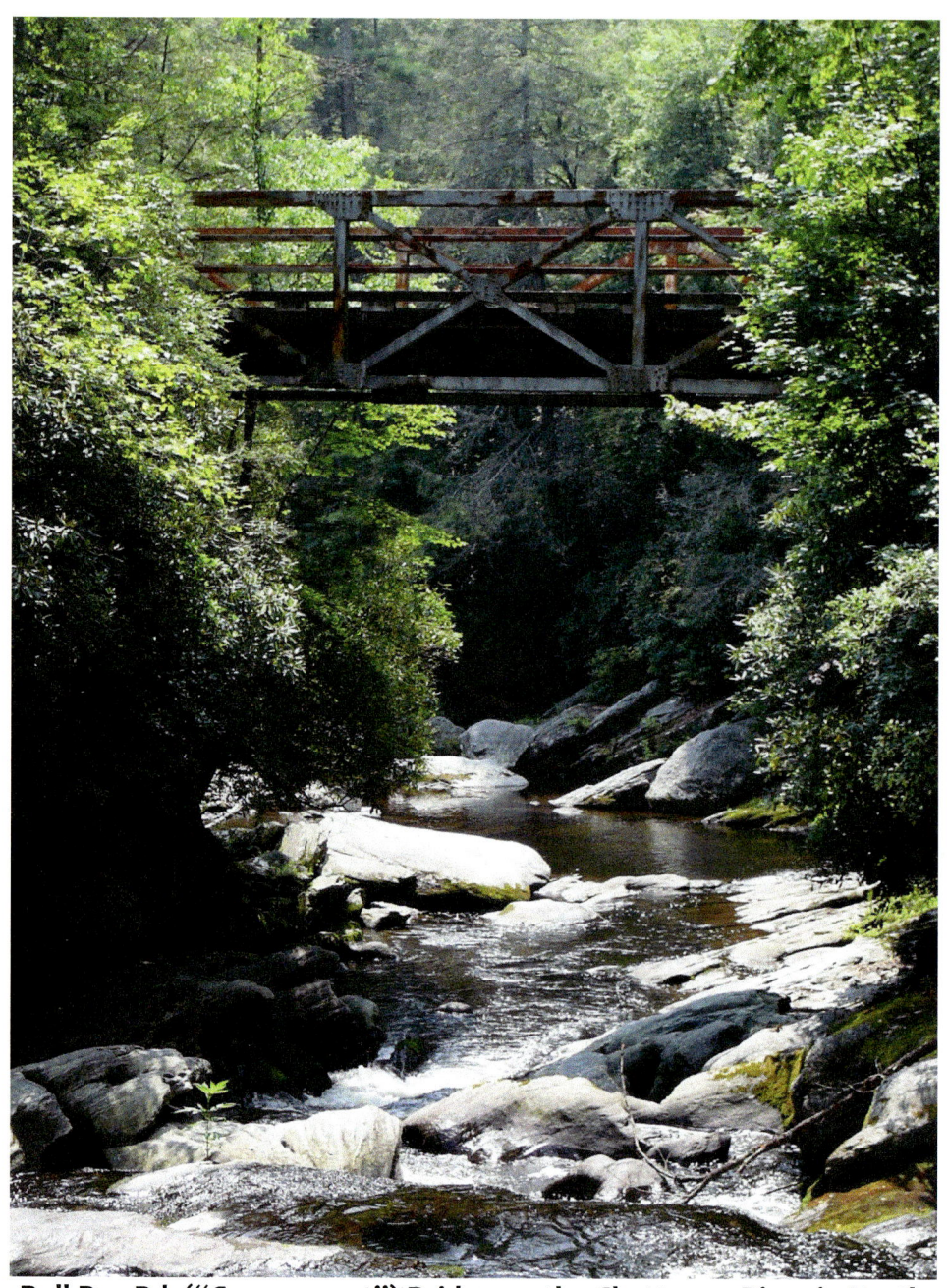

Bull Pen Rd. ("Government") Bridge on the Chattooga River in North Carolina.

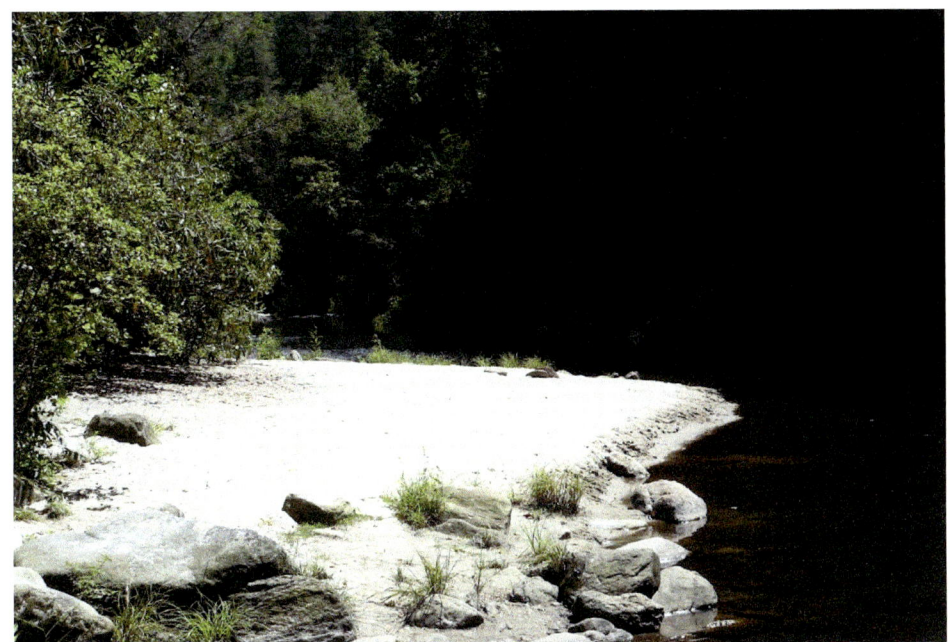
"The Beach," a sandbar on the upper Chattooga near the NC-SC stateline.

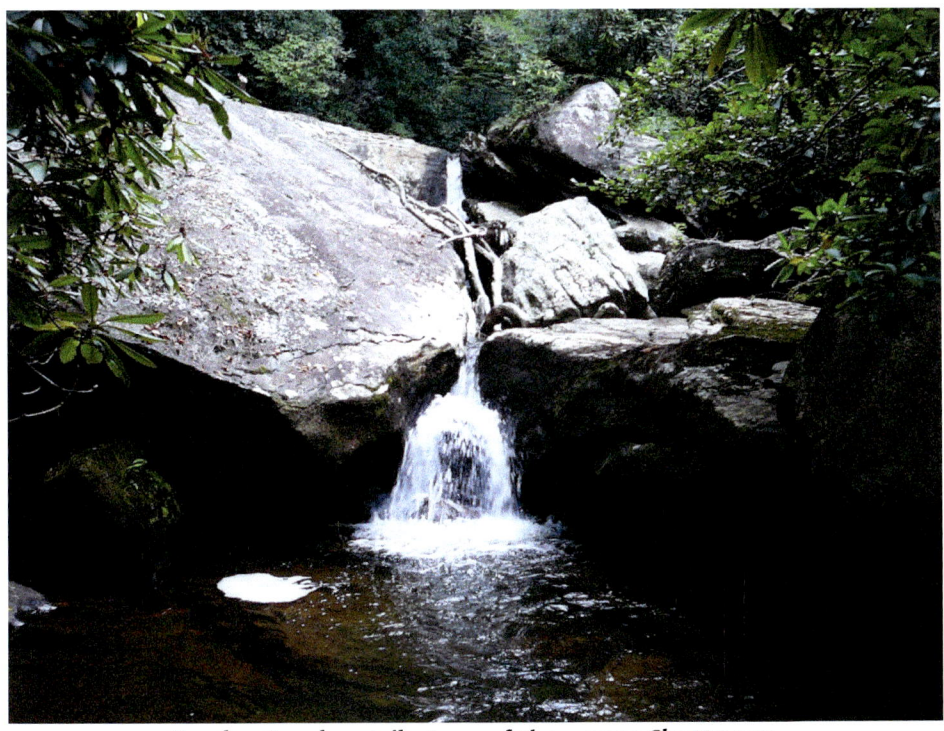
Fowler Creek, a tributary of the upper Chattooga.

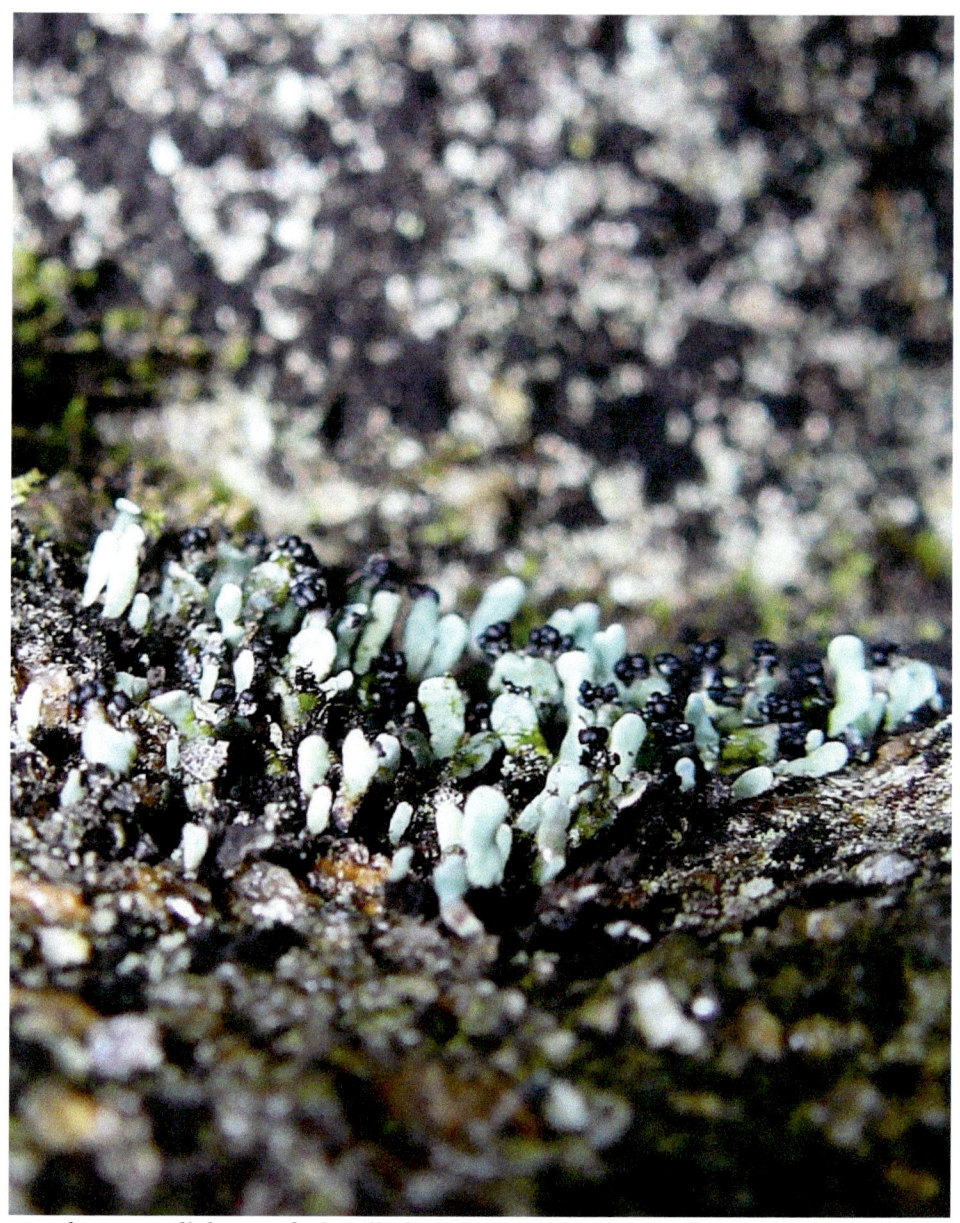
Rock gnome lichen, a federally-listed rare lichen on rocks on Fowler Creek.

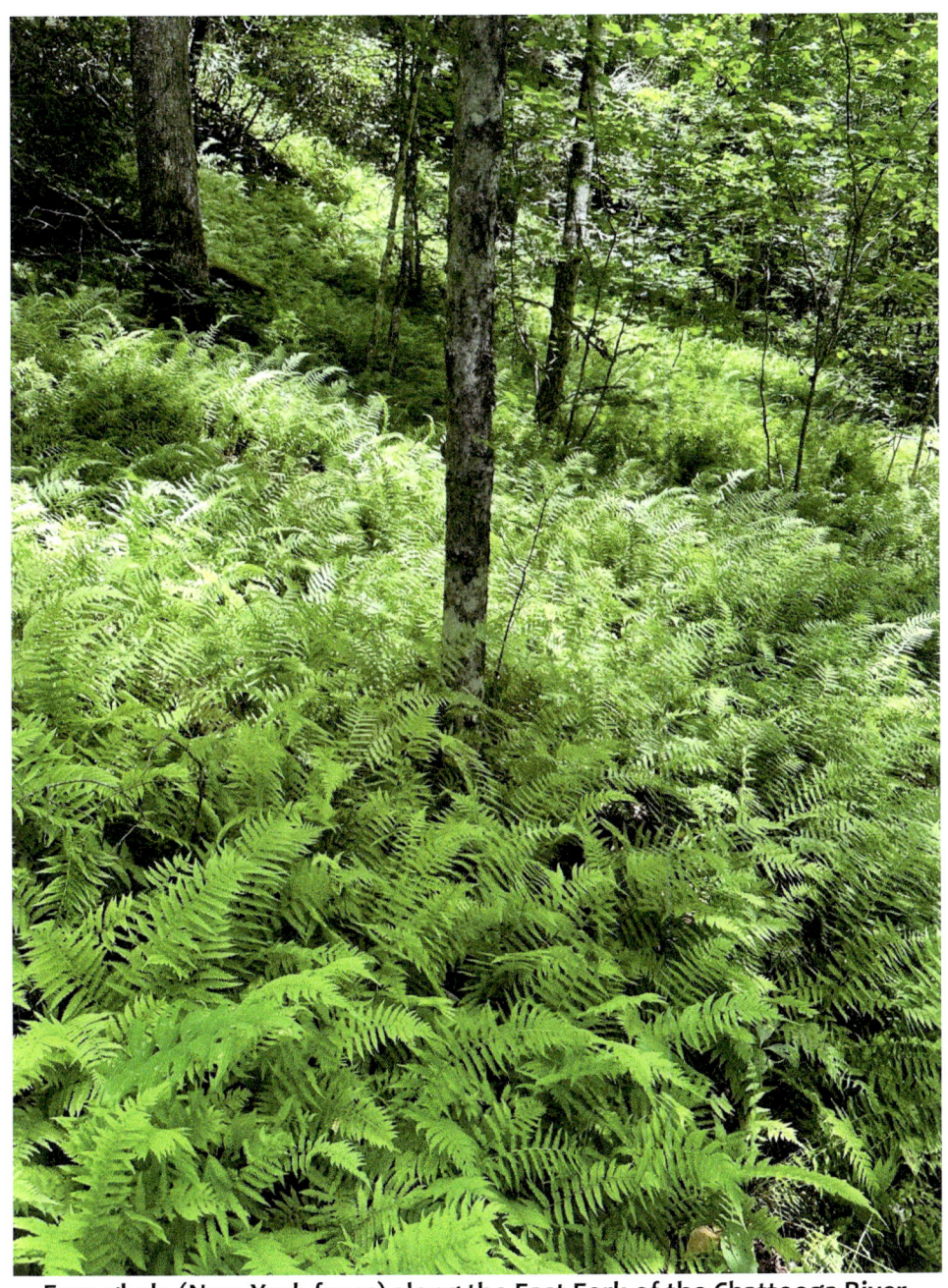
Fern glade (New York ferns) along the East Fork of the Chattooga River.

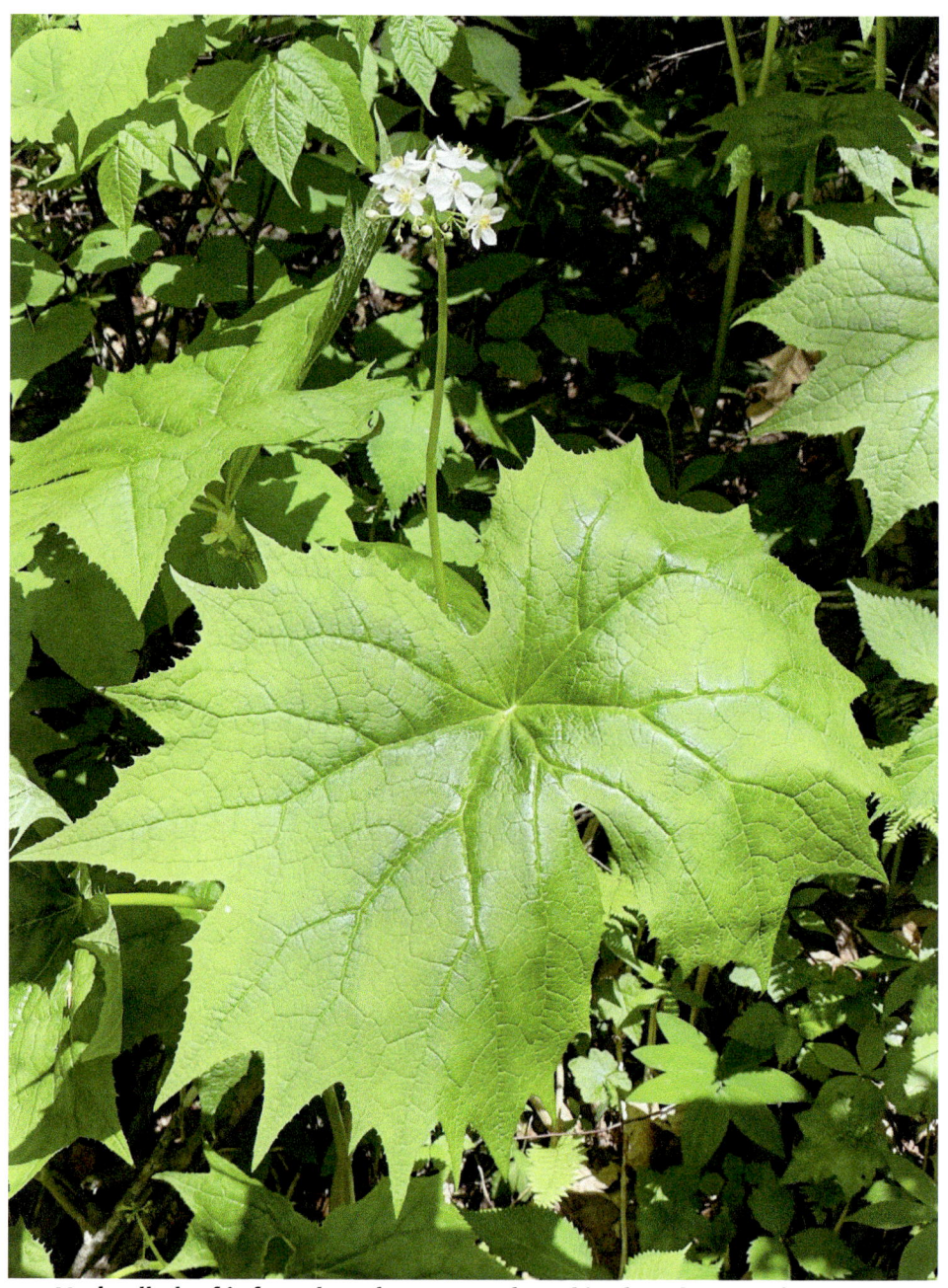

Umbrella-leaf is found on the East Fork and is abundant on the upper Tallulah River.

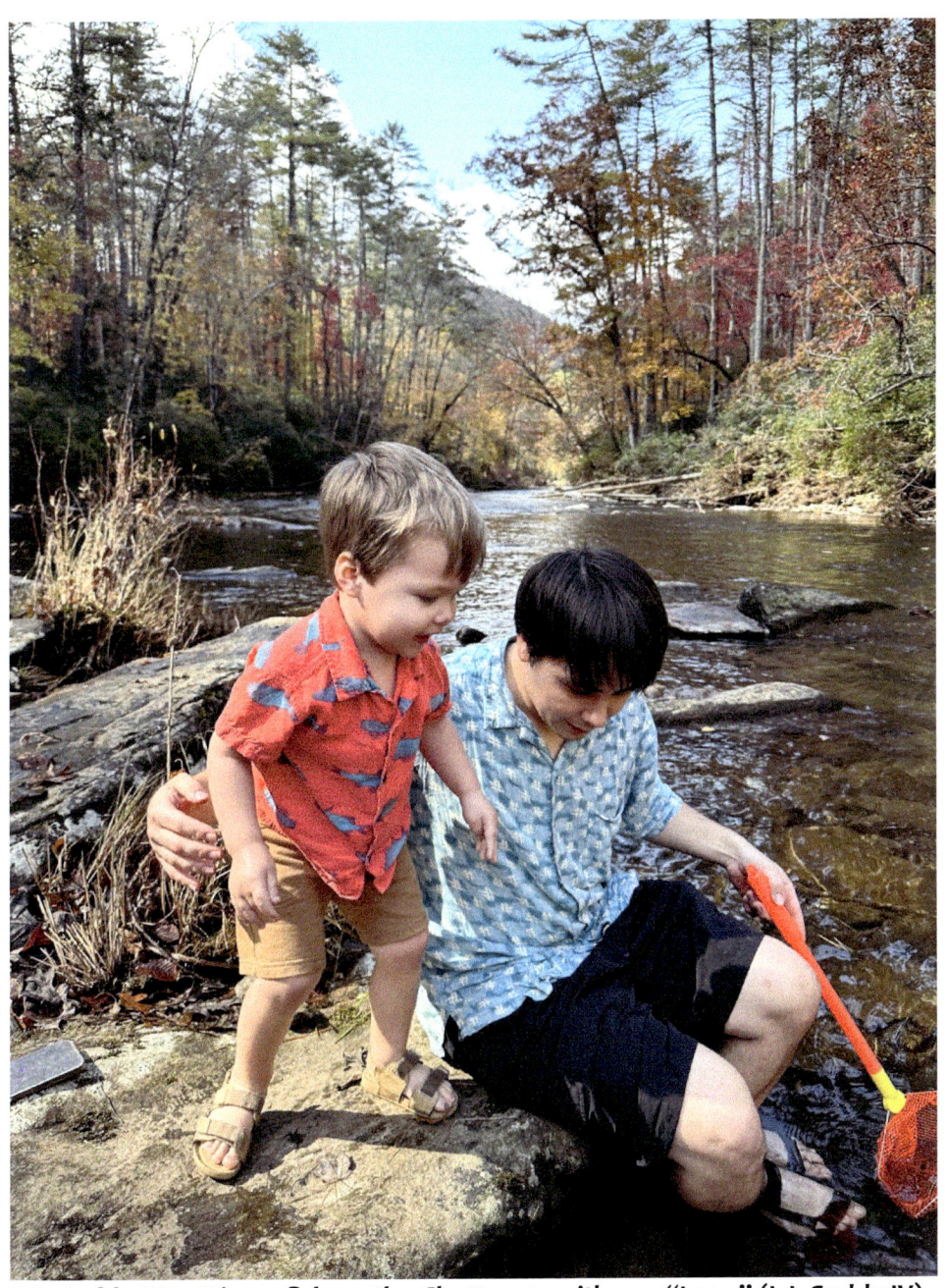

L L Gaddy III netting a fish on the Chattooga with son "Leon" (L L Gaddy IV).

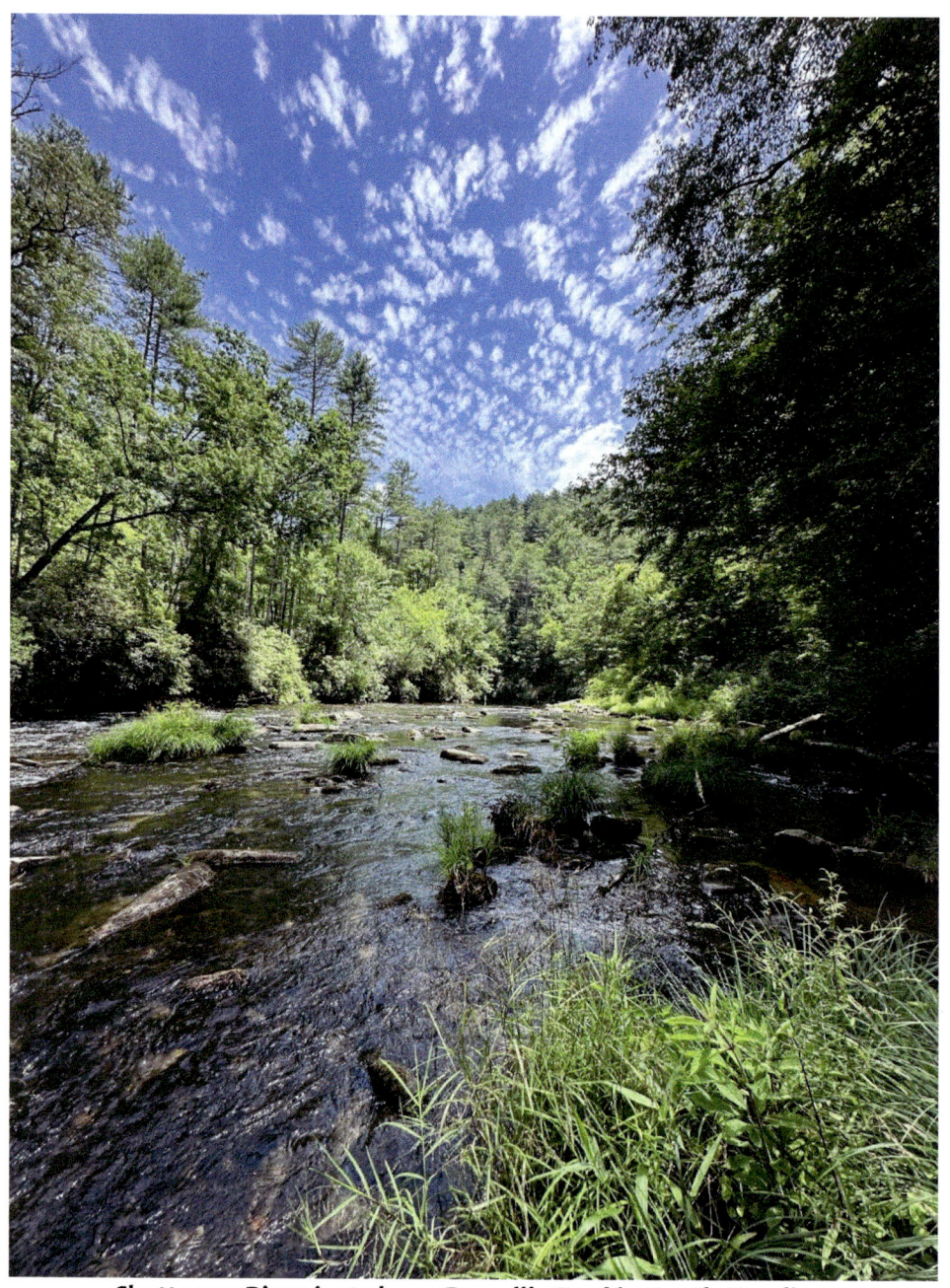
Chattooga River just above Burrell's Ford in South Carolina.

Clare Tan at the "Black Hole," a dark, deep bend in the river near Burrell's Ford.

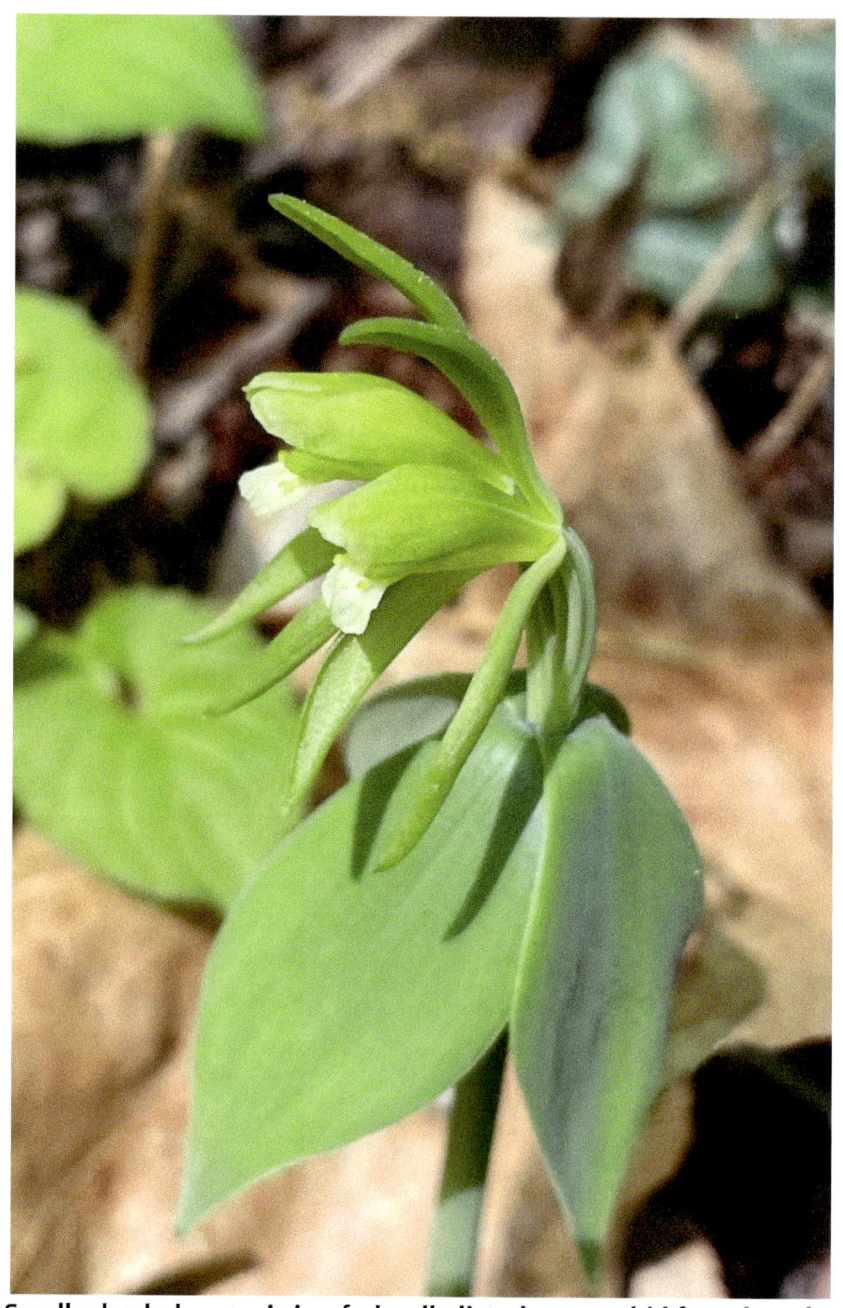
Small-whorled pogonia is a federally-listed rare orchid found on the Chattooga River.

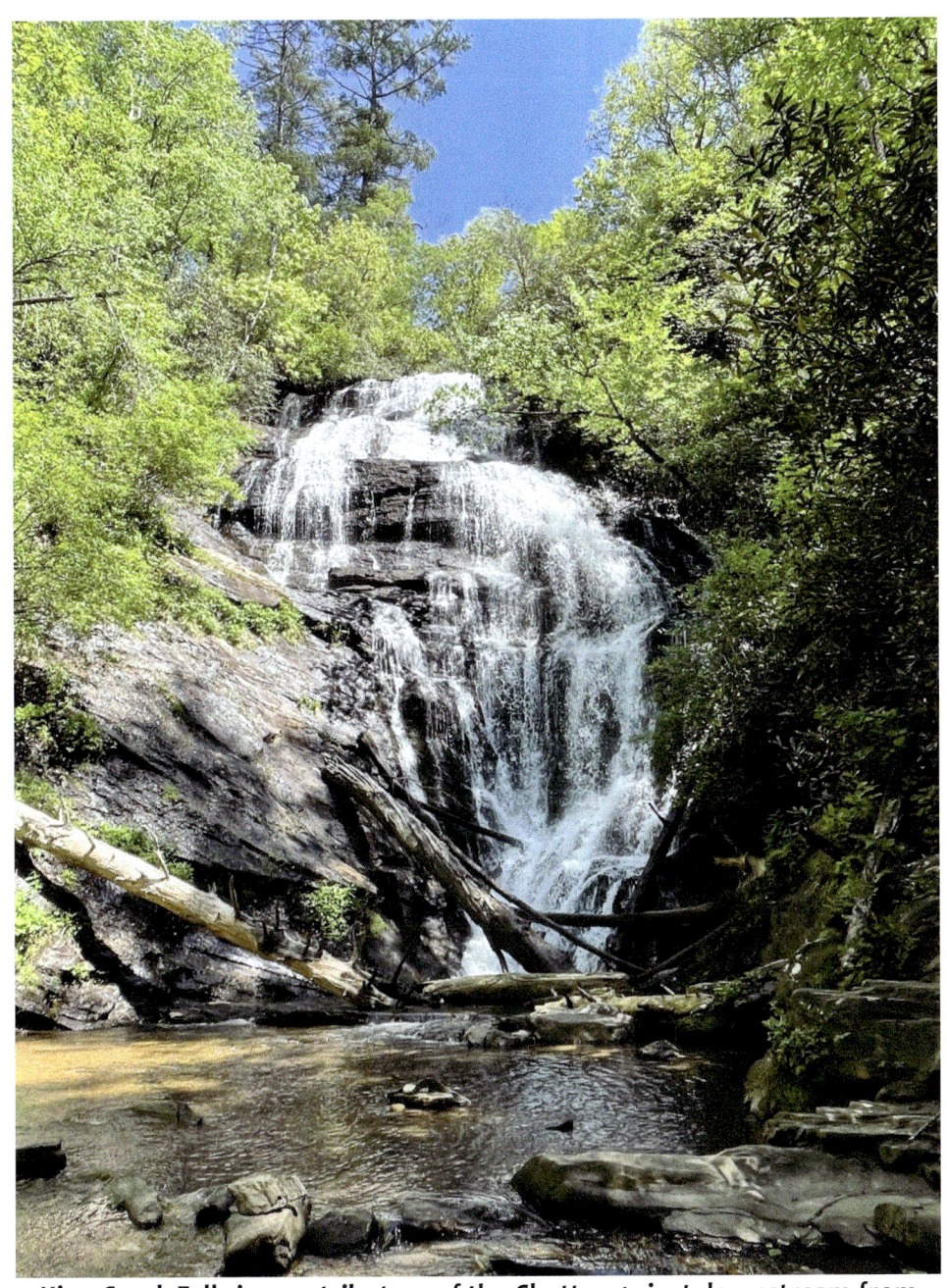

King Creek Falls is on a tributary of the Chattooga just downstream from Burrell's Ford.

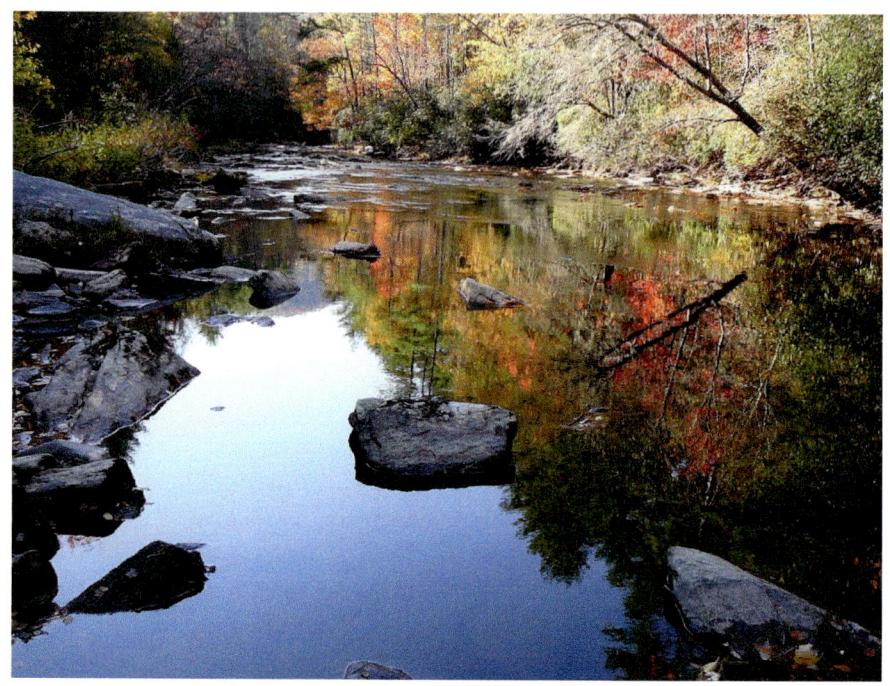
A calm stretch of the Chattooga in autumn.

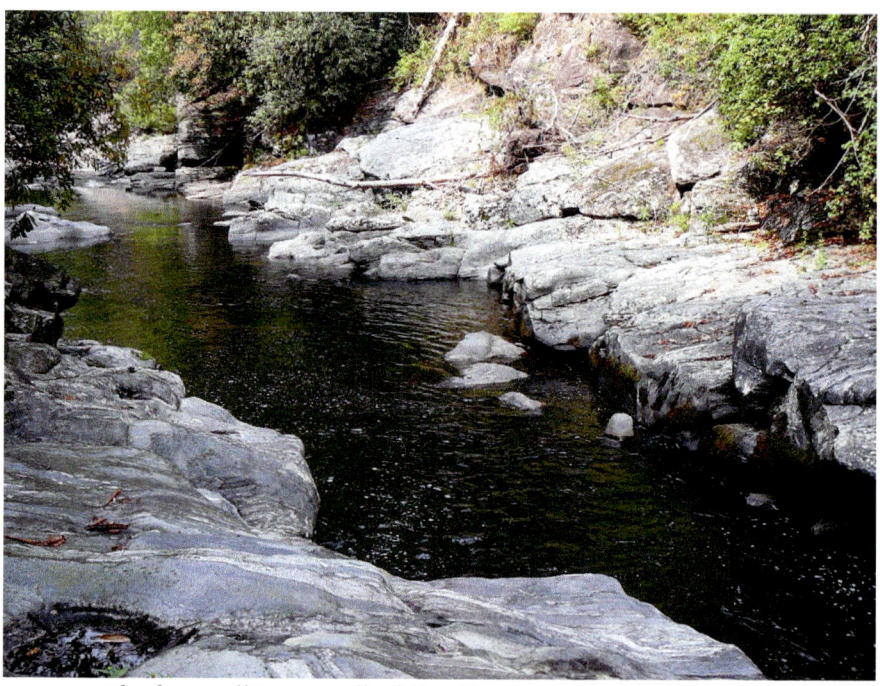
The lower "Narrows" of the Chattooga in Rock Gorge.

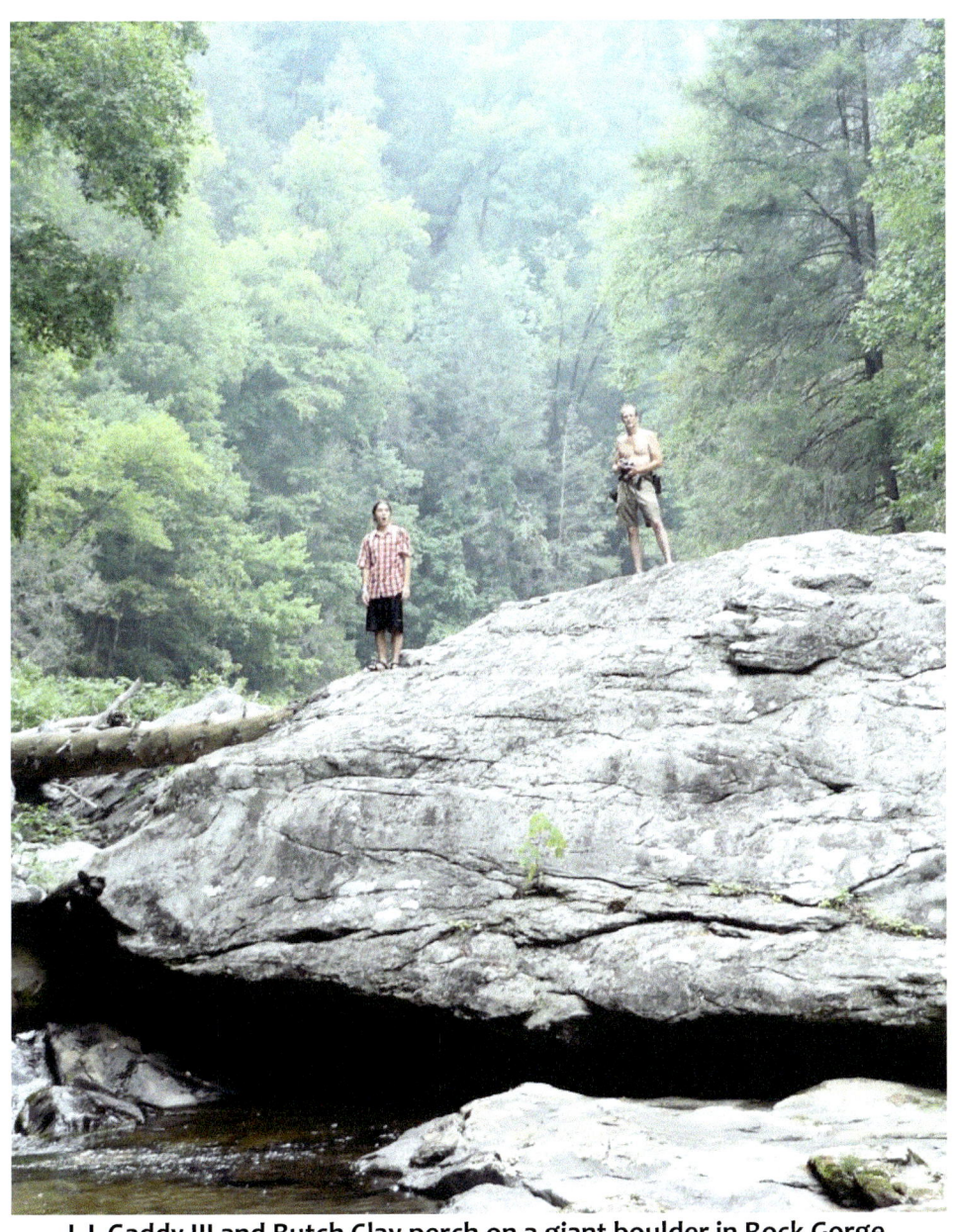
L L Gaddy III and Butch Clay perch on a giant boulder in Rock Gorge.

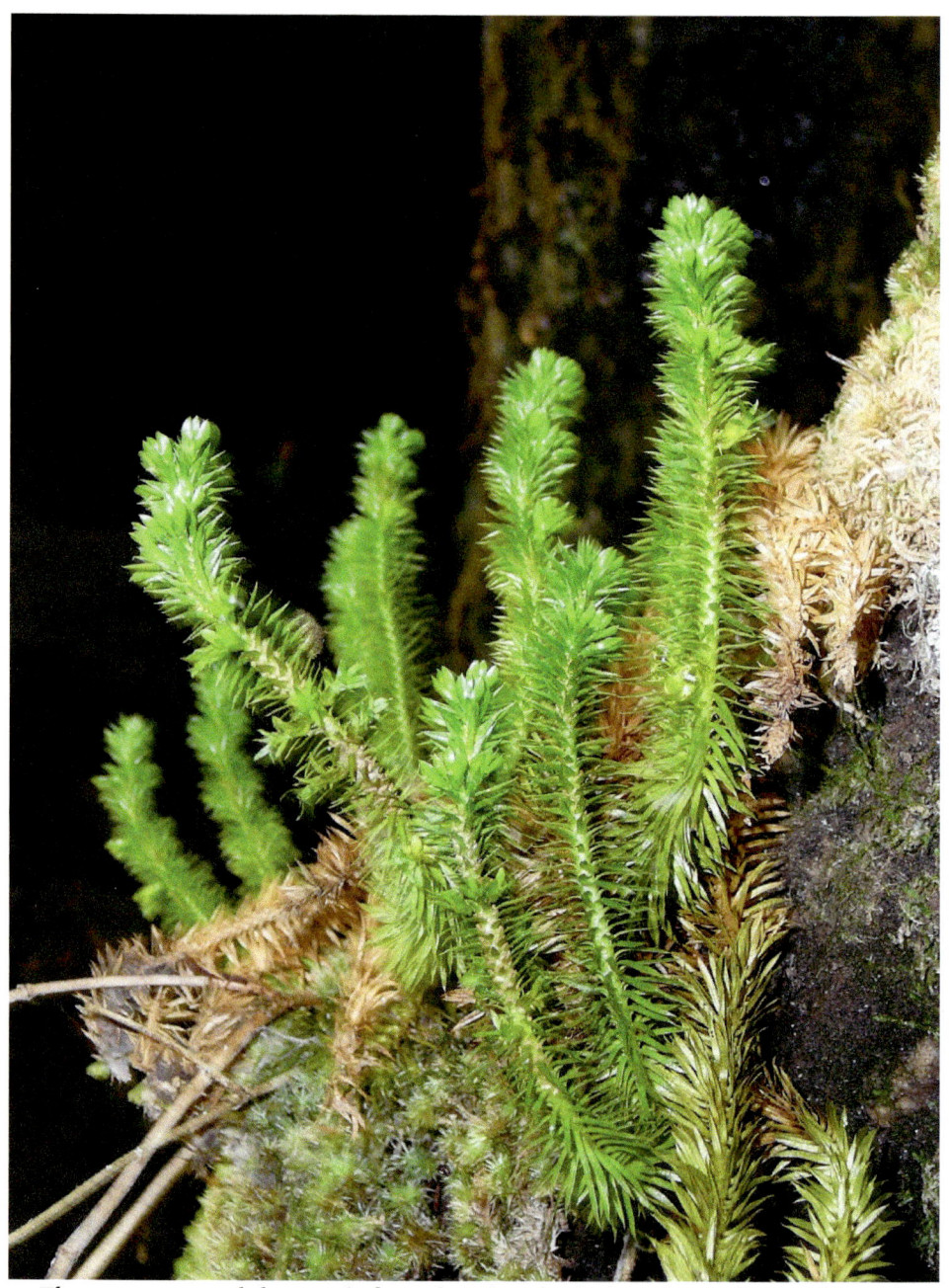
The rare gorge clubmoss is found under shaded rock overhangs in Rock Gorge.

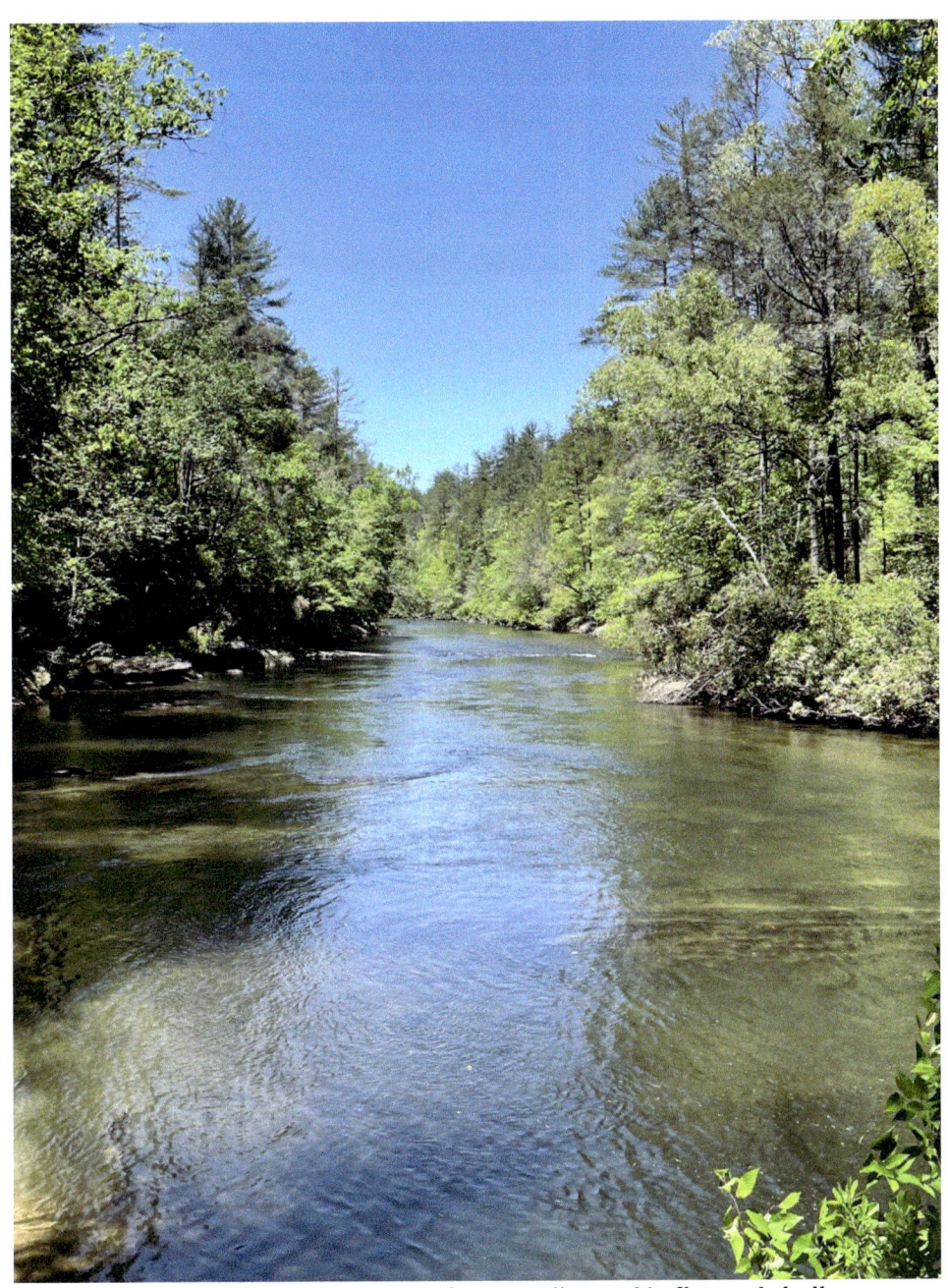
The Chattooga just upstream from Earl's Ford is flat and shallow.

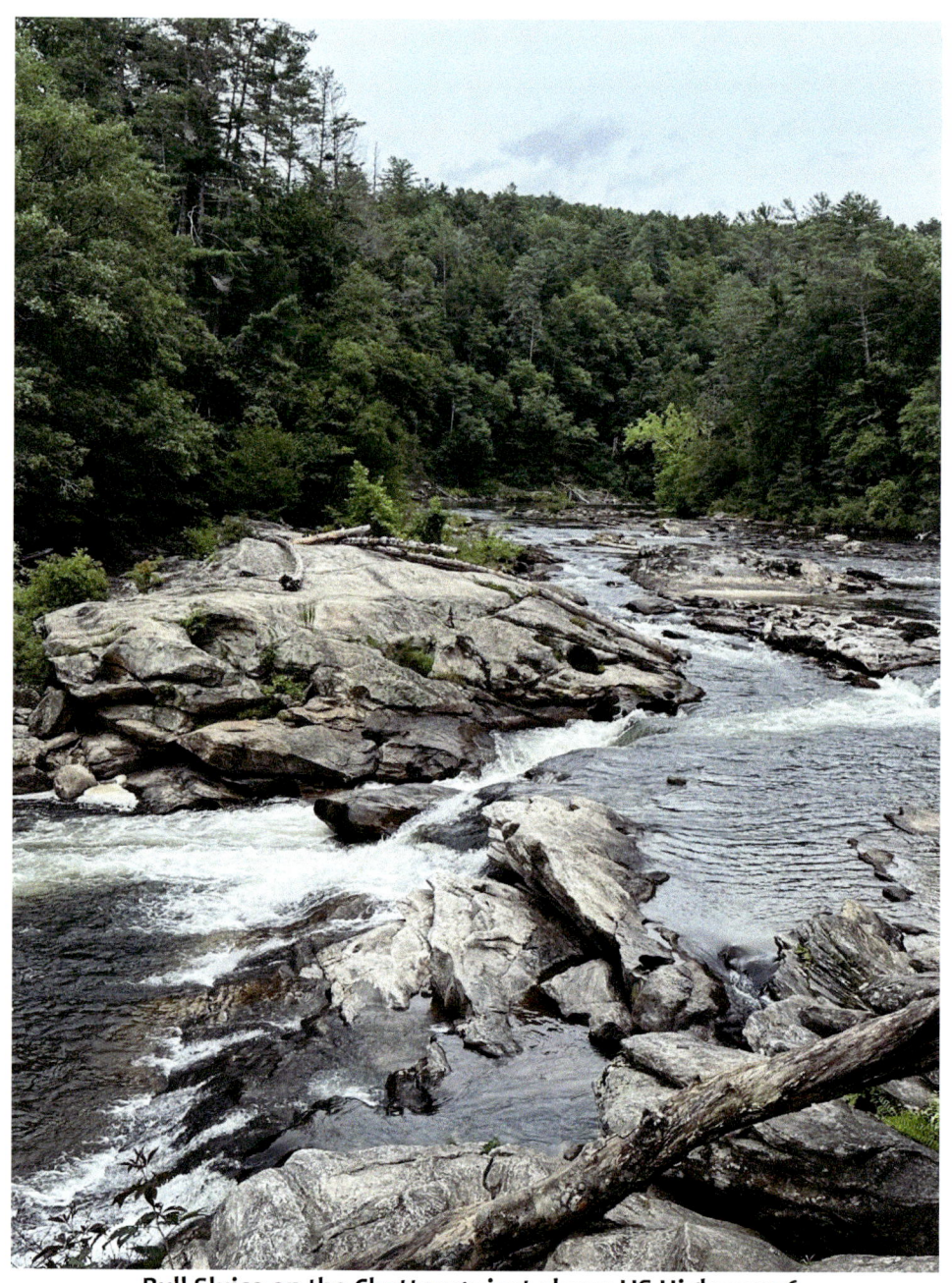
Bull Sluice on the Chattooga just above US Highway 76.

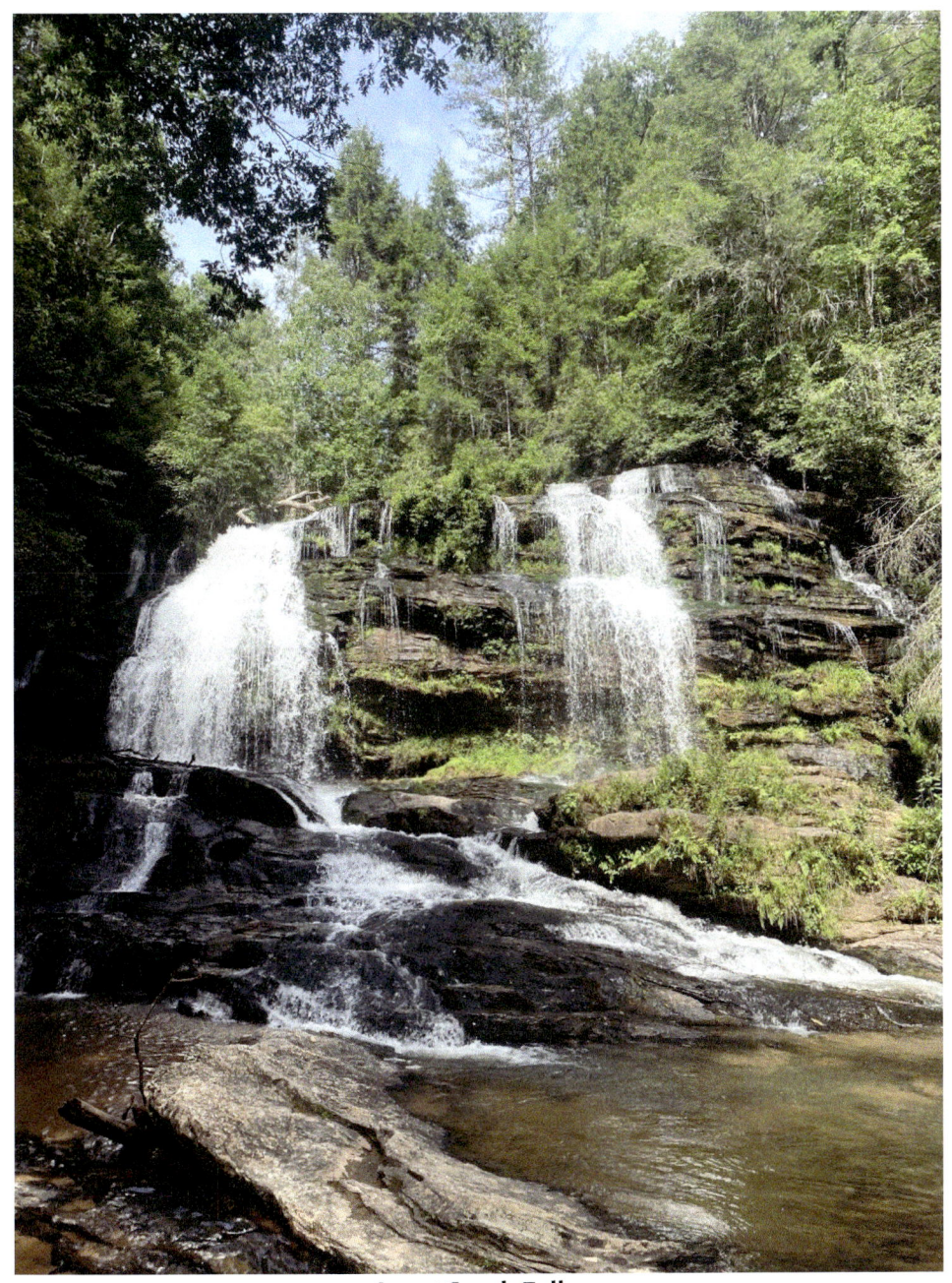
Long Creek Falls.

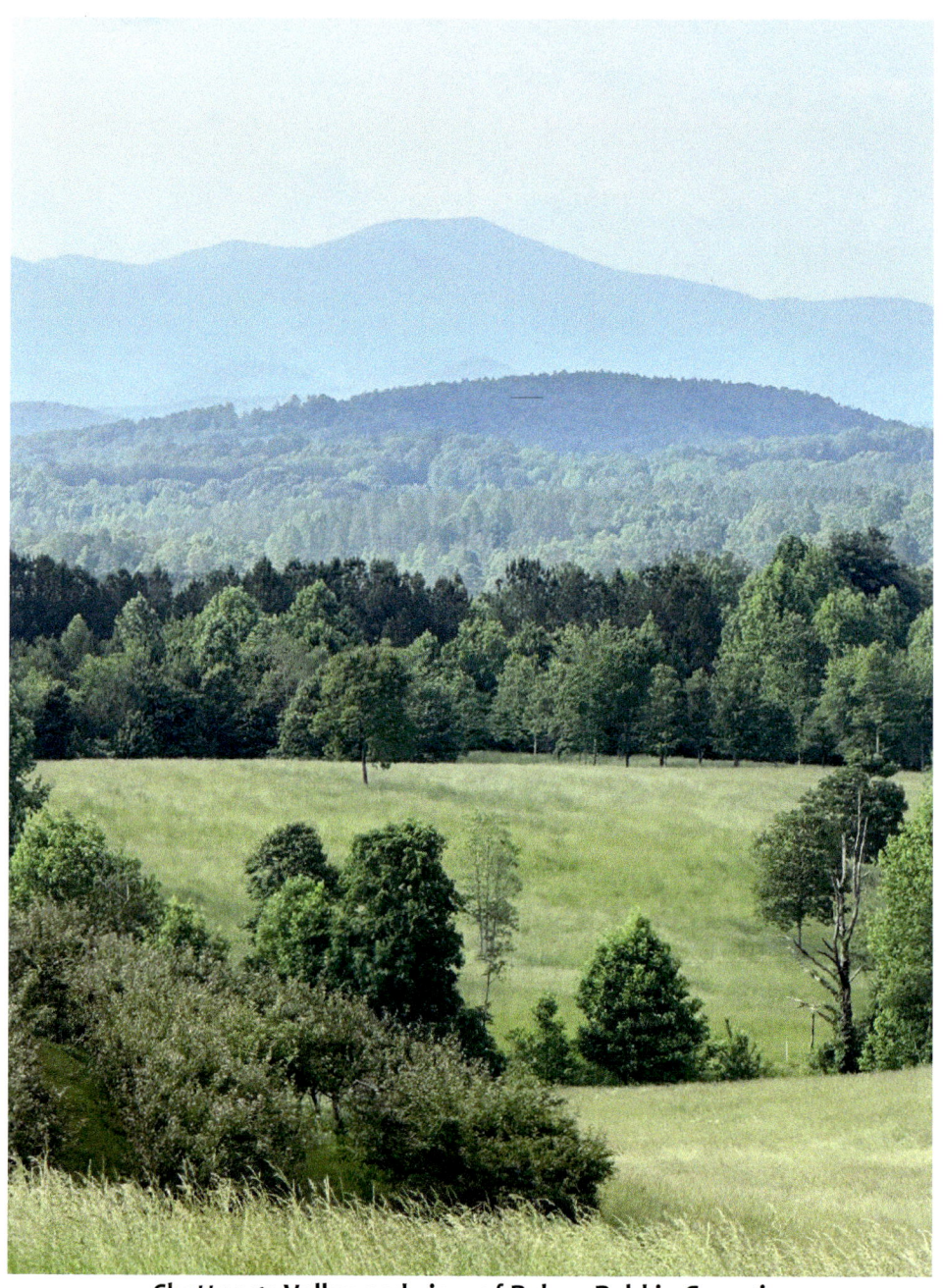
Chattooga Valley and view of Rabun Bald in Georgia.

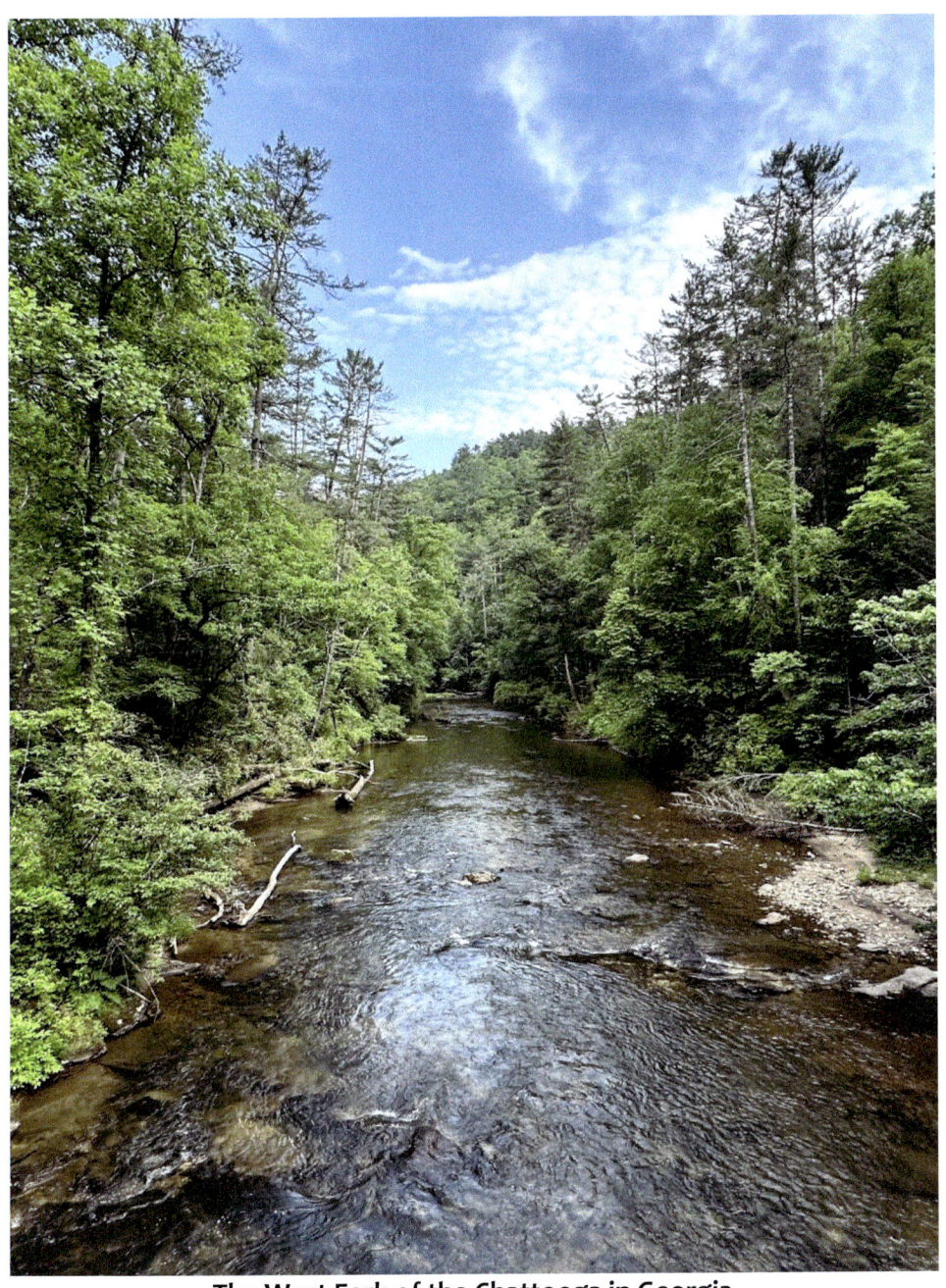
The West Fork of the Chattooga in Georgia.

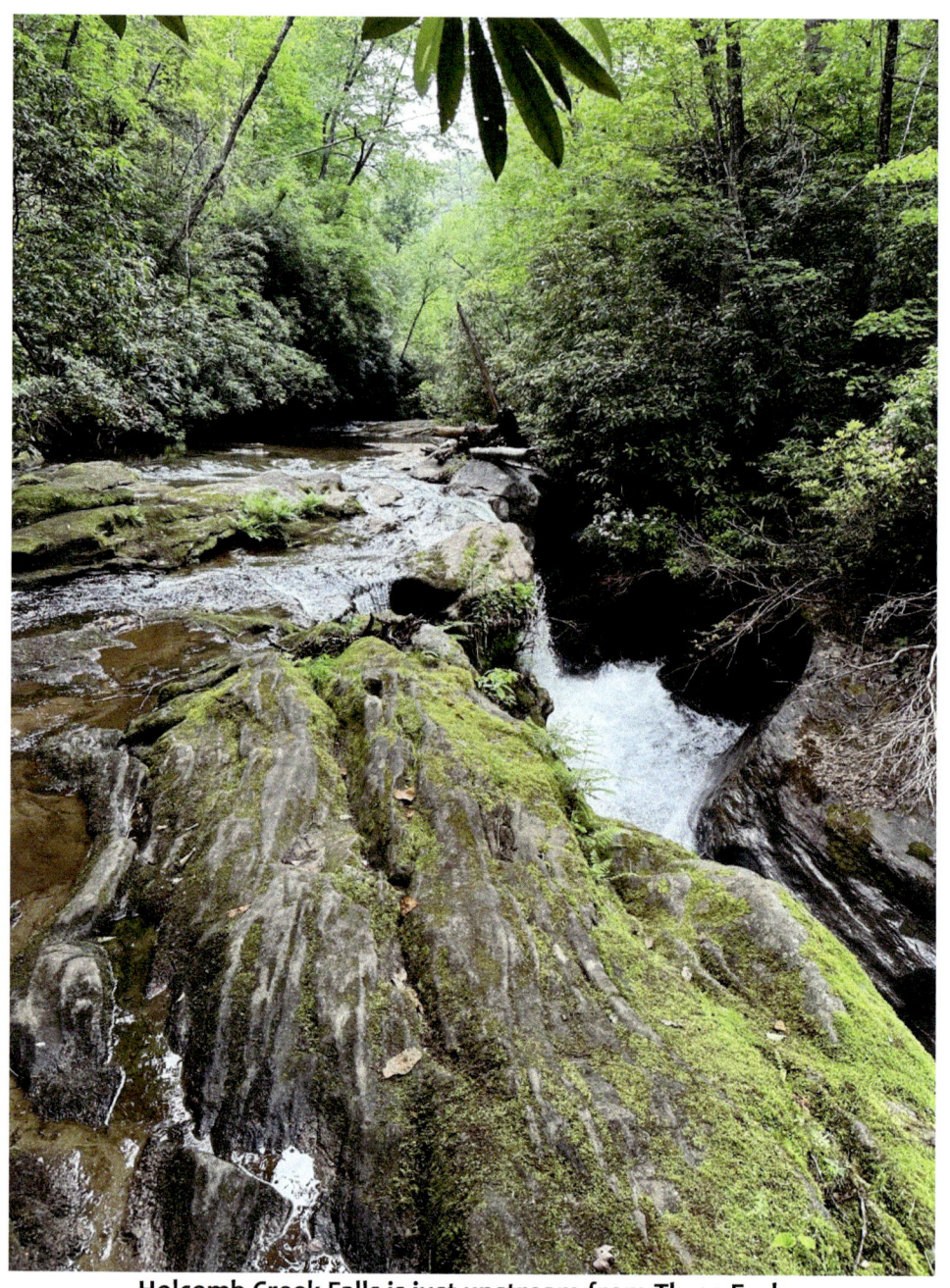
Holcomb Creek Falls is just upstream from Three Forks.

TUGALO RIVER and TOCCOA (GA) AREA
(includes PANTHER CREEK, BRASSTOWN CREEK, CEDAR CREEK, CURRAHEE MOUNTAIN, AND TOCCOA FALLS)

The Tugaloo River is formed by the junction of the Tallulah and Chattooga Rivers along the SC-GA state line. Geologists think that it once flowed southwest down the Panther Creek corridor into the Chattahoochee in Georgia and was "pirated" or captured by the Savannah's downcutting into its channel. Brasstown Creek in South Carolina, which enters the present flow of the Tugalo just after it exits Lake Yonah, may itself have been captured by the Chauga River at the elbow of the Chauga to the north in South Carolina. Both captures ended by dramatically increasing the flow of the Savannah.

Both Panther Creek and Brasstown Creek are oriented east-west and therefore have many north-facing slope and ravines formed by tributaries. The combination of mesic slopes and ravines formed over Chauga Belt metasedimentary rocks rich in calcium and magnesium has made Panther and Brasstown Creeks among the richest in plant species diversity in the region.

Farther down the Tugalo, Cedar Creek, a small creek flowing into Toccoa Creek (itself rich in species), has cut a deep gorge-like ravine with steep cliffs. Famous for moss and liverwort diversity, Cedar Creek is also rich in wildflowers. In the extreme southwest of our study area, several interesting sites are found in the Toccoa, Georgia area. Henderson Falls Park, just north of Toccoa, is rich in herbaceous species, especially whorled horsebalm, uncommon outside of the Blue Ridge Front. Currahee Mountain, just southwest of Toccoa, is a monadnock just over 1700 feet in elevation. Here, smooth coneflower, Fraser's loosestrife, whorled horsebalm, and cliff mock-orange are all found. The north- and northeast-facing slopes of Currahee have chalk maple, an understory maple associated with the Chauga Belt, in the understory. Finally, just northwest of Toccoa is Toccoa Falls, a waterfall with a 150-foot plus drop. This distinctive waterfall is surrounded by steep slopes with gigantic plants of Vasey's trillium in April. Though privately-owned, this site is open to the public.

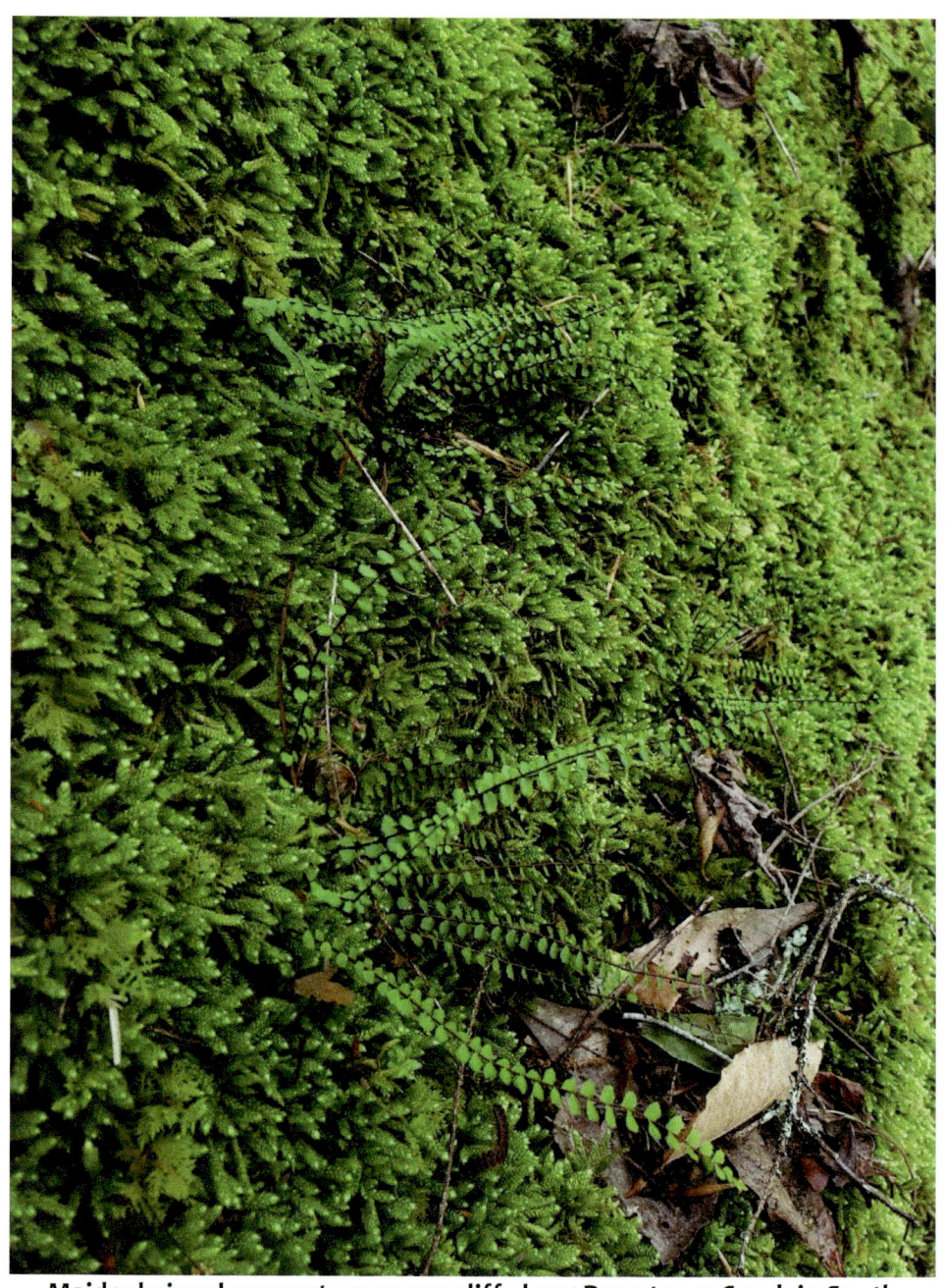

Maidenhair spleenwort on mossy cliff along Brasstown Creek in South Caroina.

Labrador violet is common along Brasstown Creek; it ranges from Canada to GA and SC.

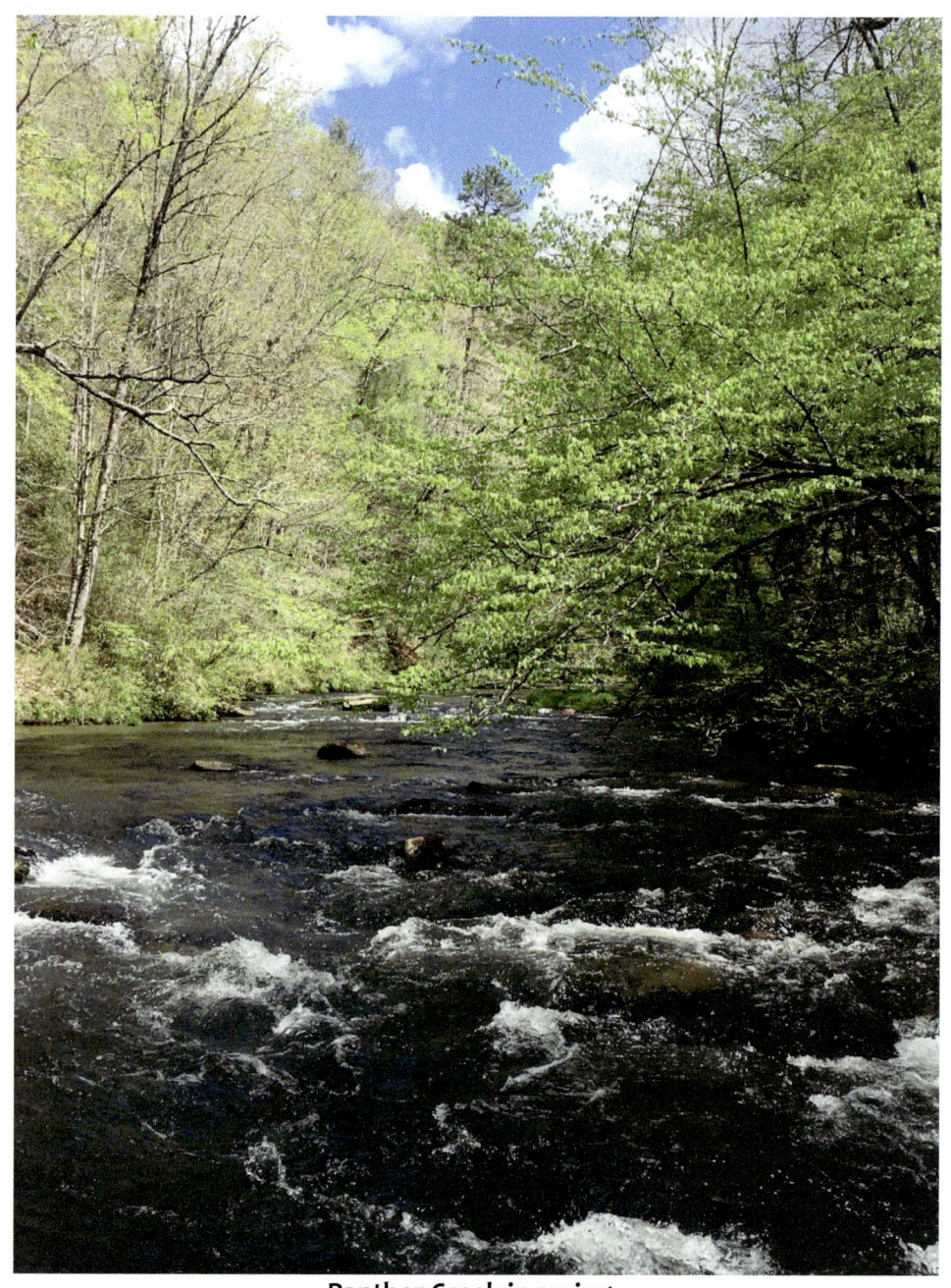
Panther Creek in spring.

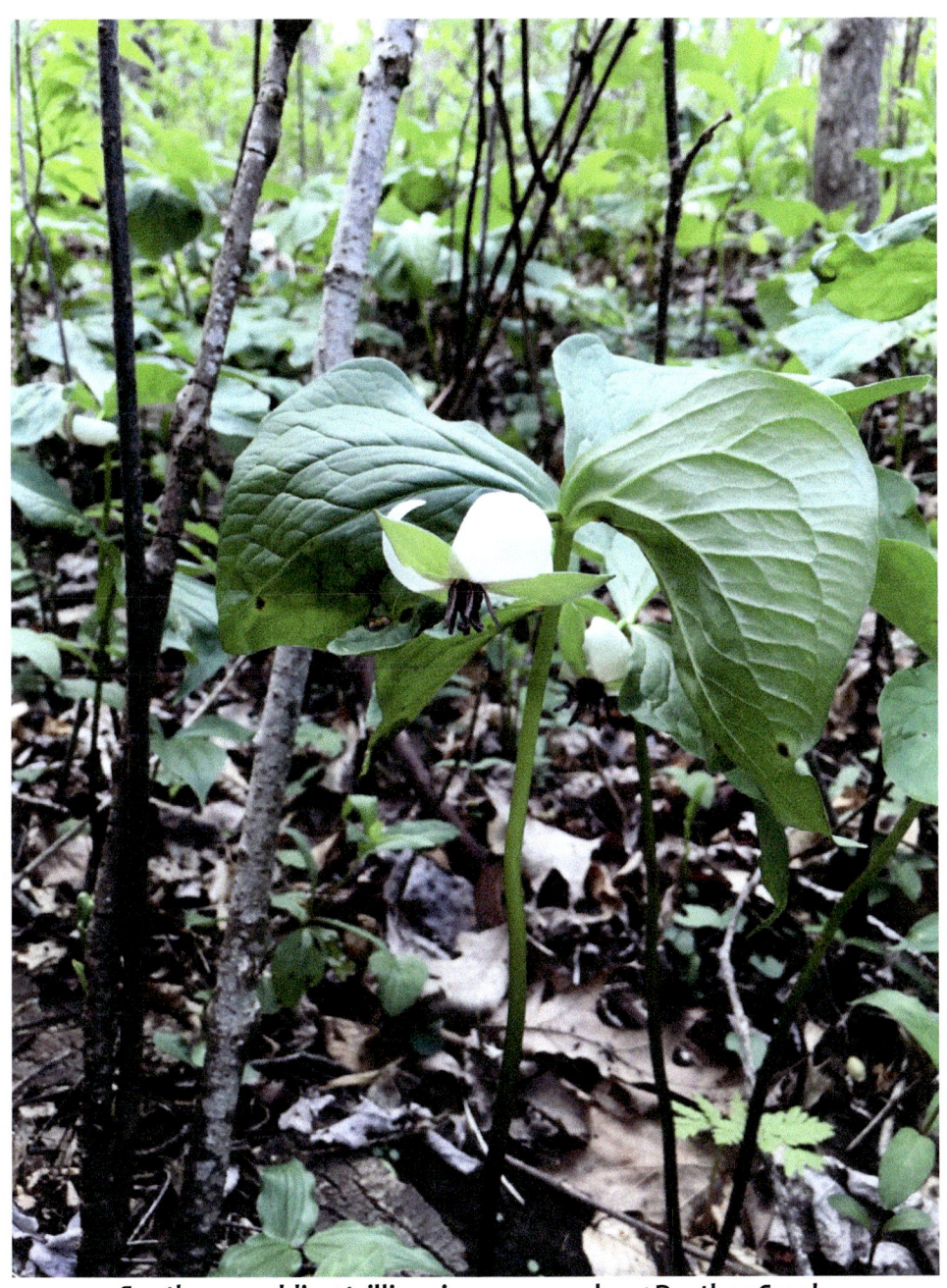
Southern nodding trillium is common along Panther Creek.

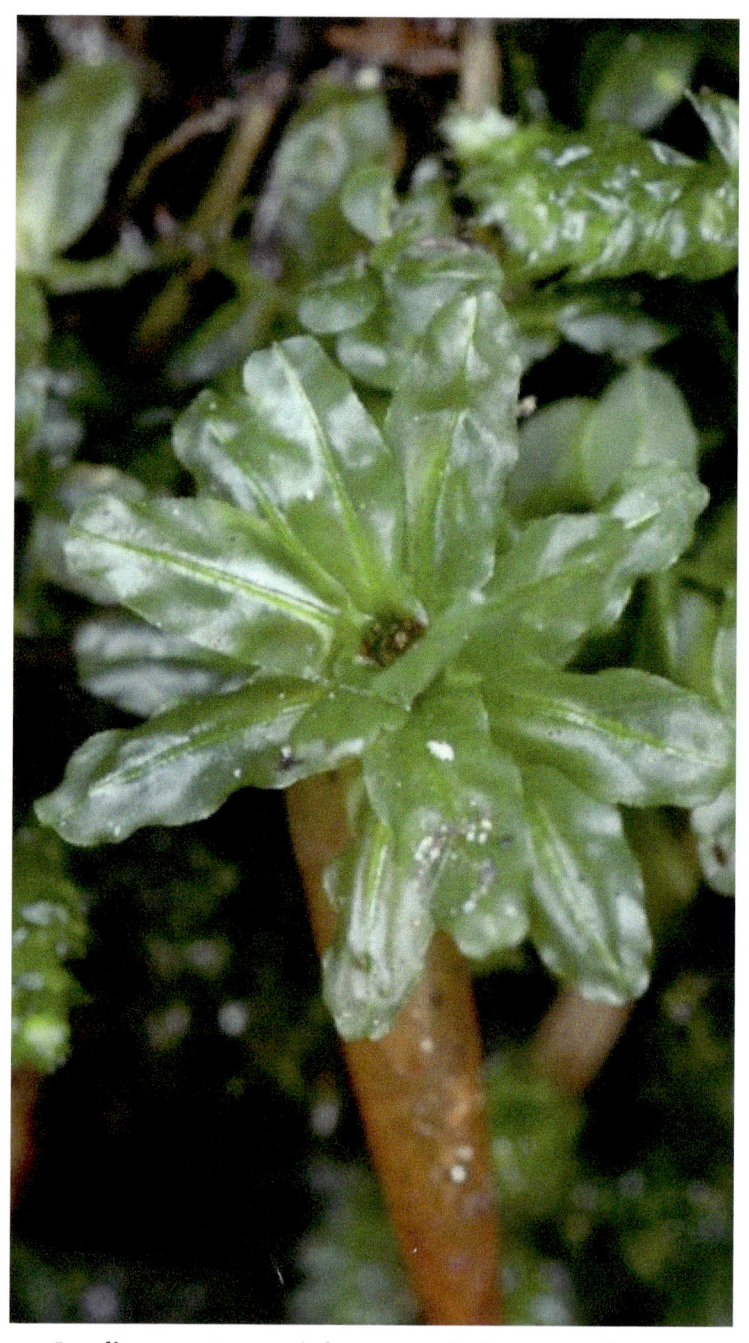

The rare Carolina gorgemoss is known only from Carolina and Georgia gorges and a gorge in the Dominican Republic.

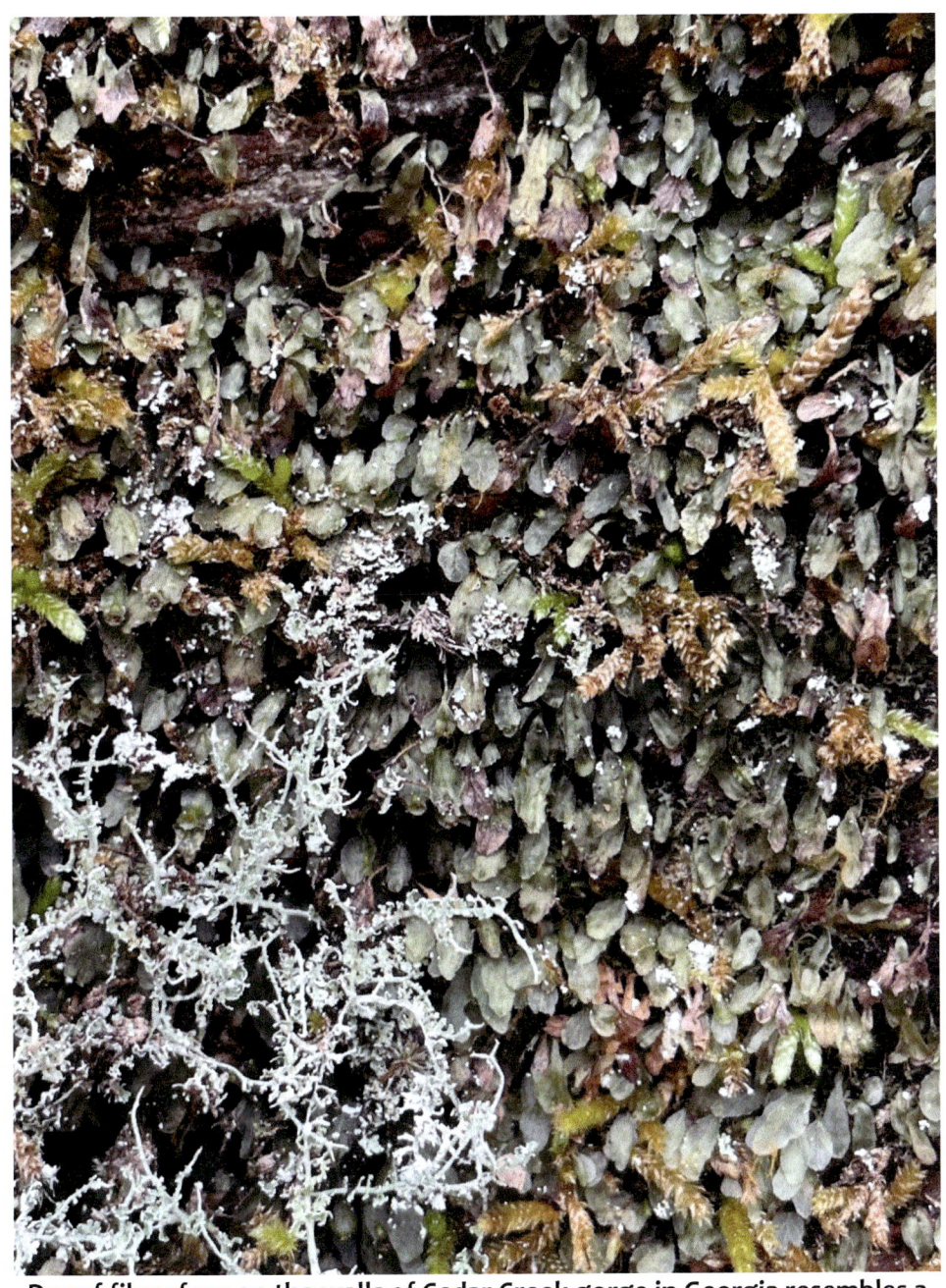

Dwarf filmy fern on the walls of Cedar Creek gorge in Georgia resembles a moss.

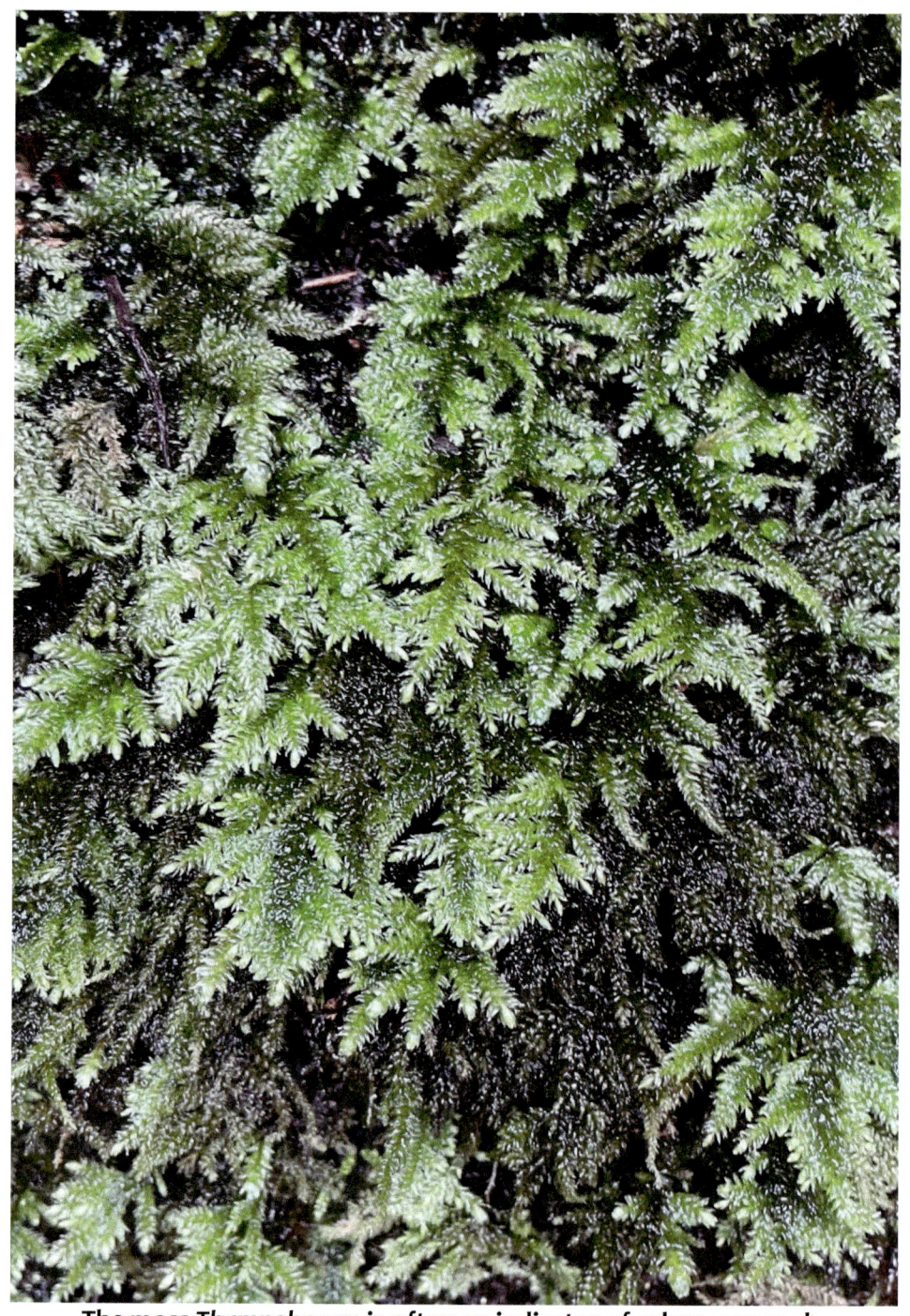
The moss *Thamnobryum* is often an indicator of calcareous rock.

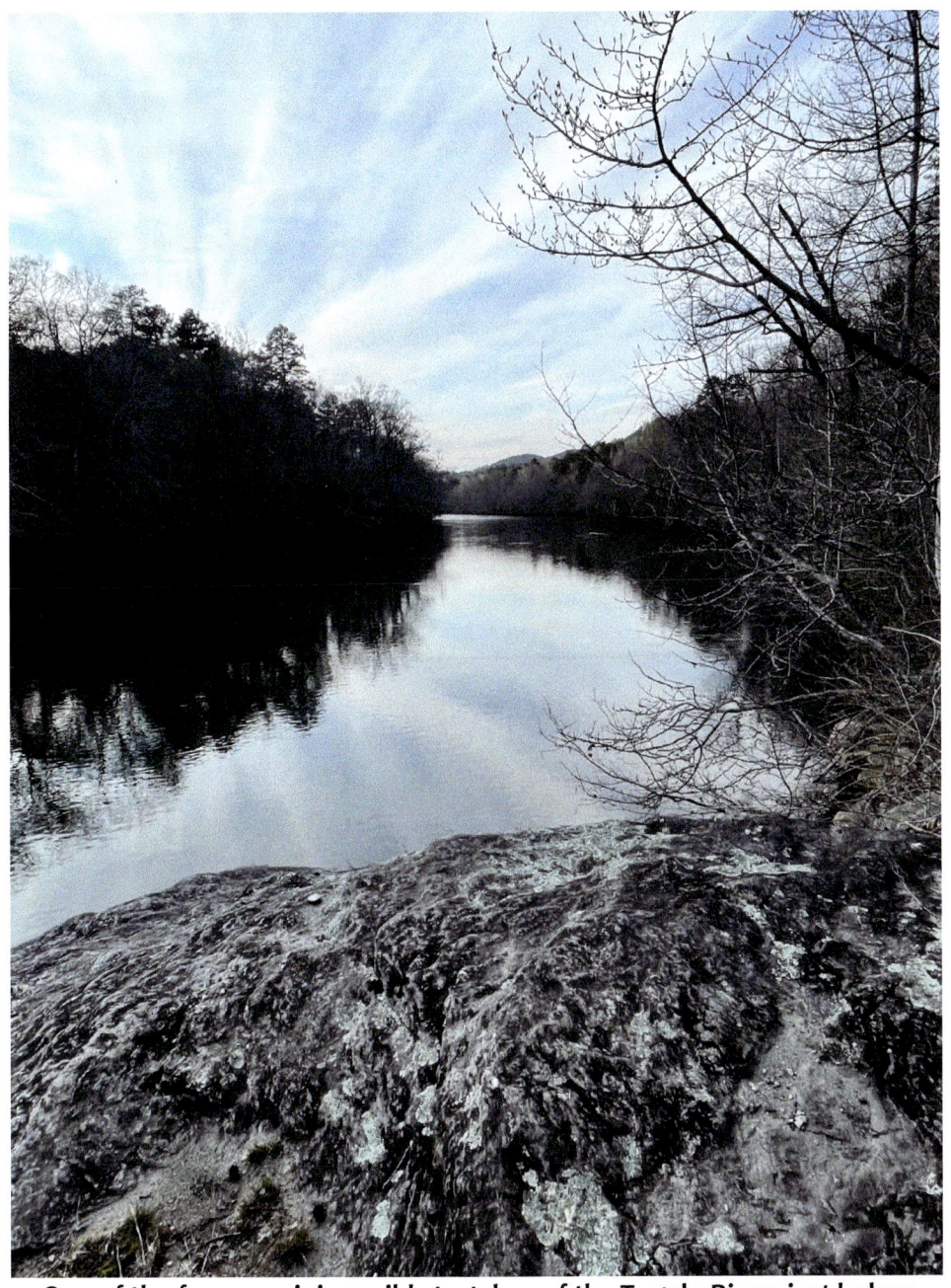

One of the few remaining wild stretches of the Tugalo River, just below Yonah Dam.

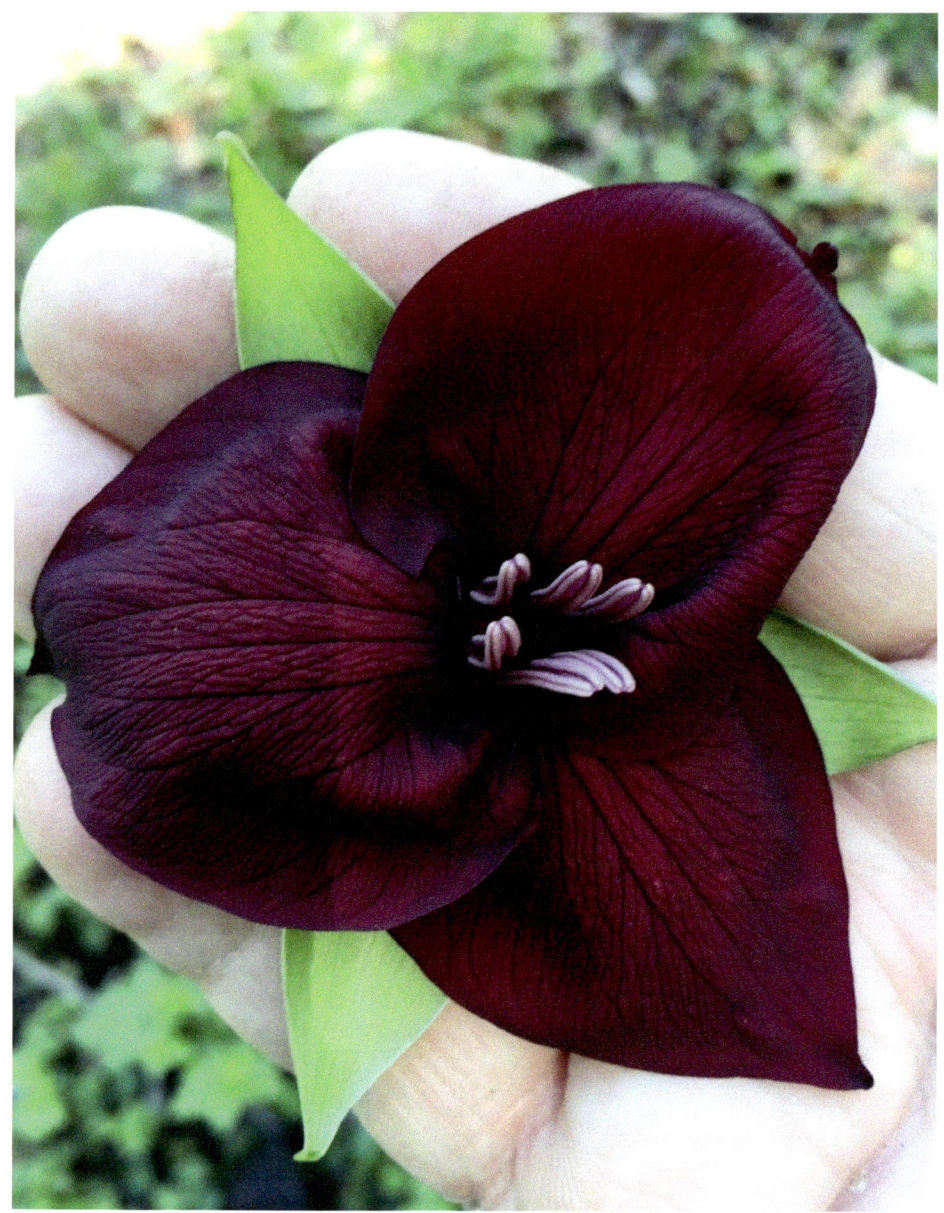
Large flowers of Vasey's trillium from below Toccoa Falls in northeast Georgia.

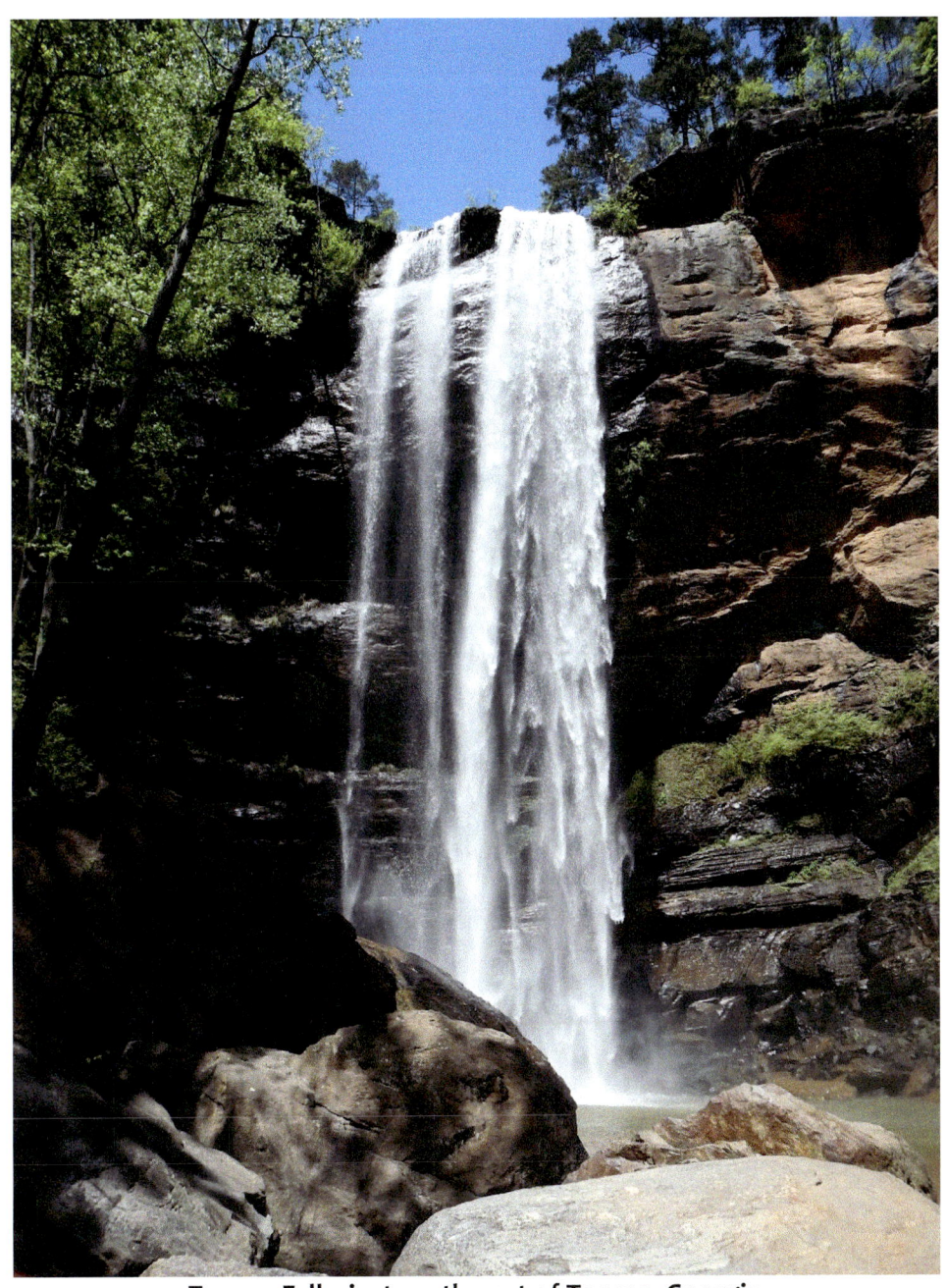

Toccoa Falls, just northwest of Toccoa, Georgia.

TALLULAH GORGE

After it was linked to Atlanta by US Highway 441 and a direct rail line, Tallulah Gorge was once the honeymoon spot of Georgia. Today, most of the restaurants and hotels are gone and the gorge is a state park. One of the deepest gorges in the southern Appalachians (up to 1200 feet in places), Tallulah Gorge harbors at least six major waterfalls, including the spectacular Tempesta and Hurricane Falls, numerous sheer quartzite cliffs, the famous persistent trillium, and many other interesting biological and geological treasures.

Hundreds of steel steps lead from state park headquarters on its eastern rim down to a swinging cable bridge over the gorge. From here spectacular waterfall and gorge views may be had. On the western slopes/cliffs of the gorge, one may get lucky in March and find the Georgia-South Carolina endemic persistent trillium in flower—it is found only in Tallulah Gorge and surrounding ravines and one site in South Carolina. In the bottom of the gorge, one can bathe in the rushing water of numerous waterfalls, attempt to climb the gorge's rock walls (not recommended), or wander in bogs and seepages filled with rare orchids, poison sumac, and yellow jackets (the good, the bad, and the ugly?).

The gorge was formerly managed by Georgia Power whose mantra was "enter at your own risk." Today, the Tallulah Gorge State Park has designated trails covering most of the upper and middle gorge, but some of the more dangerous areas of the gorge are off limits. Still, there is more to see than one can cover in a day. Avoid visiting on weekends.

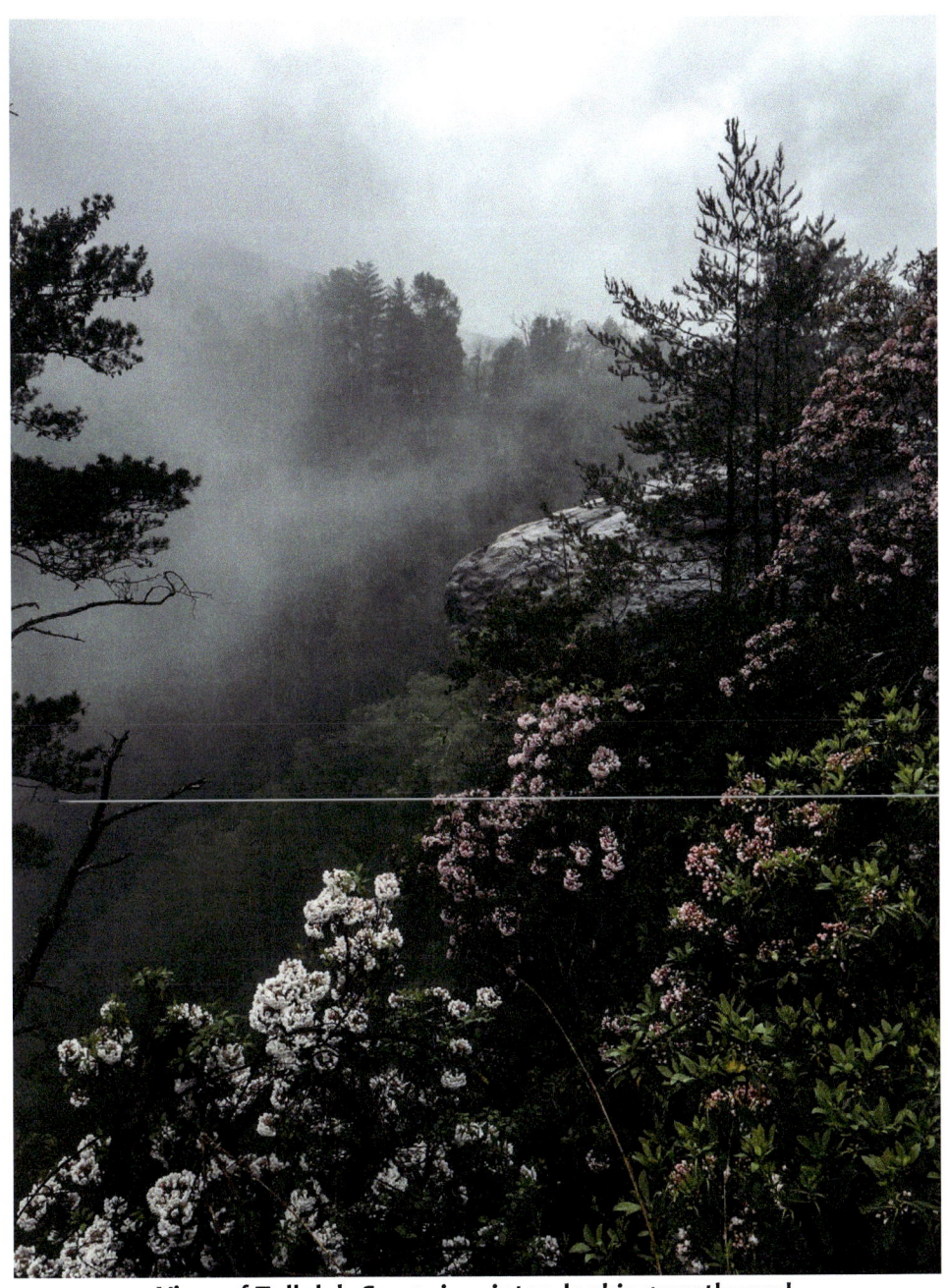
View of Tallulah Gorge in winter, looking northward.

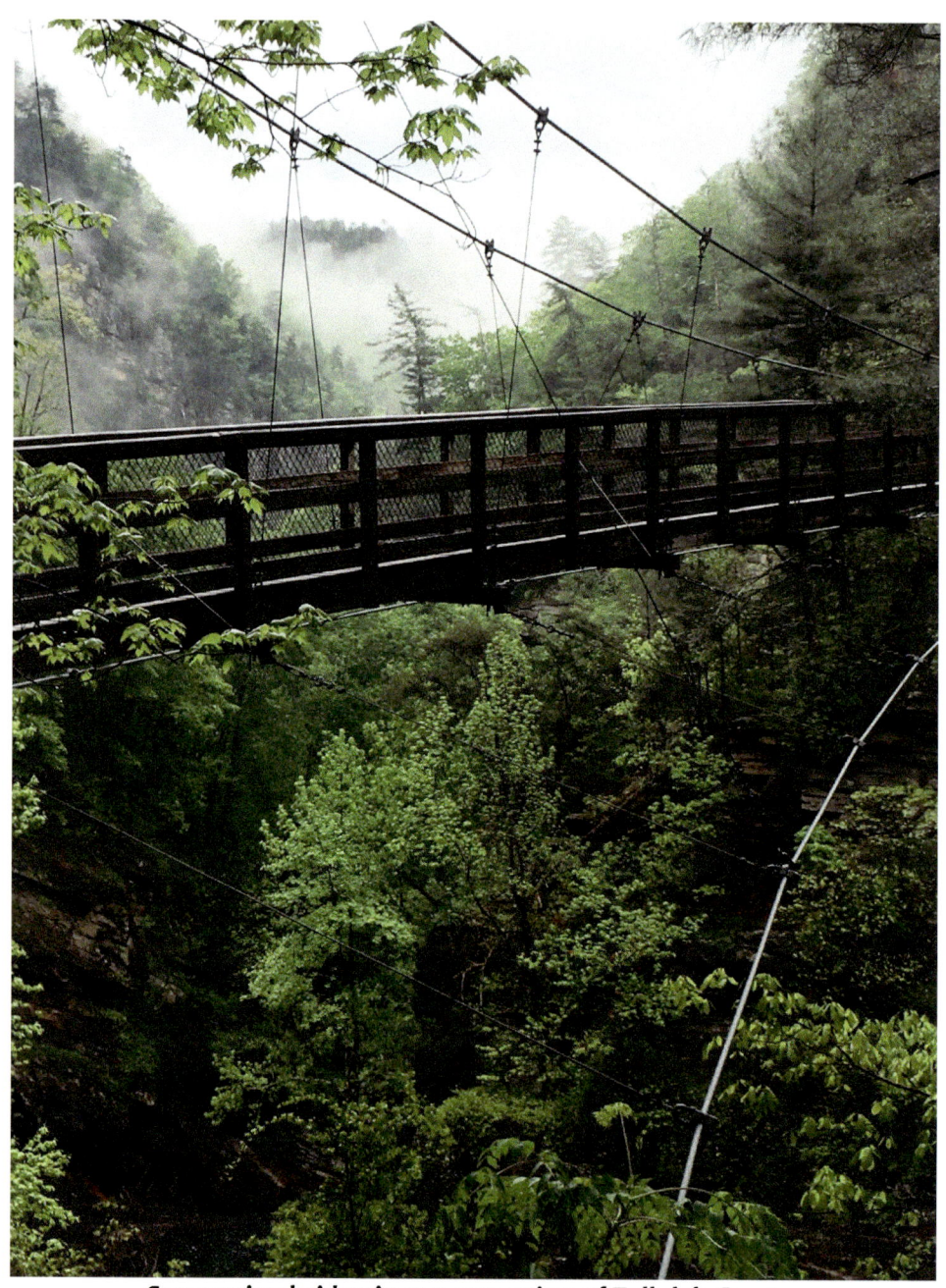
Suspension bridge in upper portion of Tallulah Gorge.

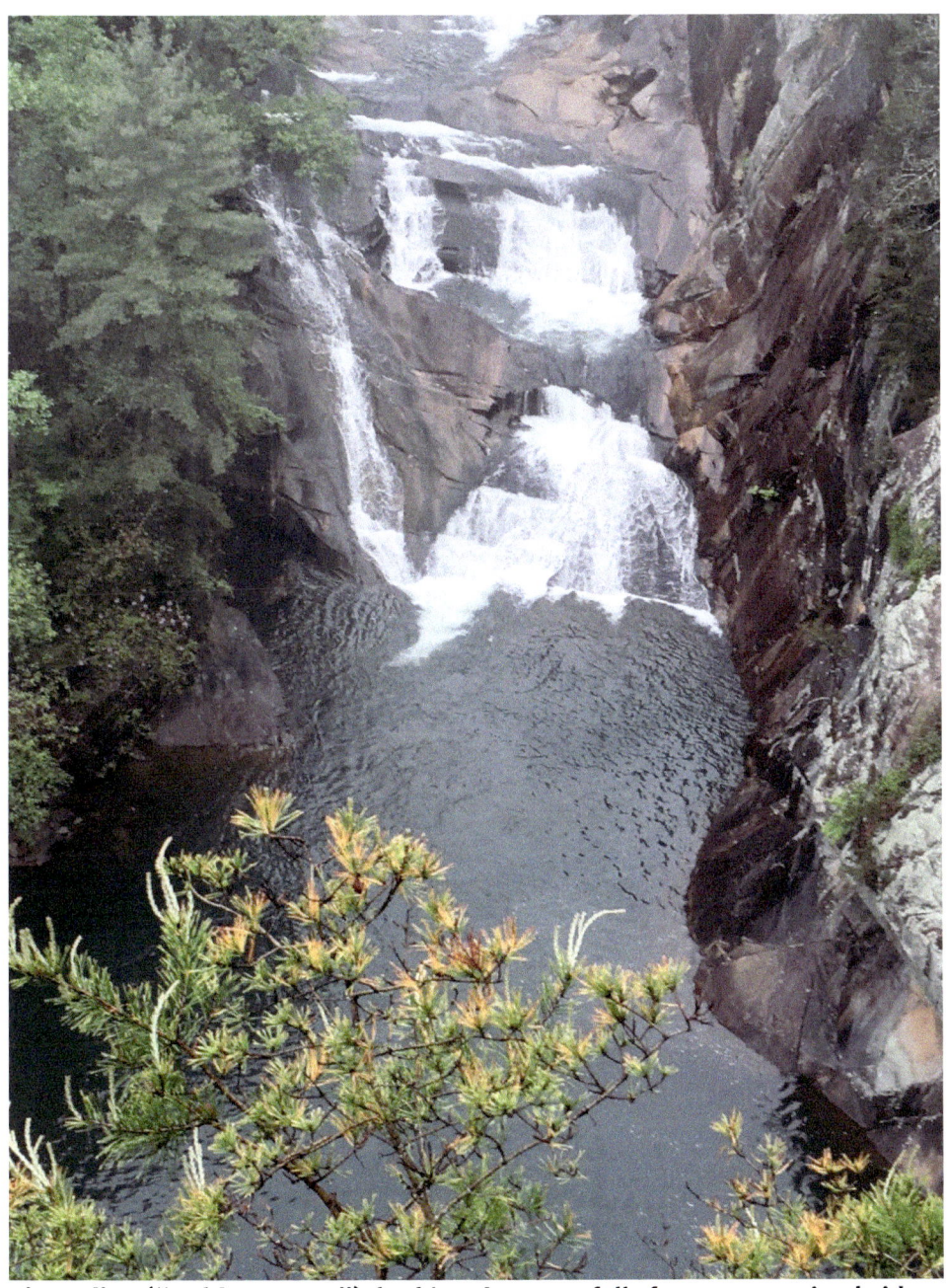
L'Eau d'Or ("Golden Water"), looking down on falls from suspension bridge.

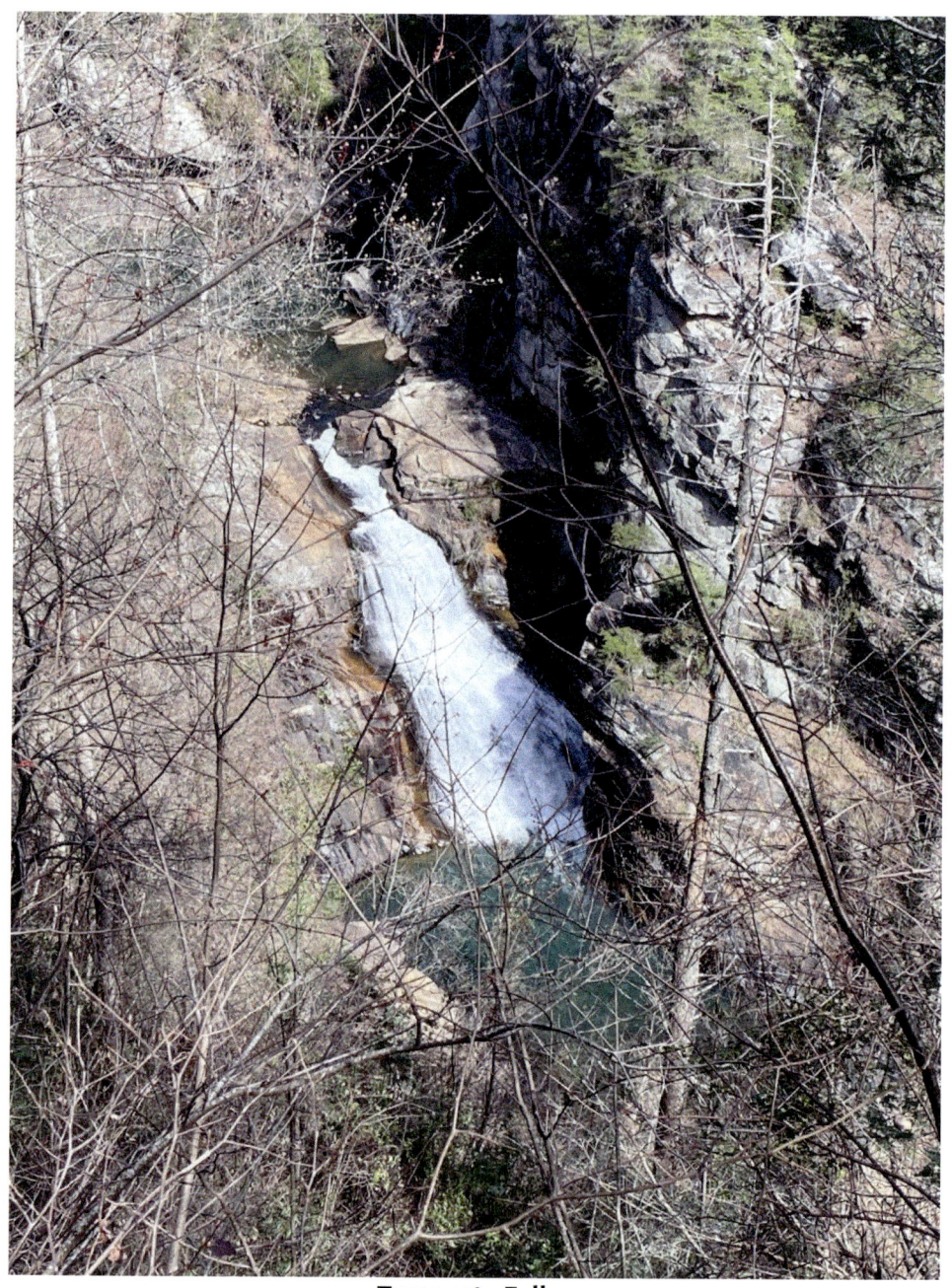
Tempesta Falls.

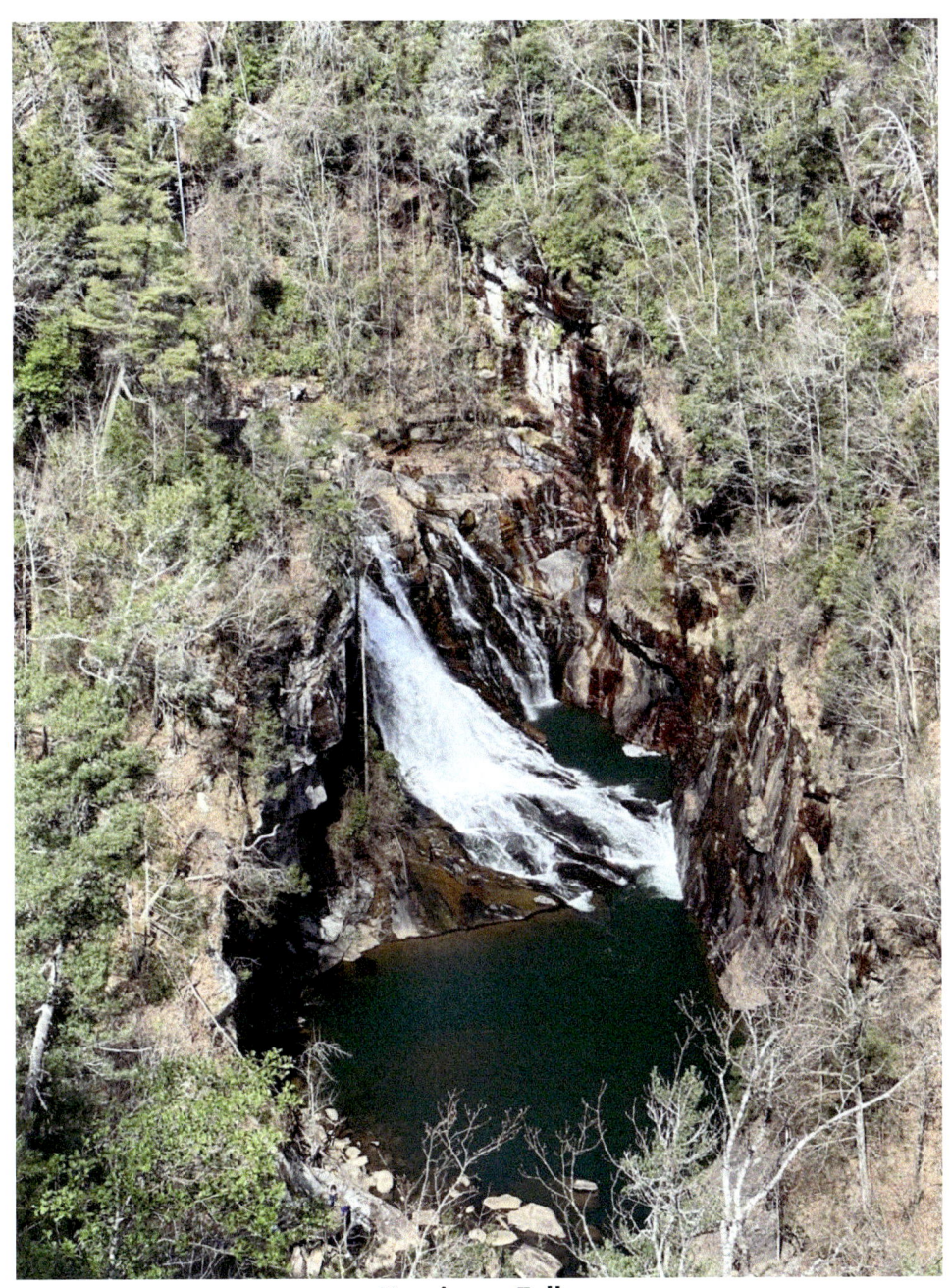

Hurricane Falls.

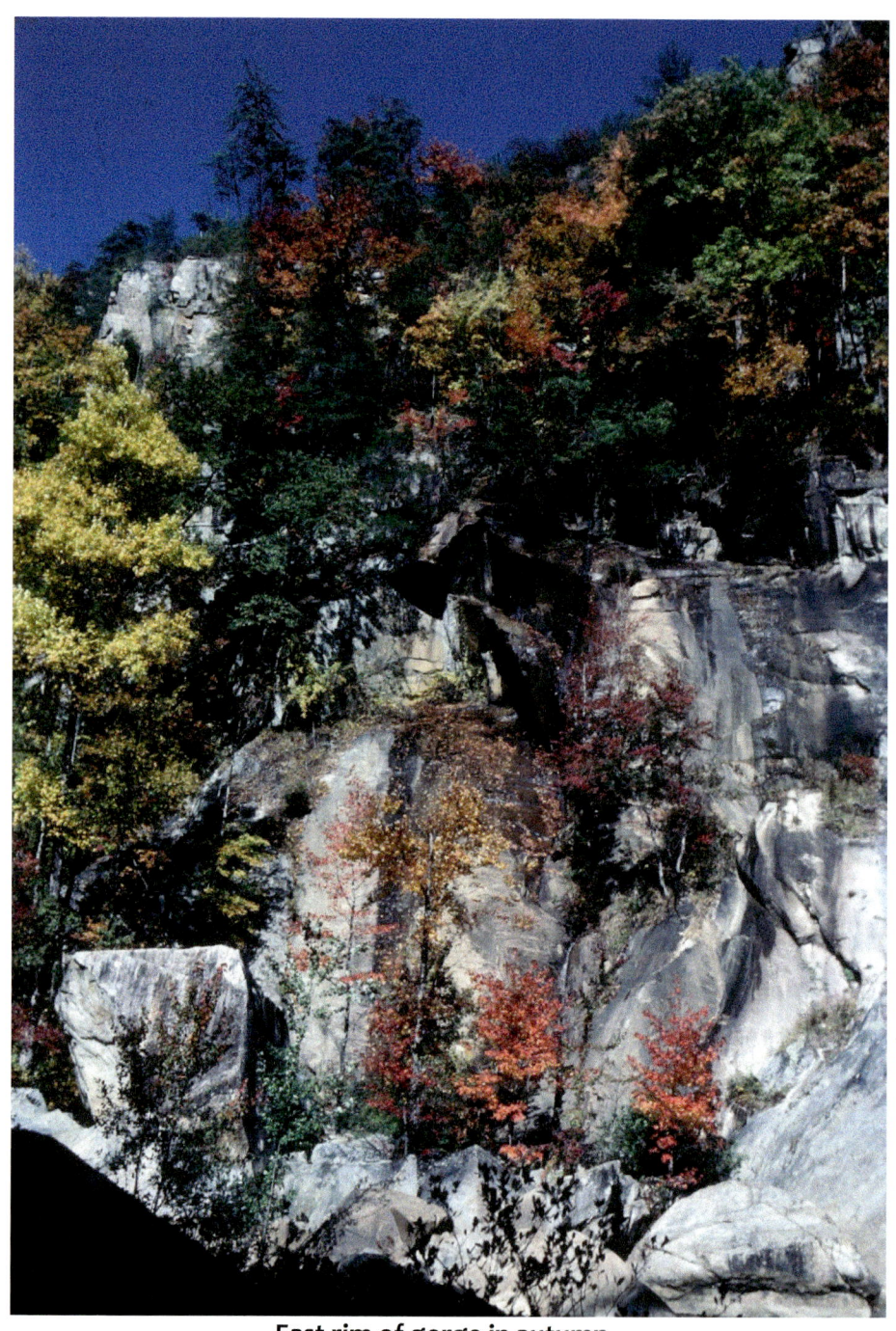
East rim of gorge in autumn.

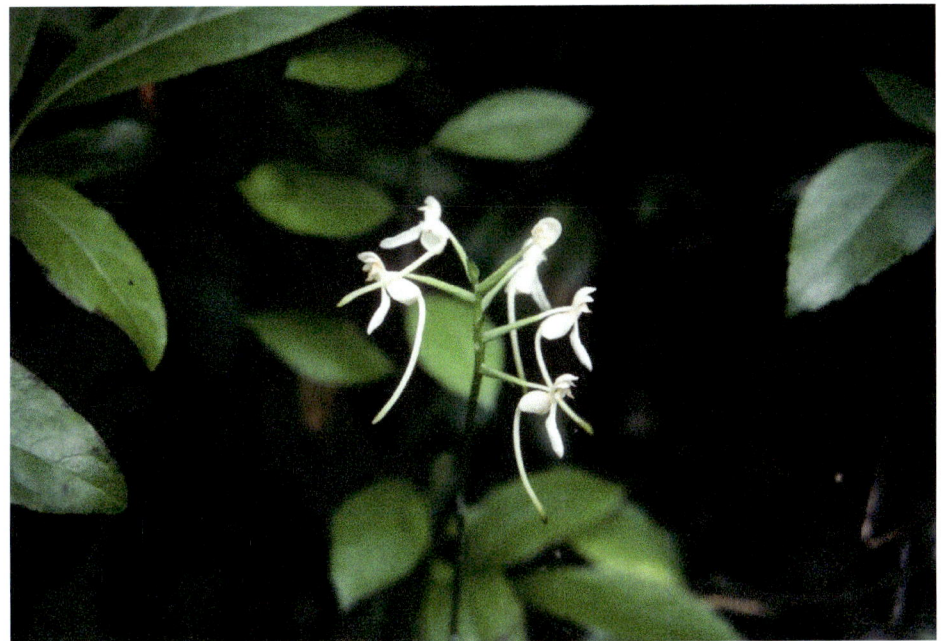
White fringeless orchid is rare in the Appalachians—here in a Tallulah Gorge bog.

The Green Salamander is also rare in the region; it was once common in Tallulah Gorge.

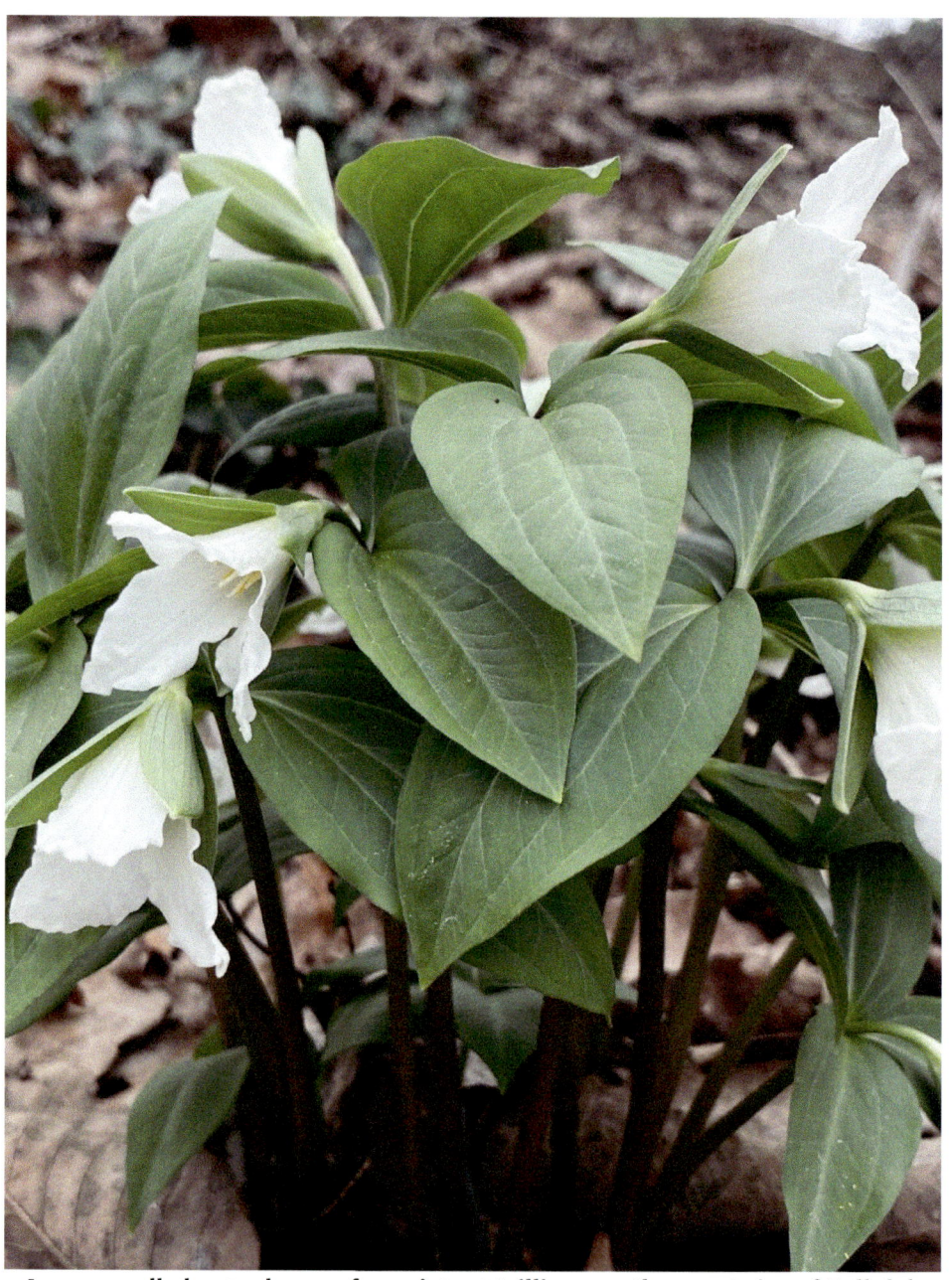
An unusually large clump of persistent trillium on the west rim of Tallulah Gorge.

THE TALLULAH RIVER ABOVE TALLULAH GORGE

The Tallulah River has been impounded multiple times above Tallulah Gorge. As one moves upstream, first there is Tallulah Falls Lake, then Lake Rabun, followed by Seed Lake, and, finally, the extensive Lake Burton. It becomes a mountain river again north of US. Highway 76 above Lake Burton. As it approaches Tate City, the last community in Georgia, on its way to the eastern continental divide at Deep Gap (a famous ramp-collecting area) at 4,341 feet, it becomes a narrow, roaring river again with giant boulders and nice rapids. It is a rocky brook near its end in the Southern Nantahala Wilderness area in North Carolina. Here, cove forests with sugar maple, non-existent in the remainder of the Savannah River drainage, are common at around 4000 feet below the montane dwarfed red oak forests of Standing Indian, which at 5499 feet is the highest point in the Savannah River drainage.

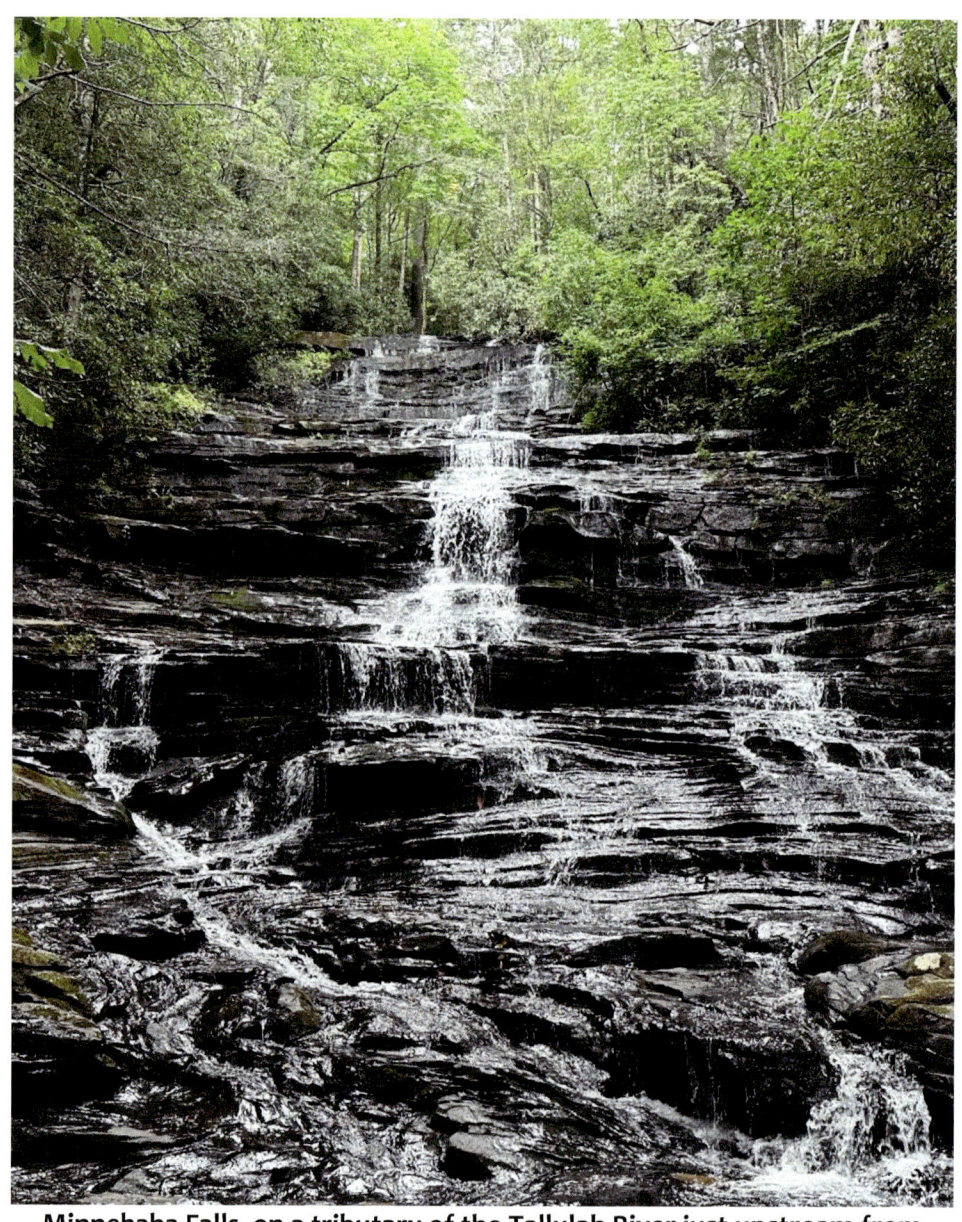

Minnehaha Falls, on a tributary of the Tallulah River just upstream from Tallulah Gorge.

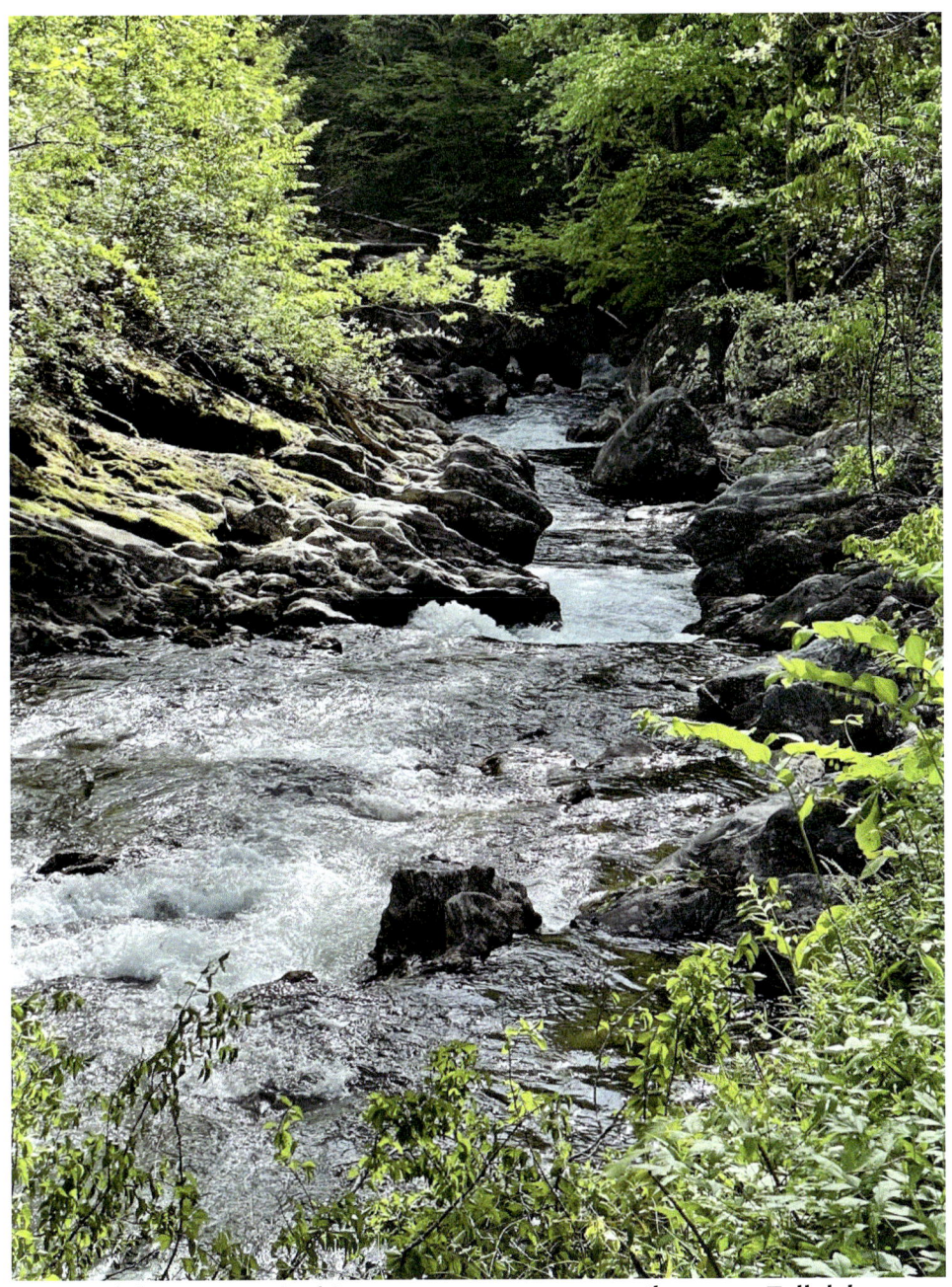

Mini-gorges and whitewater are common on the upper Tallulah.

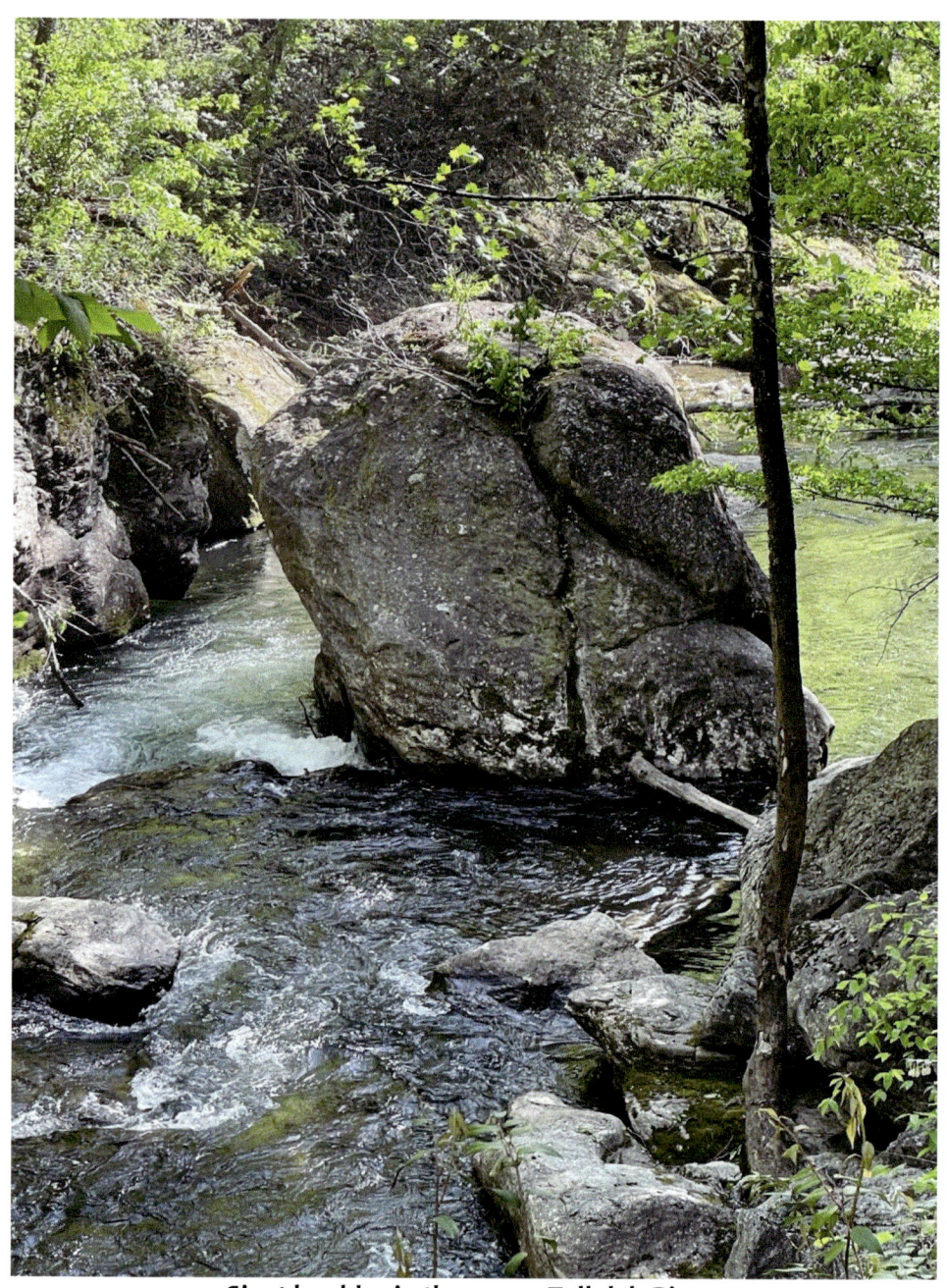
Giant boulder in the upper Tallulah River.

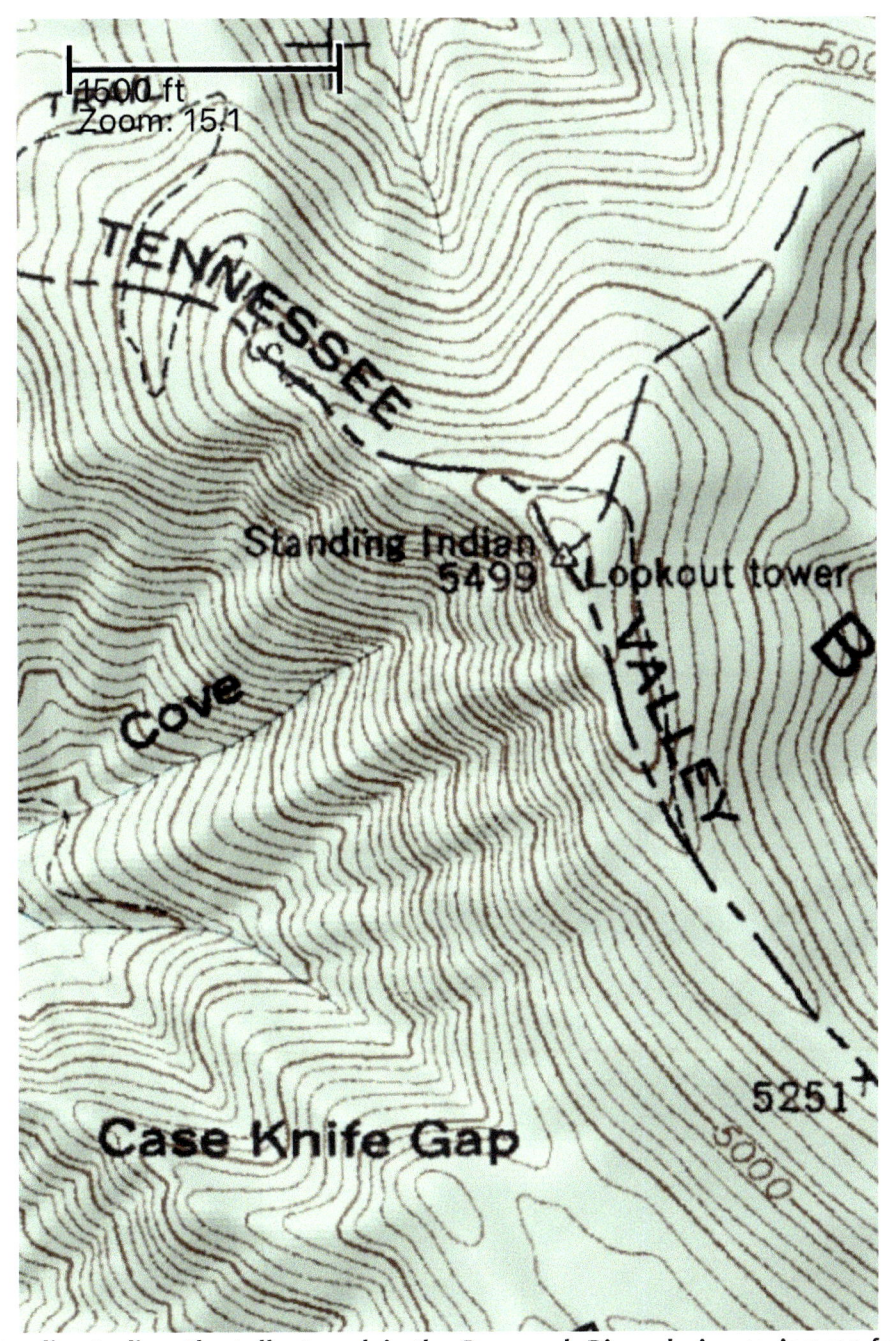

Standing Indian, the tallest peak in the Savannah River drainage, is 5499 feet tall.

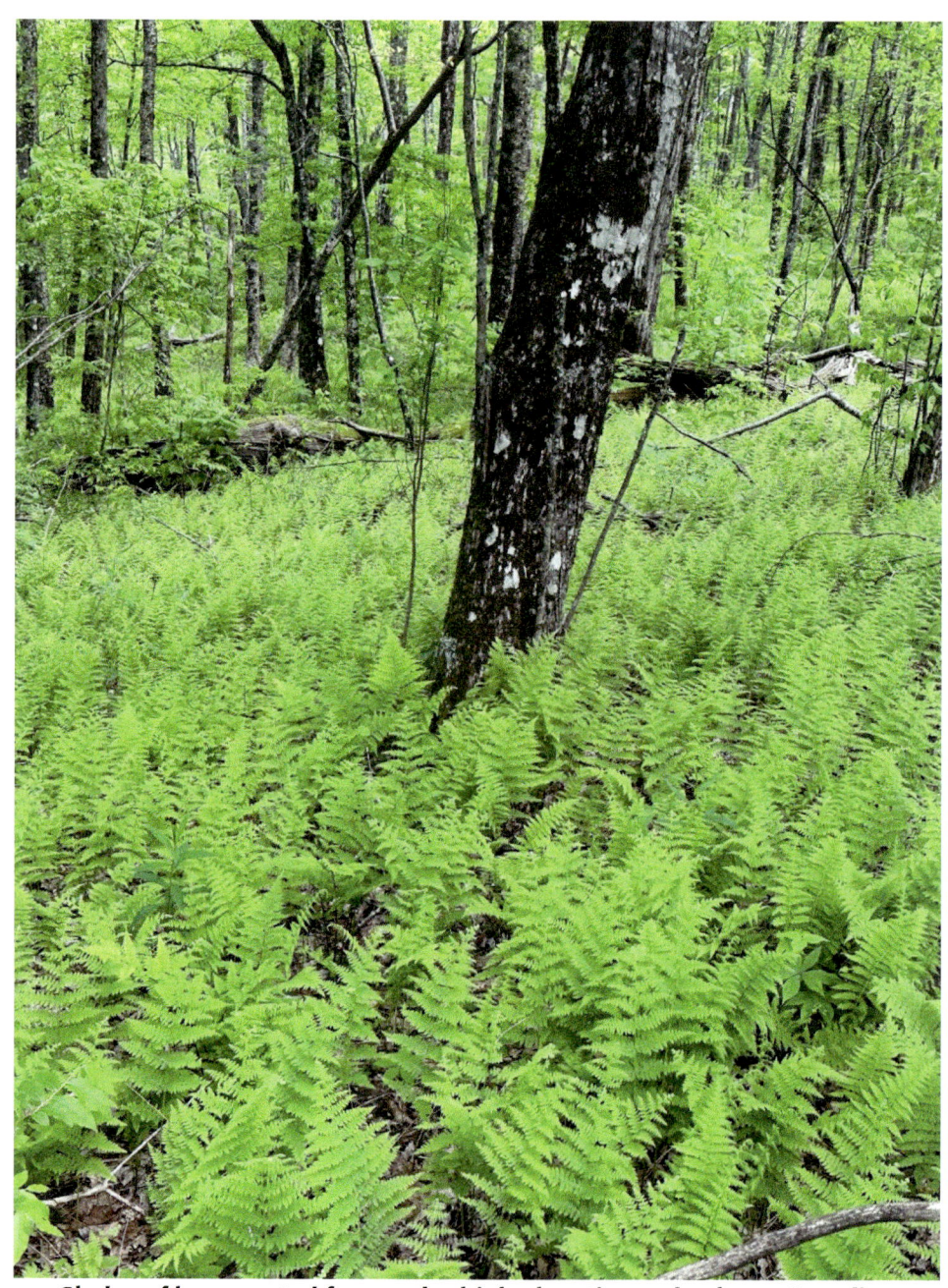
Glades of hay-scented fern under high elevation red oaks on Standing Indian.

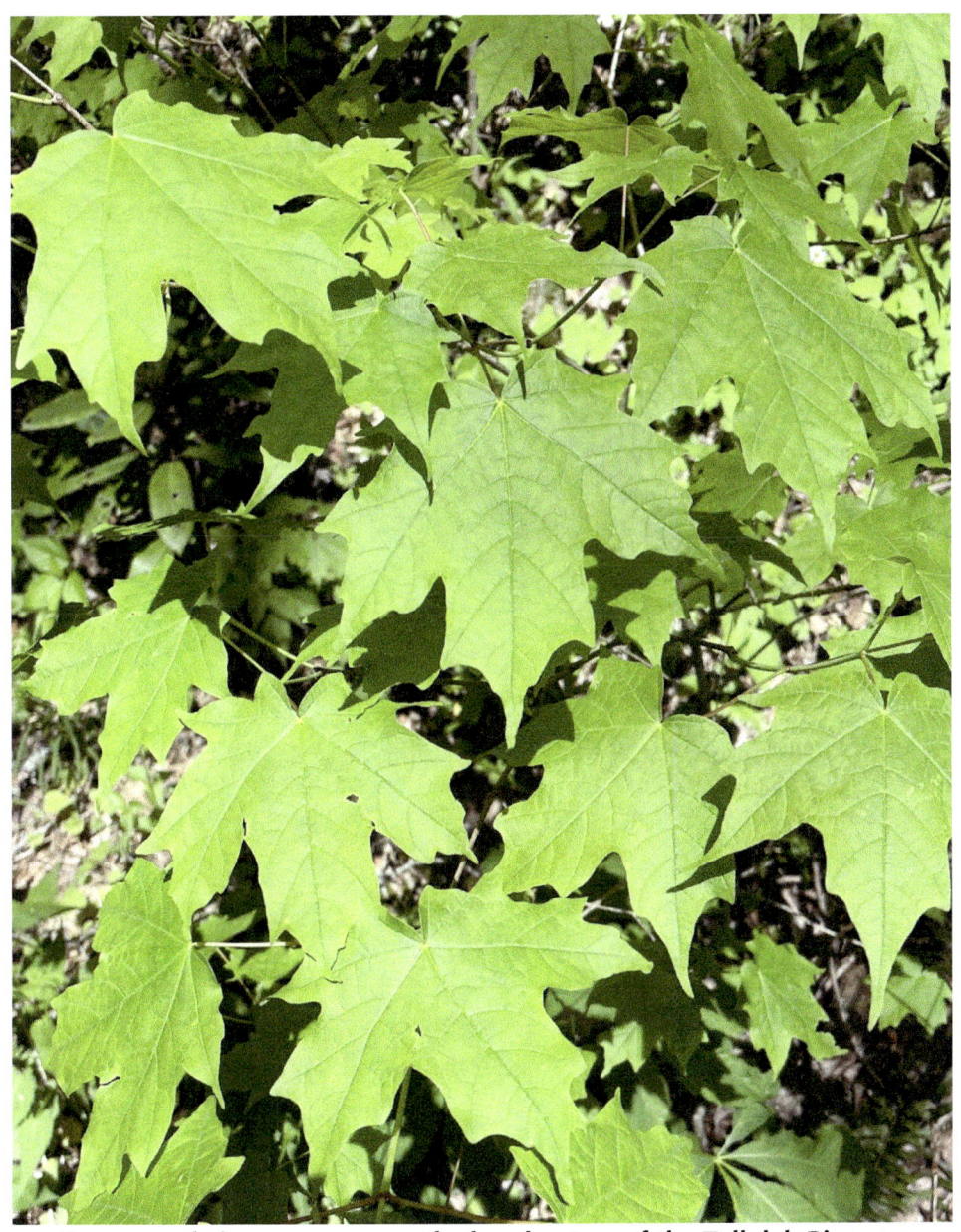
Sugar maple is common near the headwaters of the Tallulah River on Standing Indian.

NOTEWORTHY PLANTS and ANIMALS: GALLERY

A healthy colony of the rare persistent trillium in Tallulah Gorge.

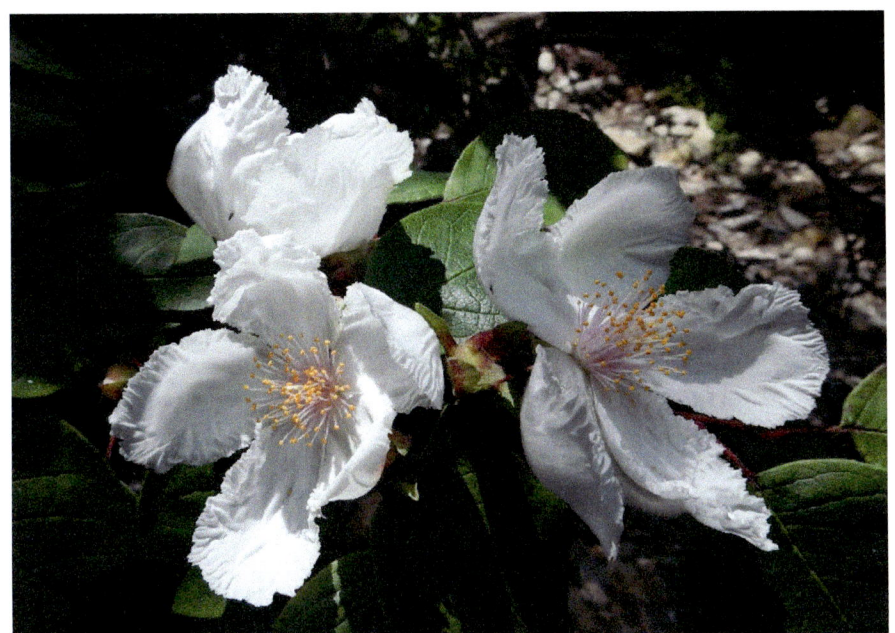
The rare mountain wild camellia is found along the upper Chattooga River.

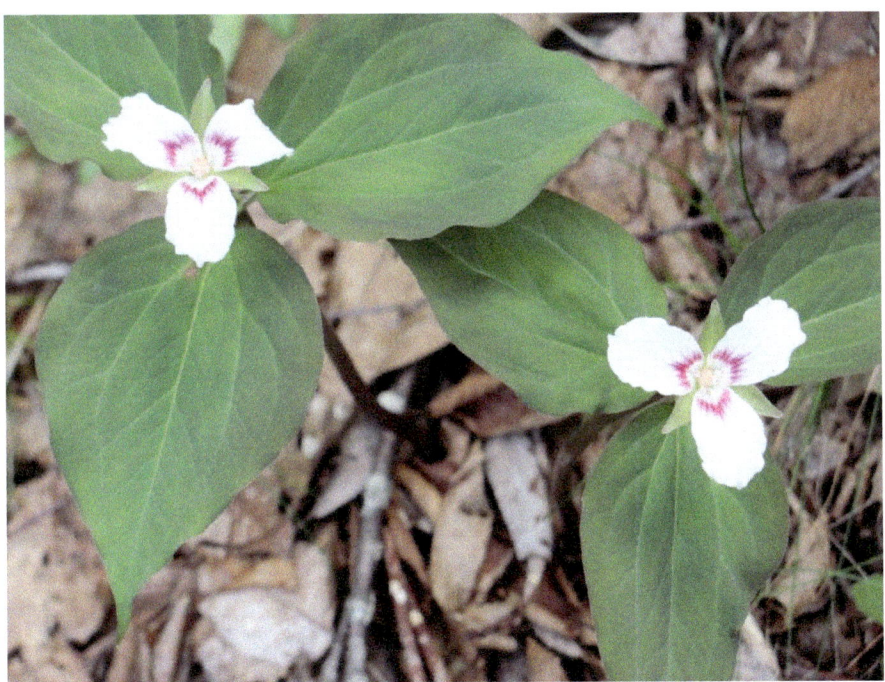
Painted trillium is found only at higher elevations along the Blue Ridge front.

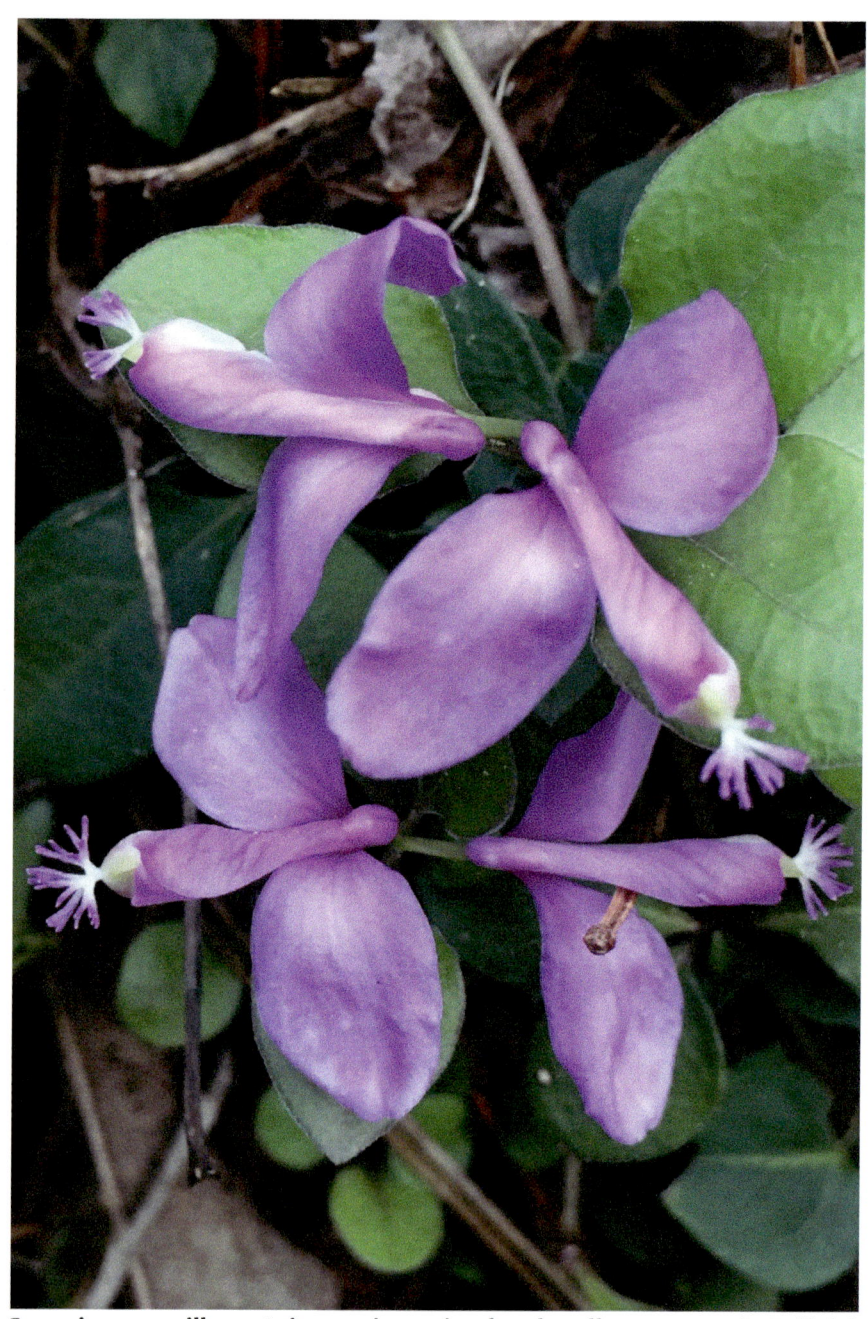
Gay wings, a milkwort, is rare in region but locally common in Tallulah Gorge.

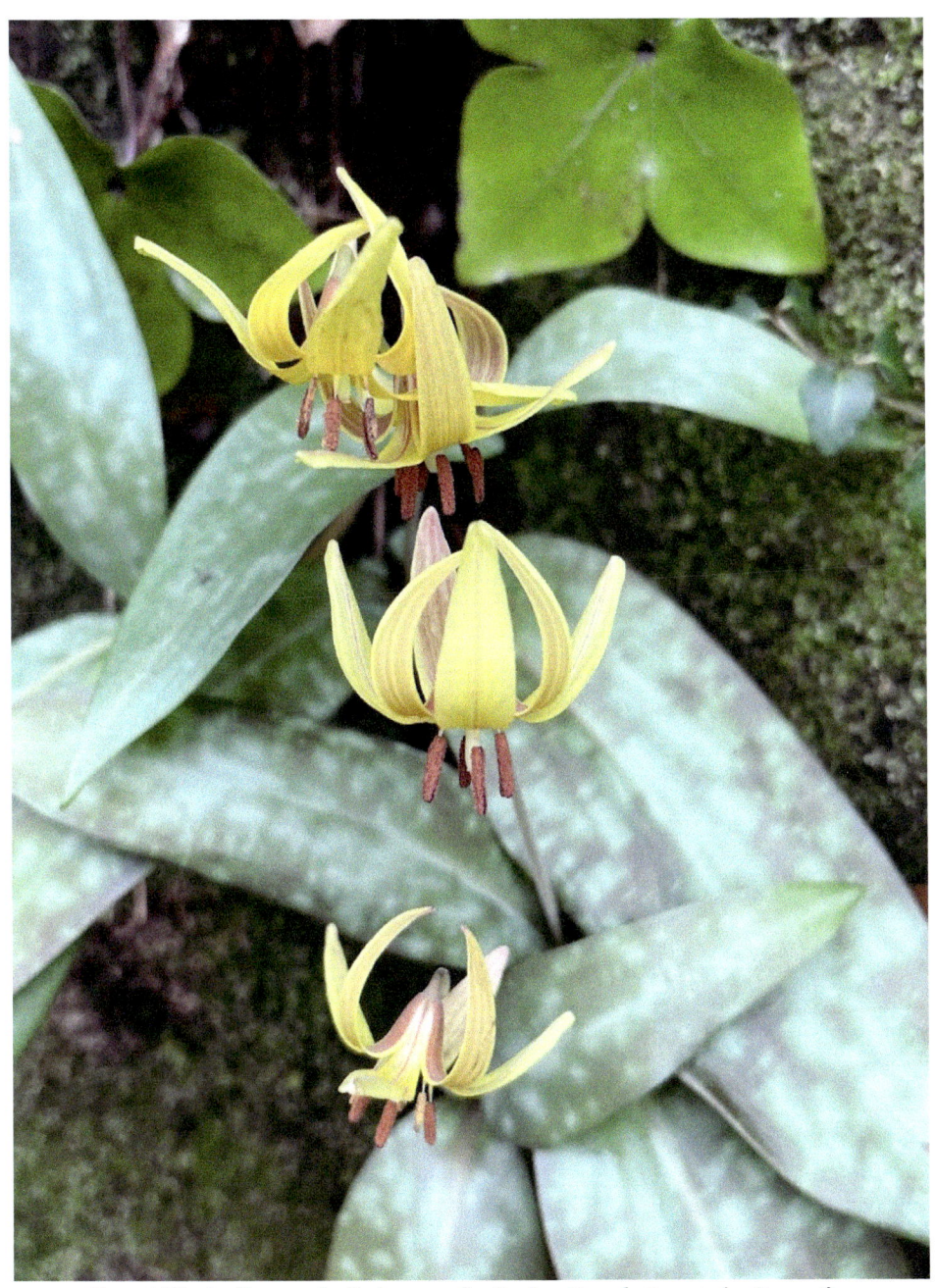
Trout lily in flower in February in Cedar Creek Gorge in Georgia.

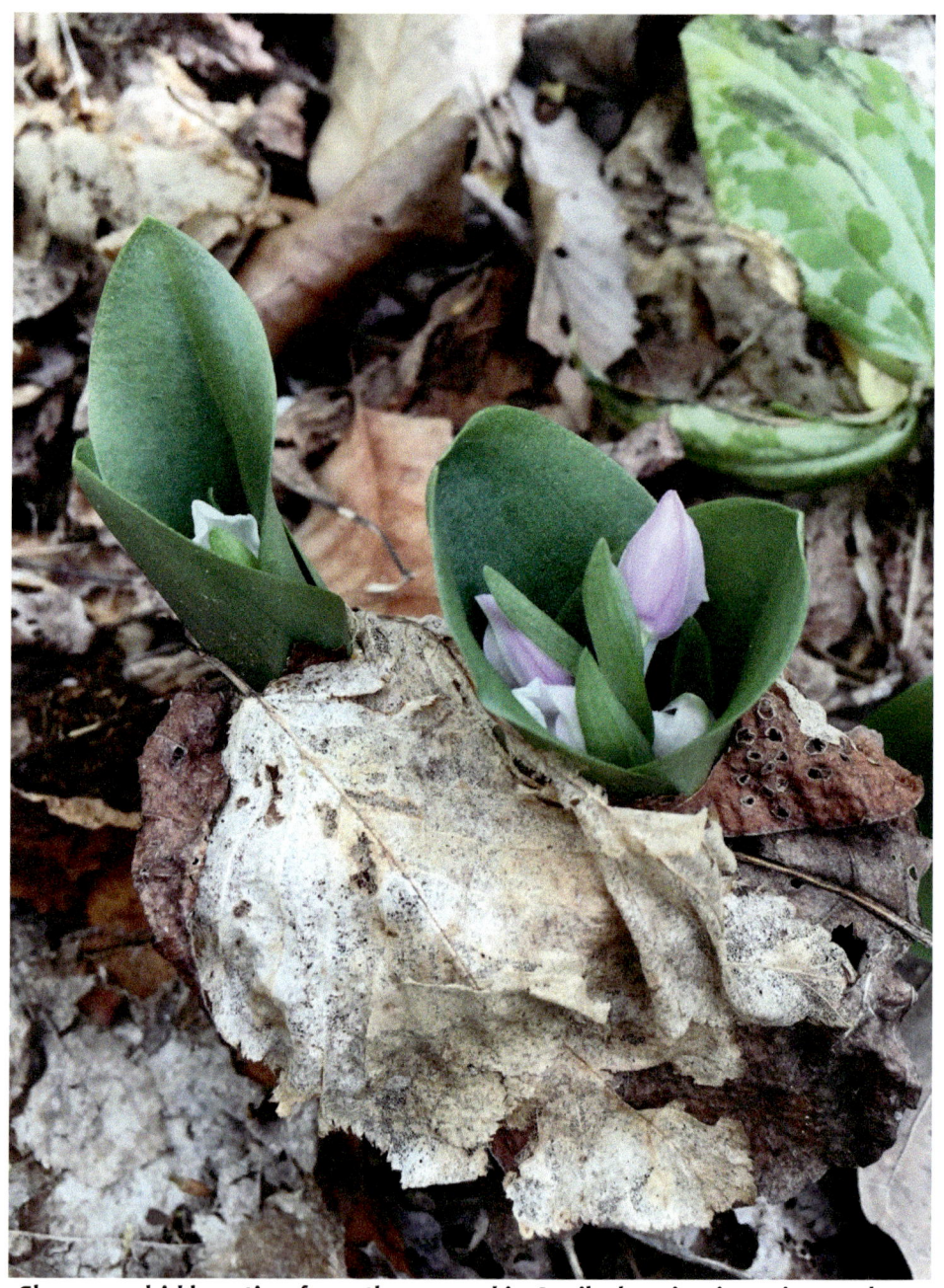

Showy orchid bursting from the ground in April, showing its unique colors.

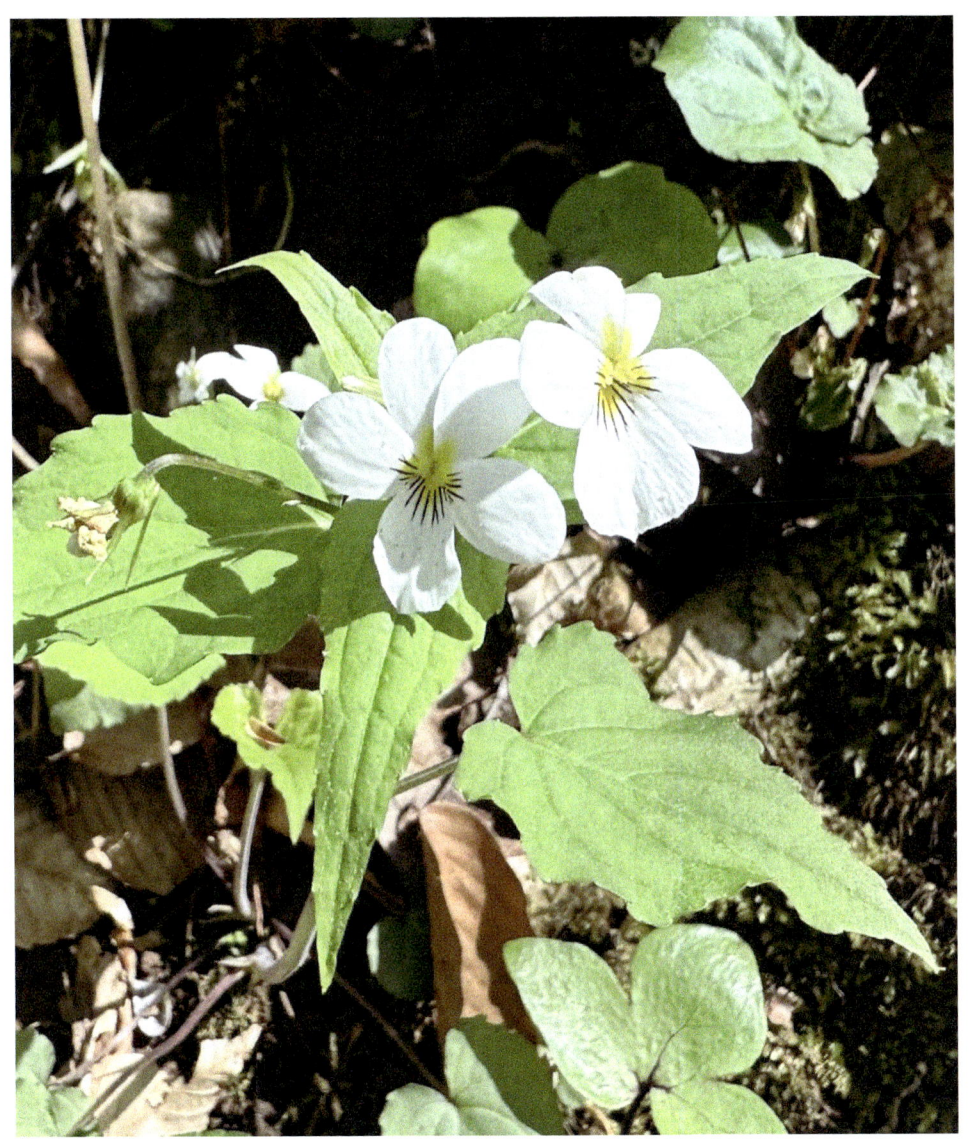
Canada violet is found in rich coves along the Blue Ridge Front.

Walking fern on calcareous boulder in Cedar Creek Gorge (note sprouting on frond tips).

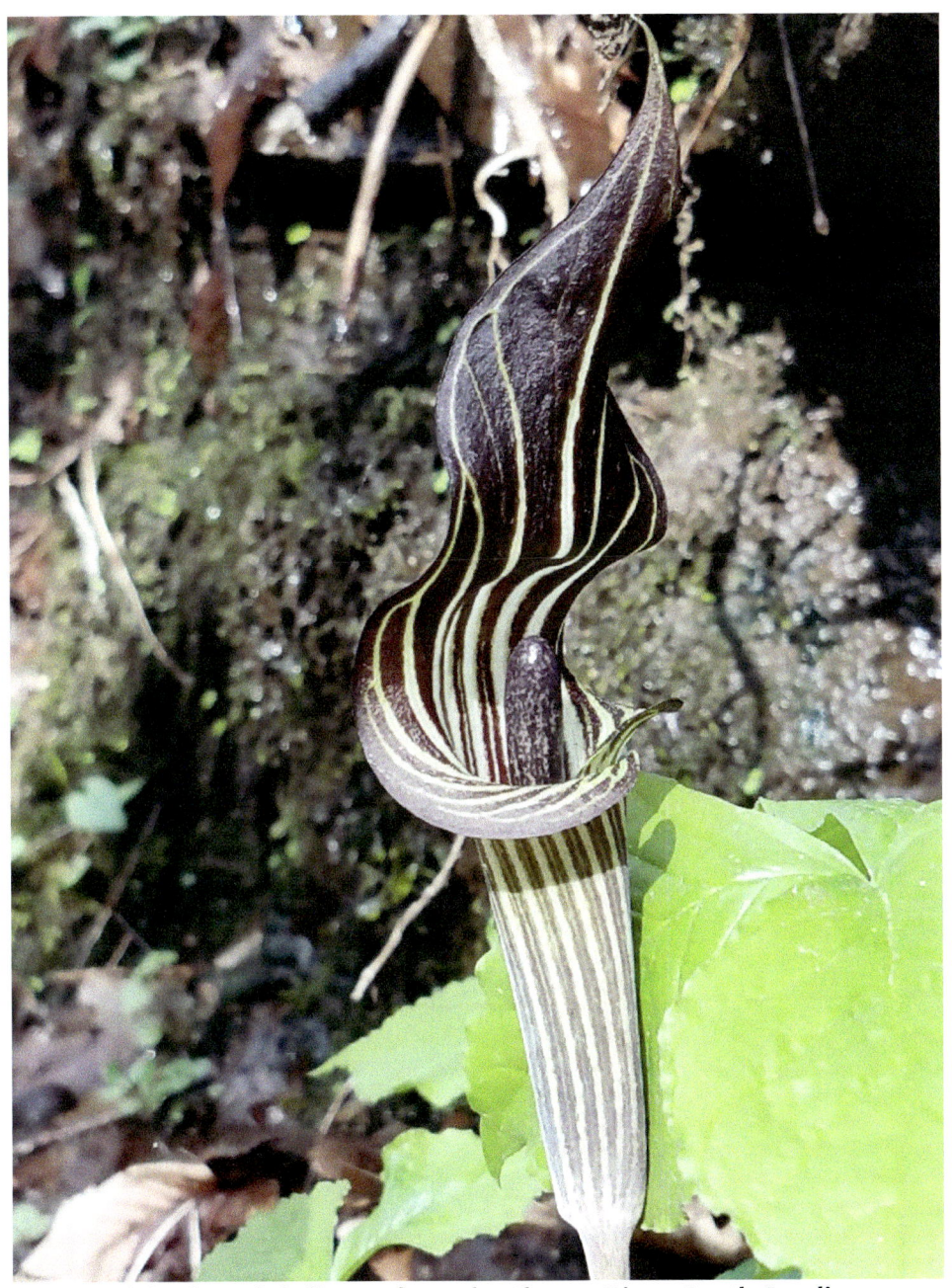
Jack-in-the-pulpit flower from the Chauga River, South Carolina.

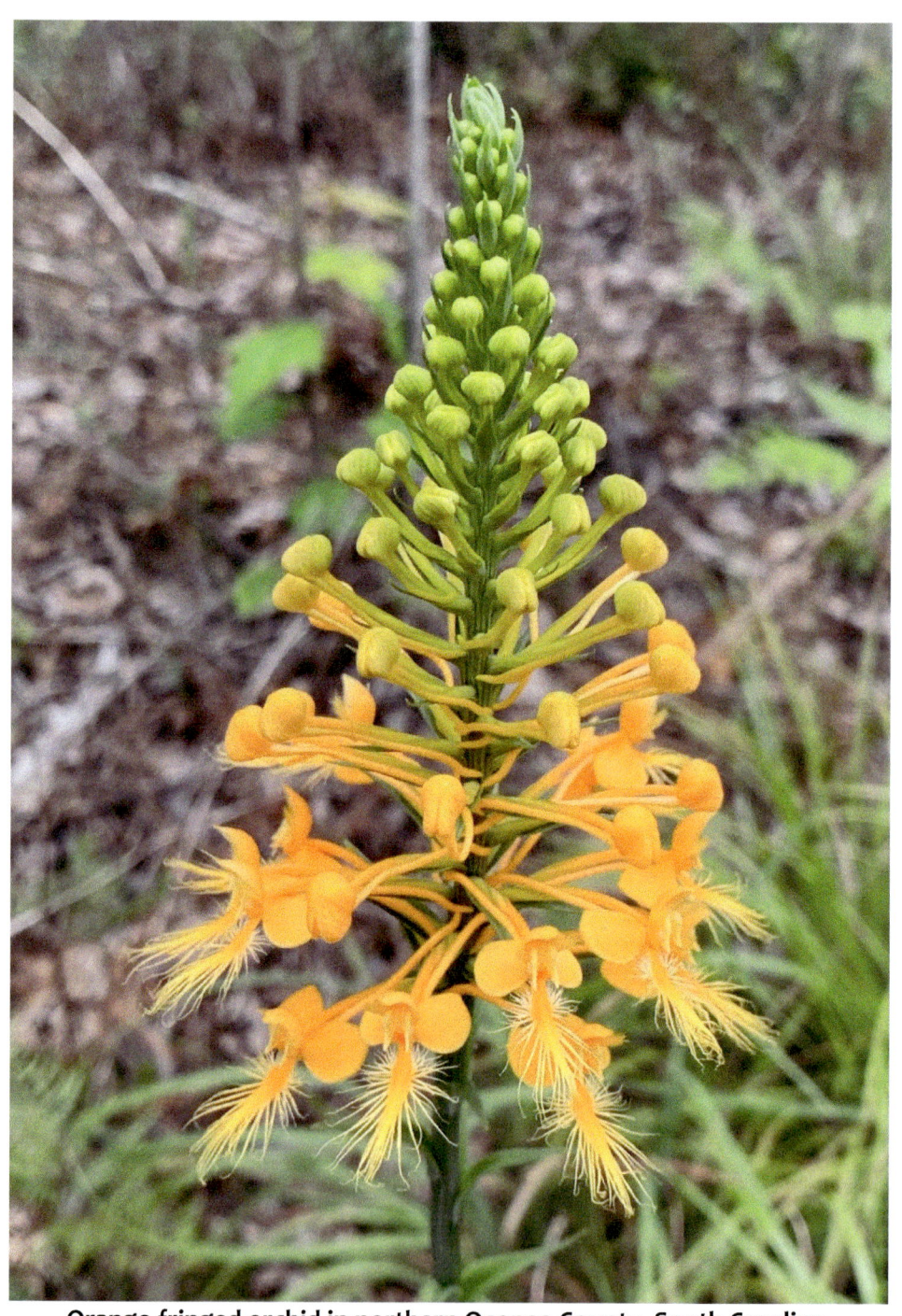
Orange-fringed orchid in northern Oconee County, South Carolina.

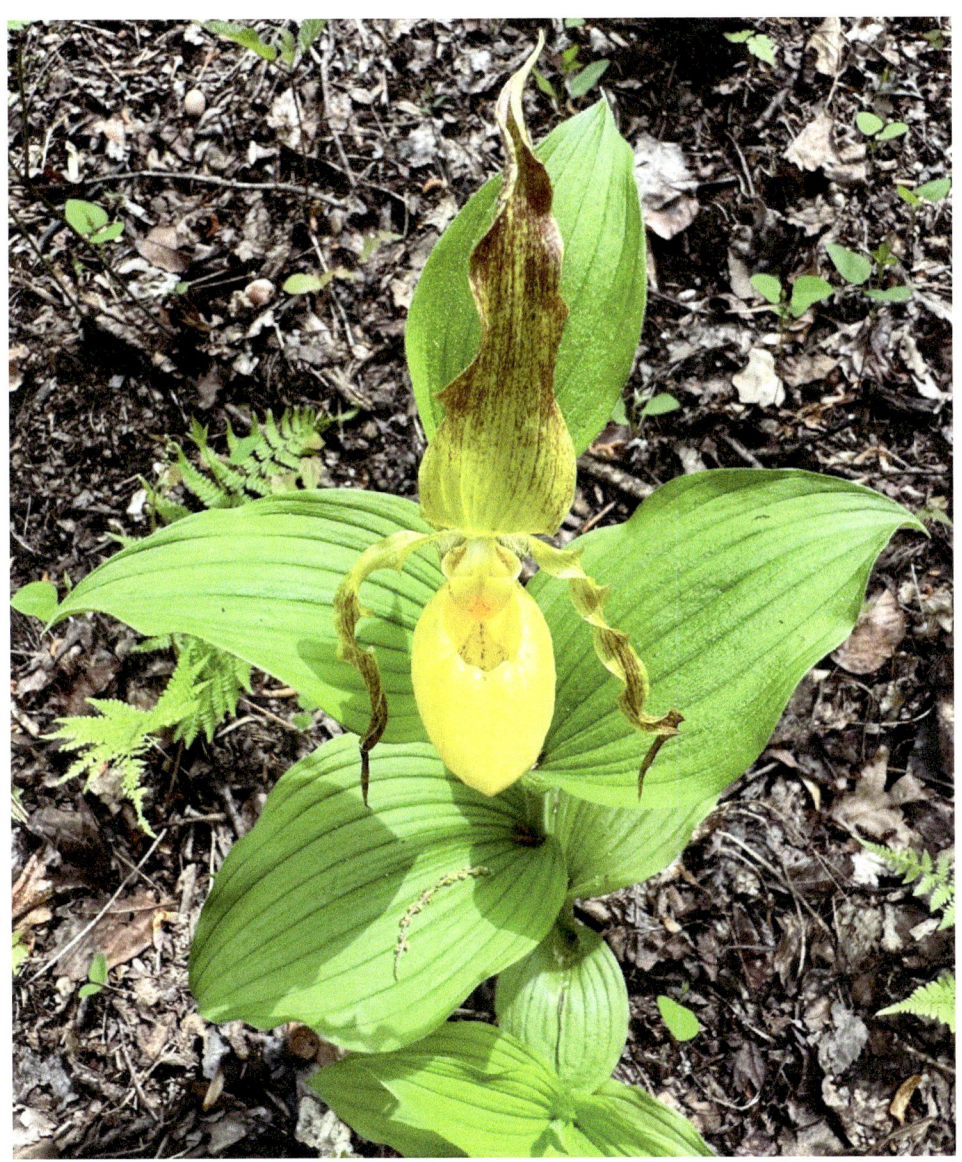
Yellow lady's slipper can be found on the slopes of Cedar Creek and Crooked Creek, both tributaries of the Chauga River.

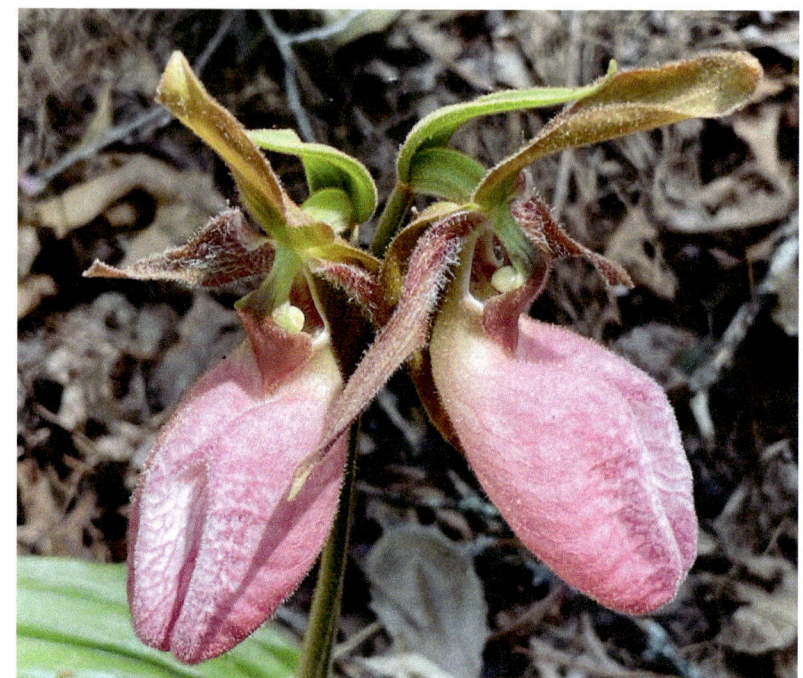
A double pink lady's-slipper along the Chattooga River.

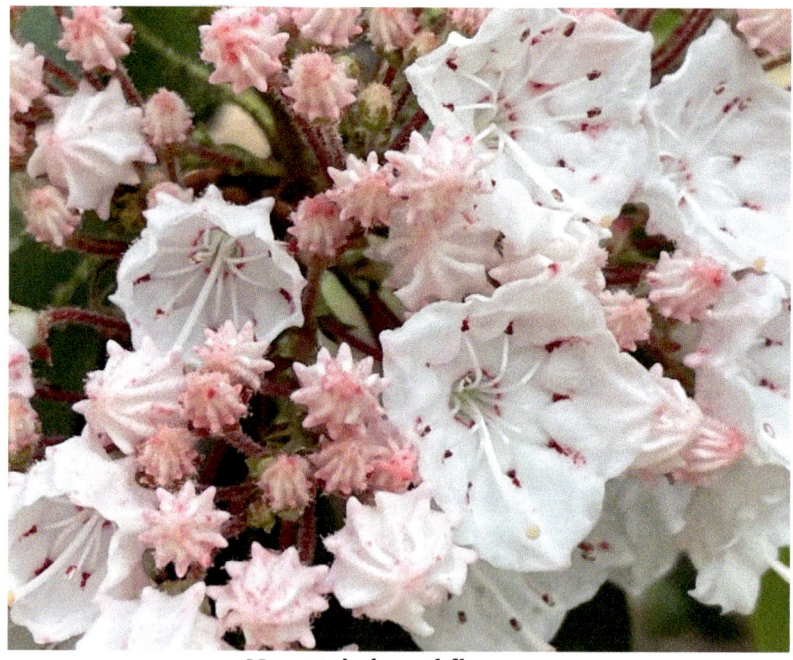
Mountain laurel flowers.

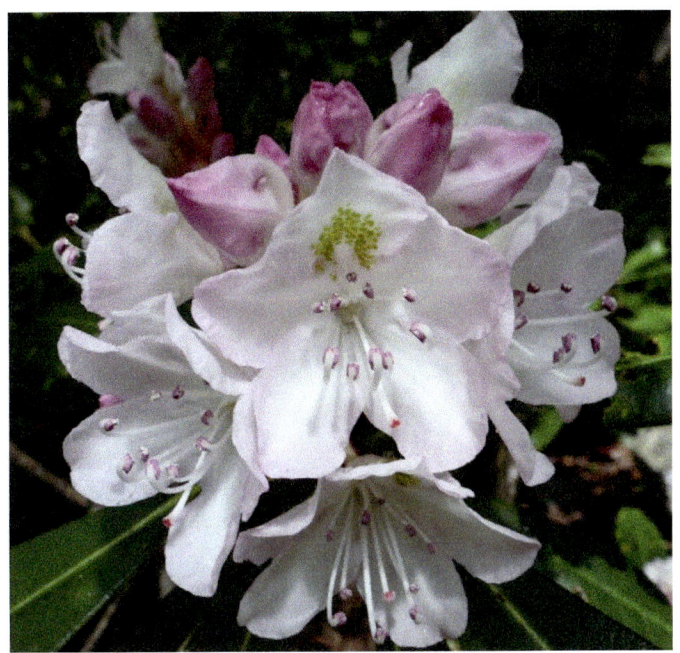
Rose bay or great laurel.

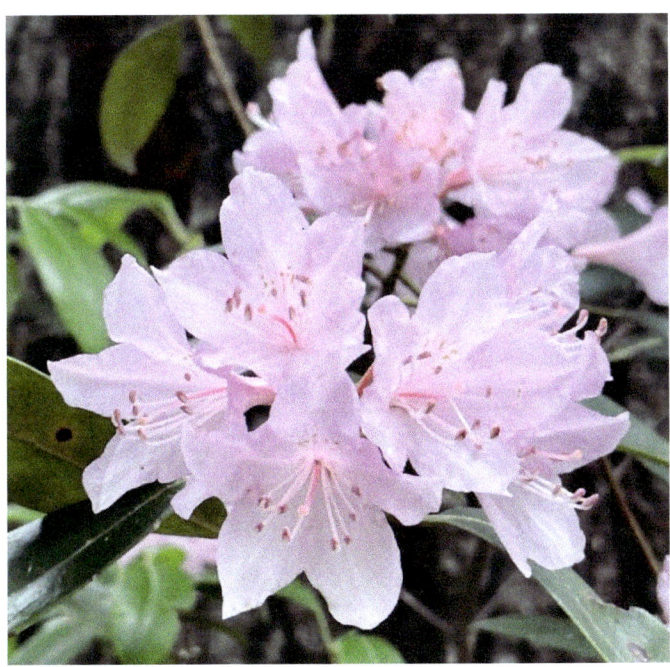
Carolina laurel has shorter leaves than great laurel and flowers earlier.

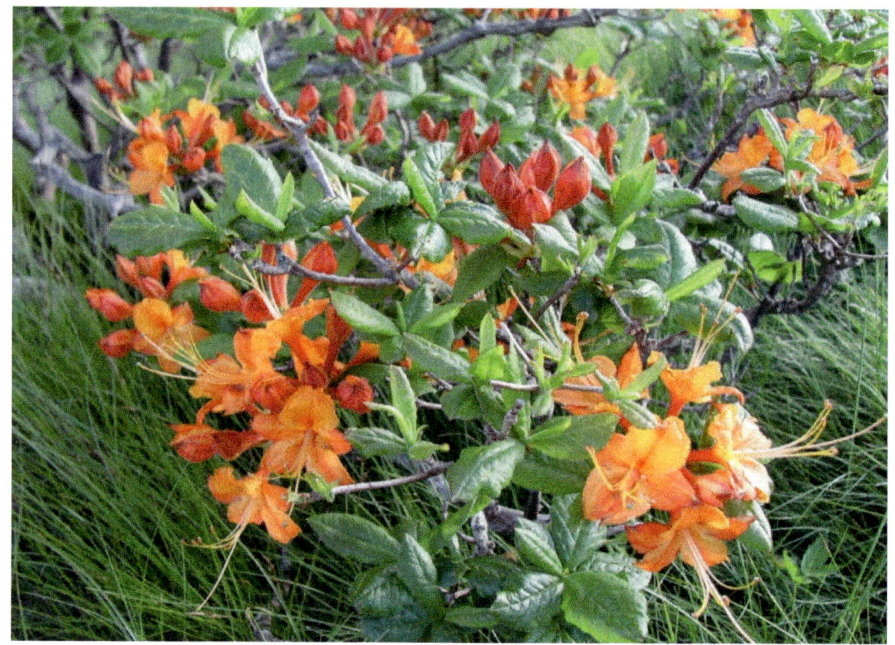
Flame azalea is uncommon in the Gorge Region.

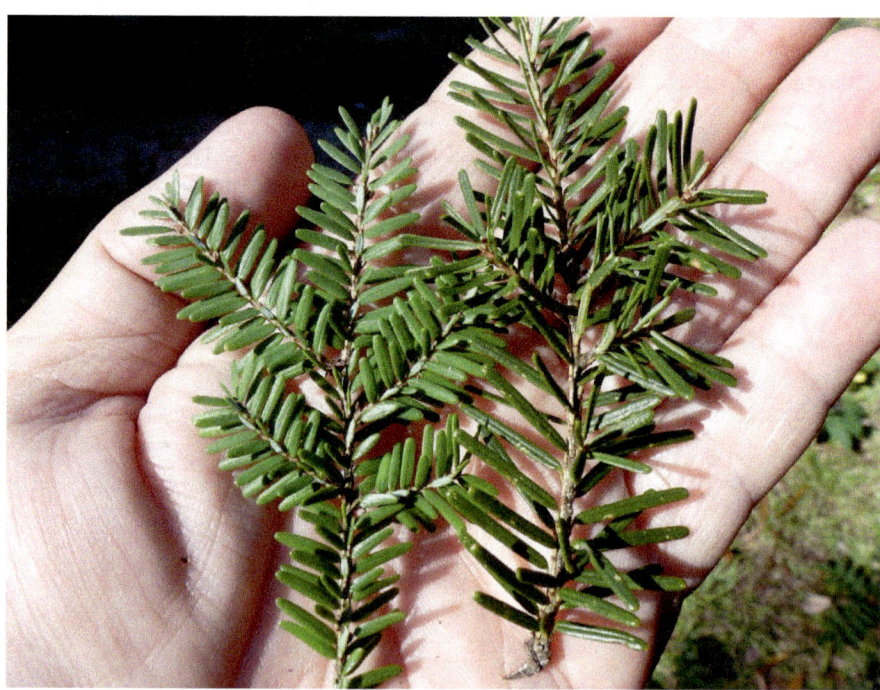
Leaves of Canada or eastern hemlock on left, Carolina hemlock on right.

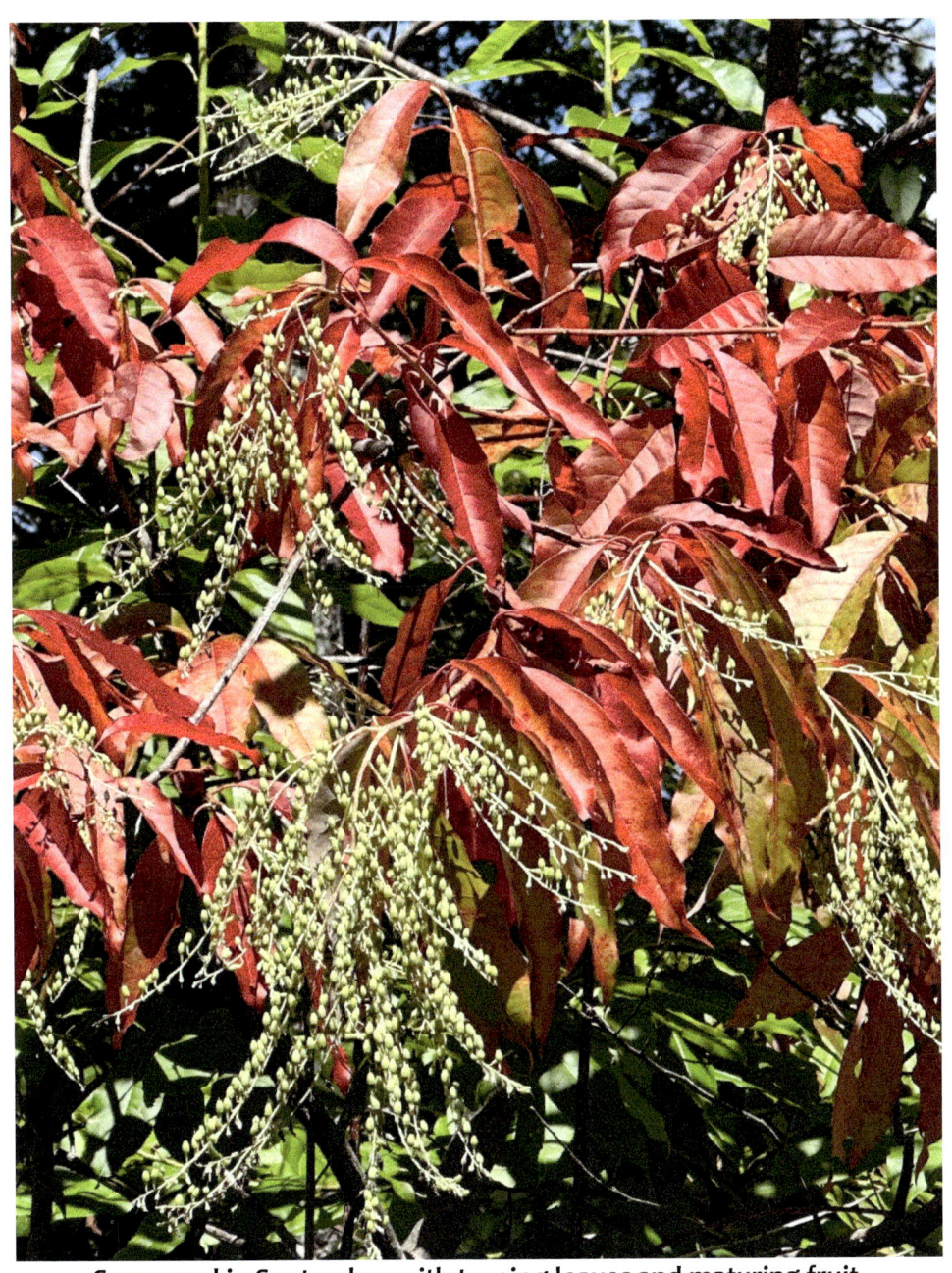
Sourwood in September with turning leaves and maturing fruit.

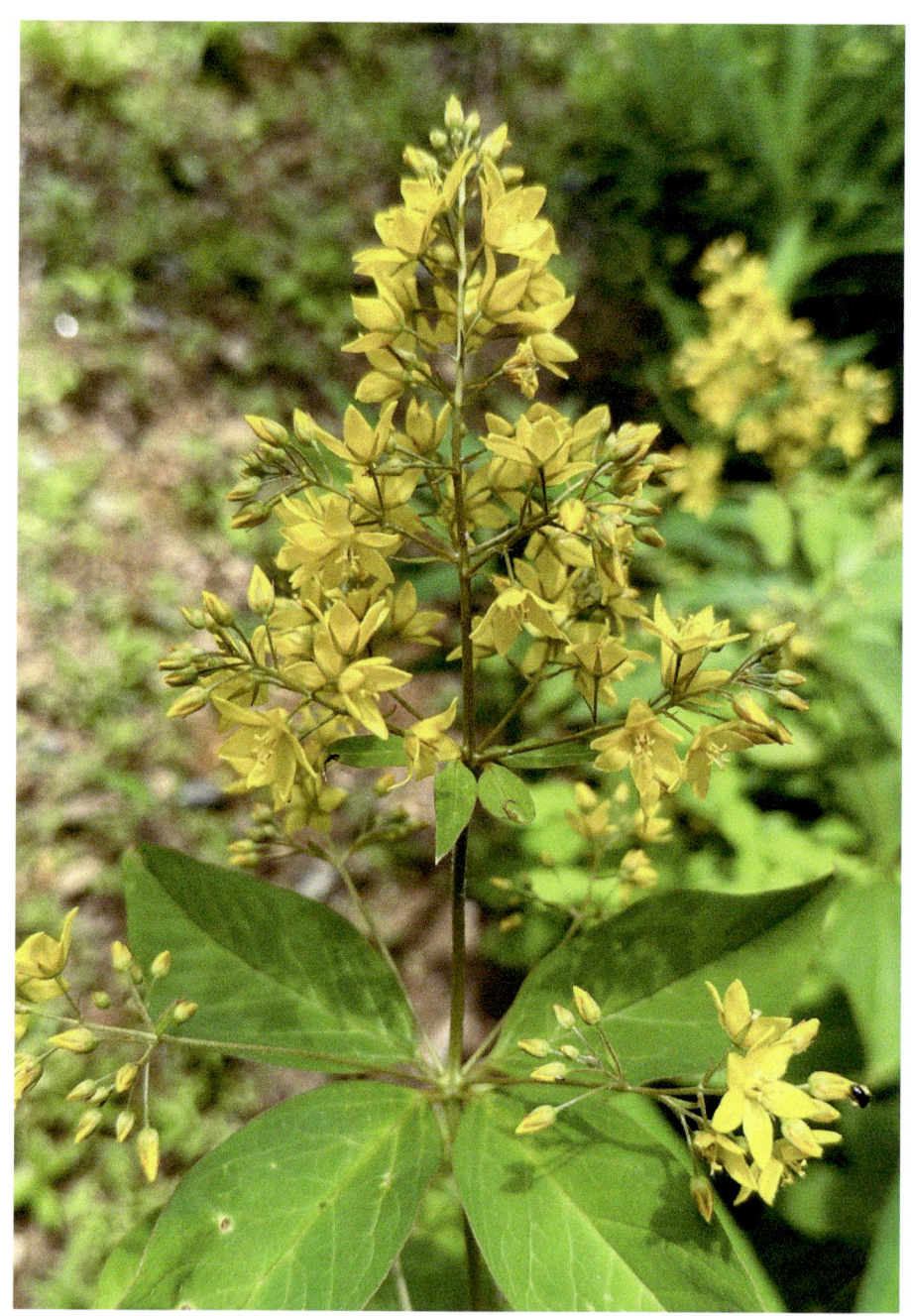
Fraser's loosestrife, a tall, showy, rare light-gap species found in openings in the region.

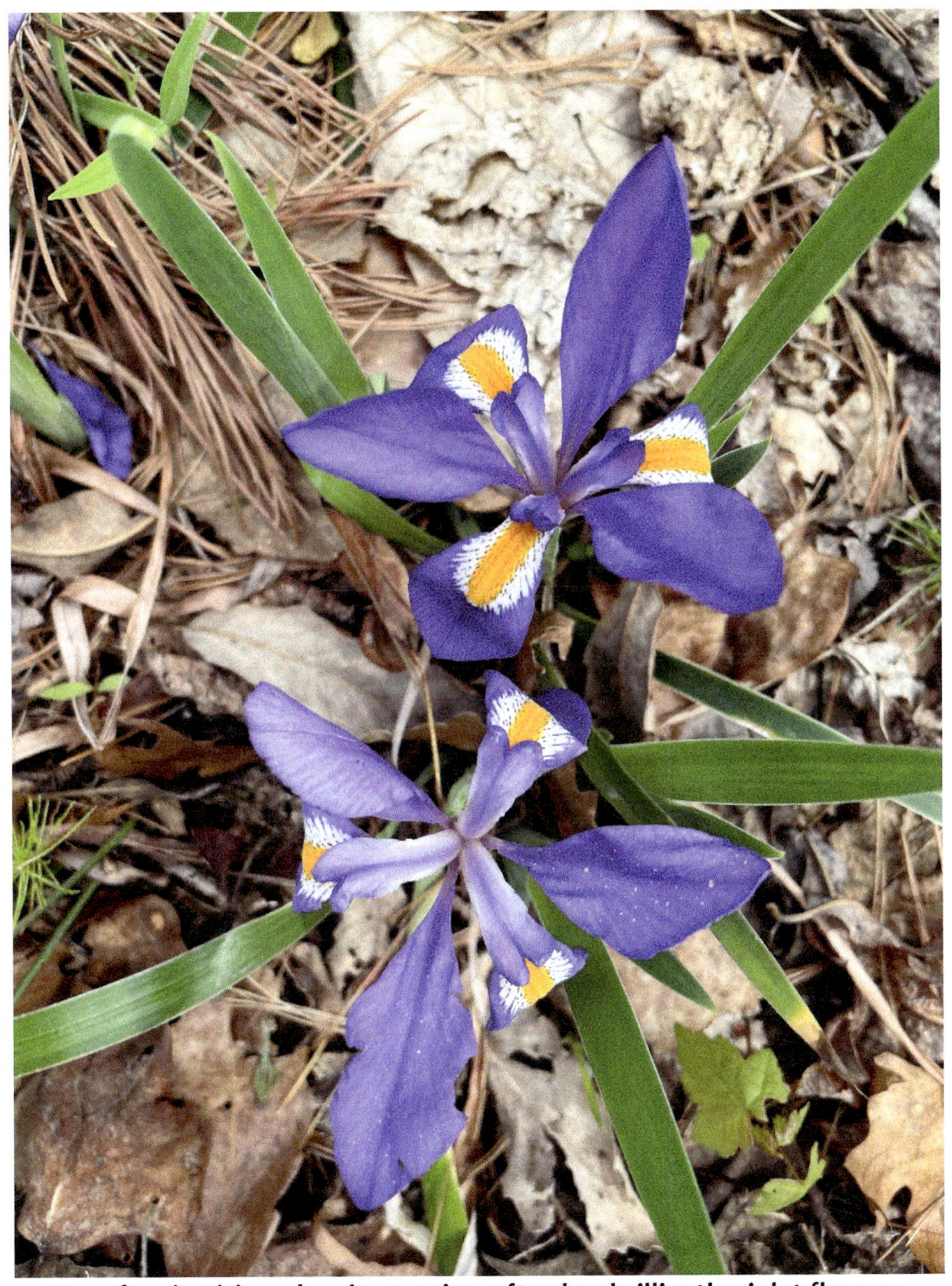

Dwarf spring iris, a dry-site species, often has brilliantly violet flowers.

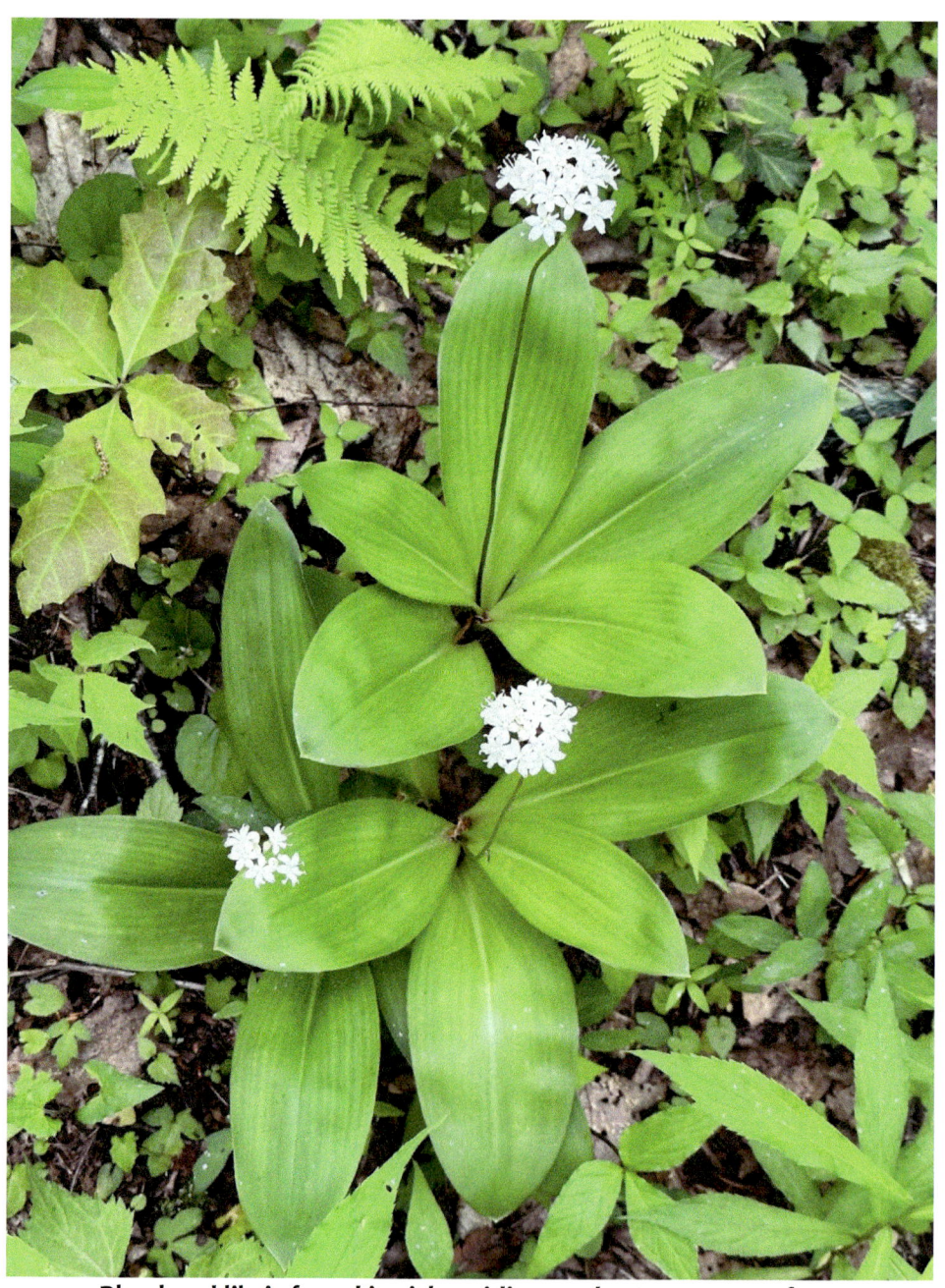
Blue-bead lily is found in rich, acidic woods at 2000-4000 feet.

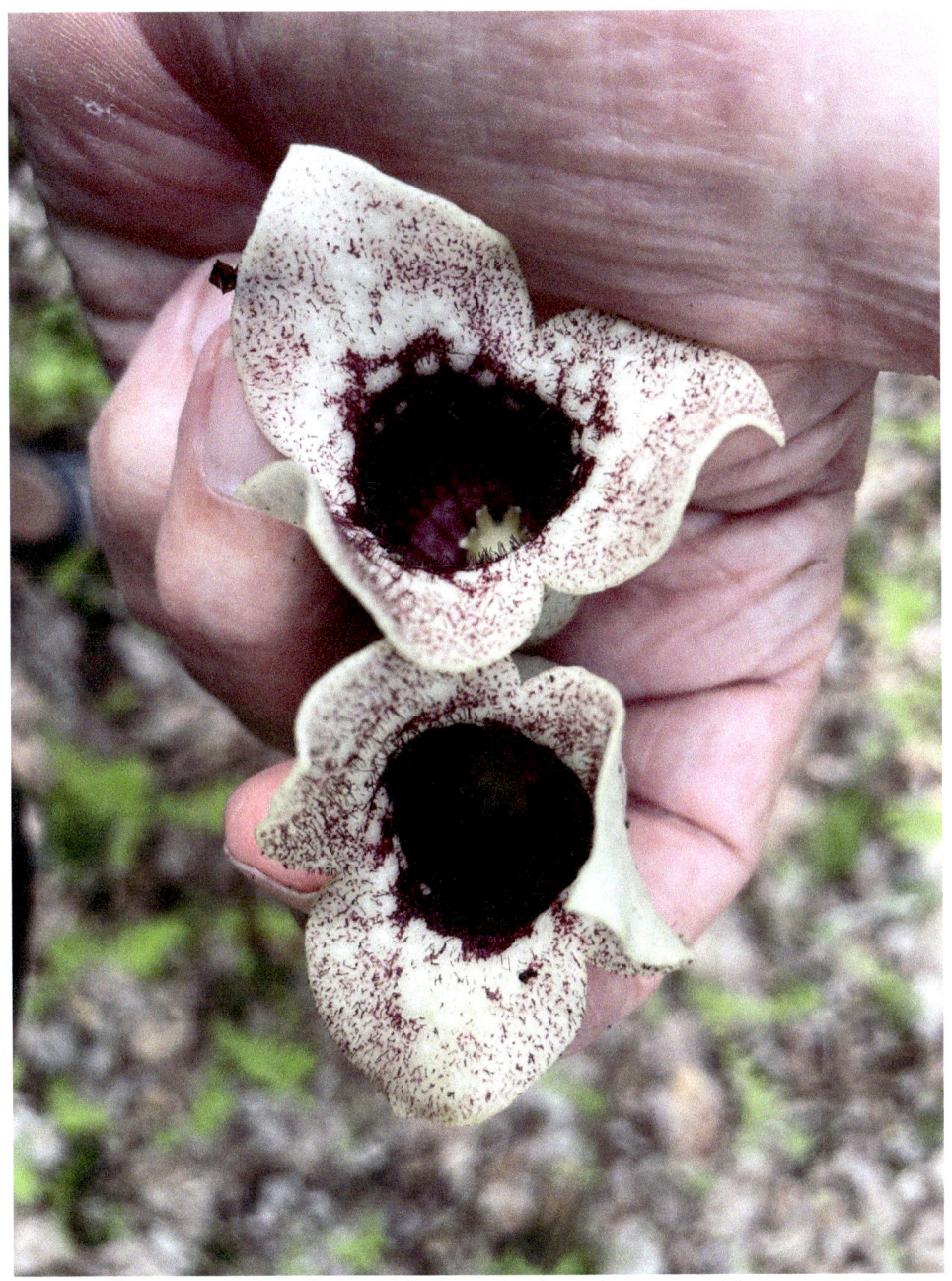
Giant flowers of Shuttleworth's heartleaf on the upper Chattooga River.

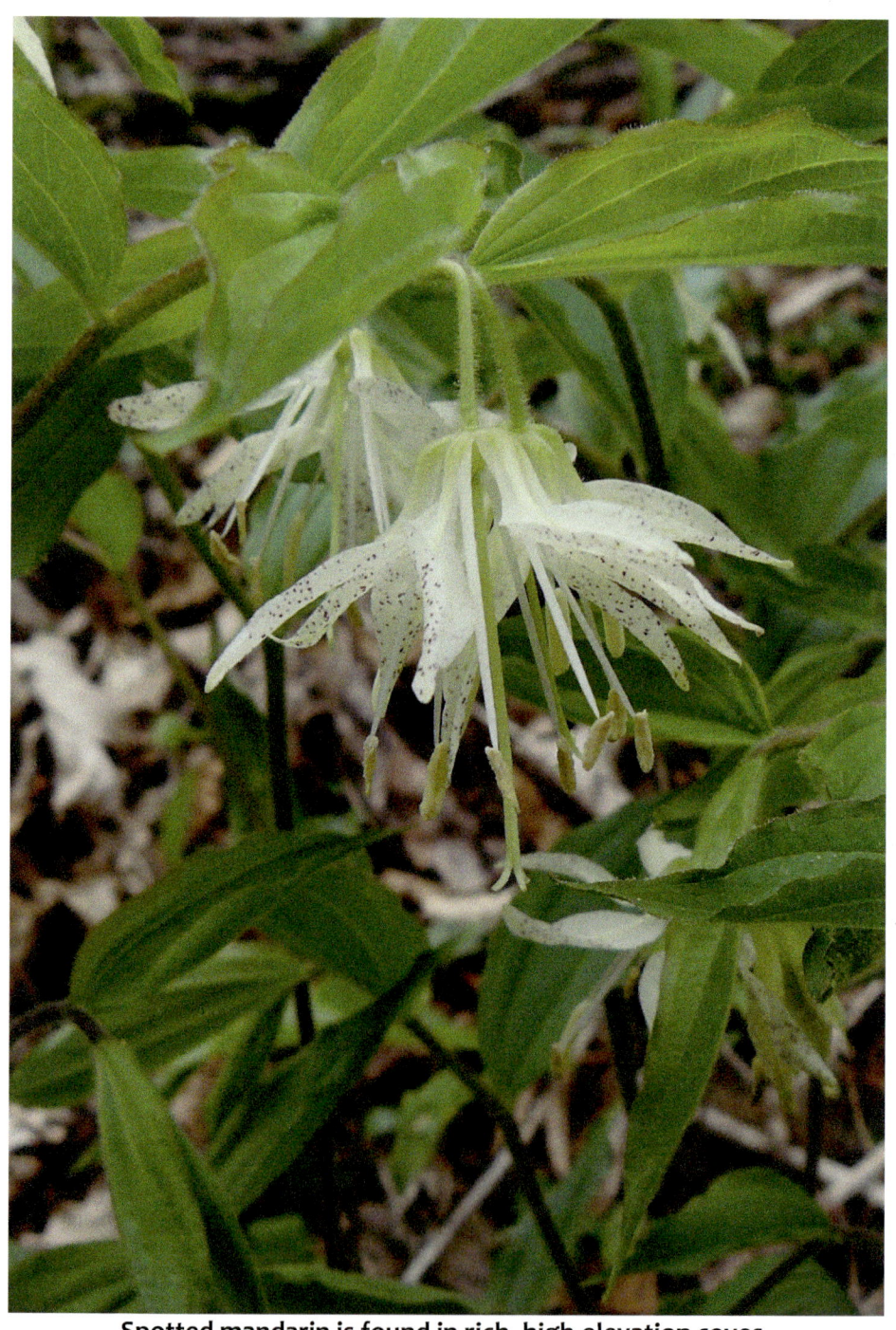
Spotted mandarin is found in rich, high-elevation coves.

Weedy thicket of ginseng along the Chattooga.

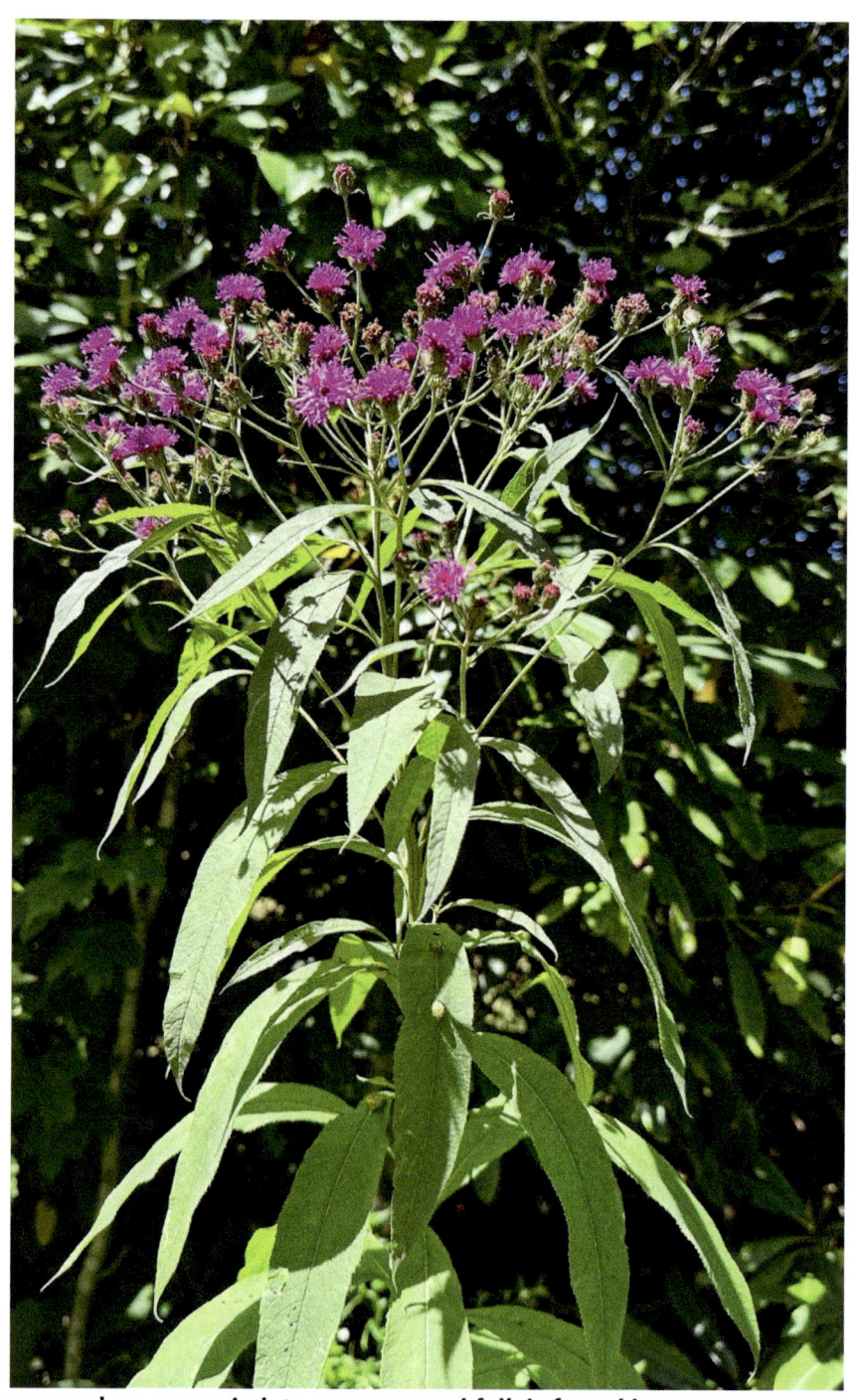
Ironweed, common in late summer and fall, is found in open, wet areas.

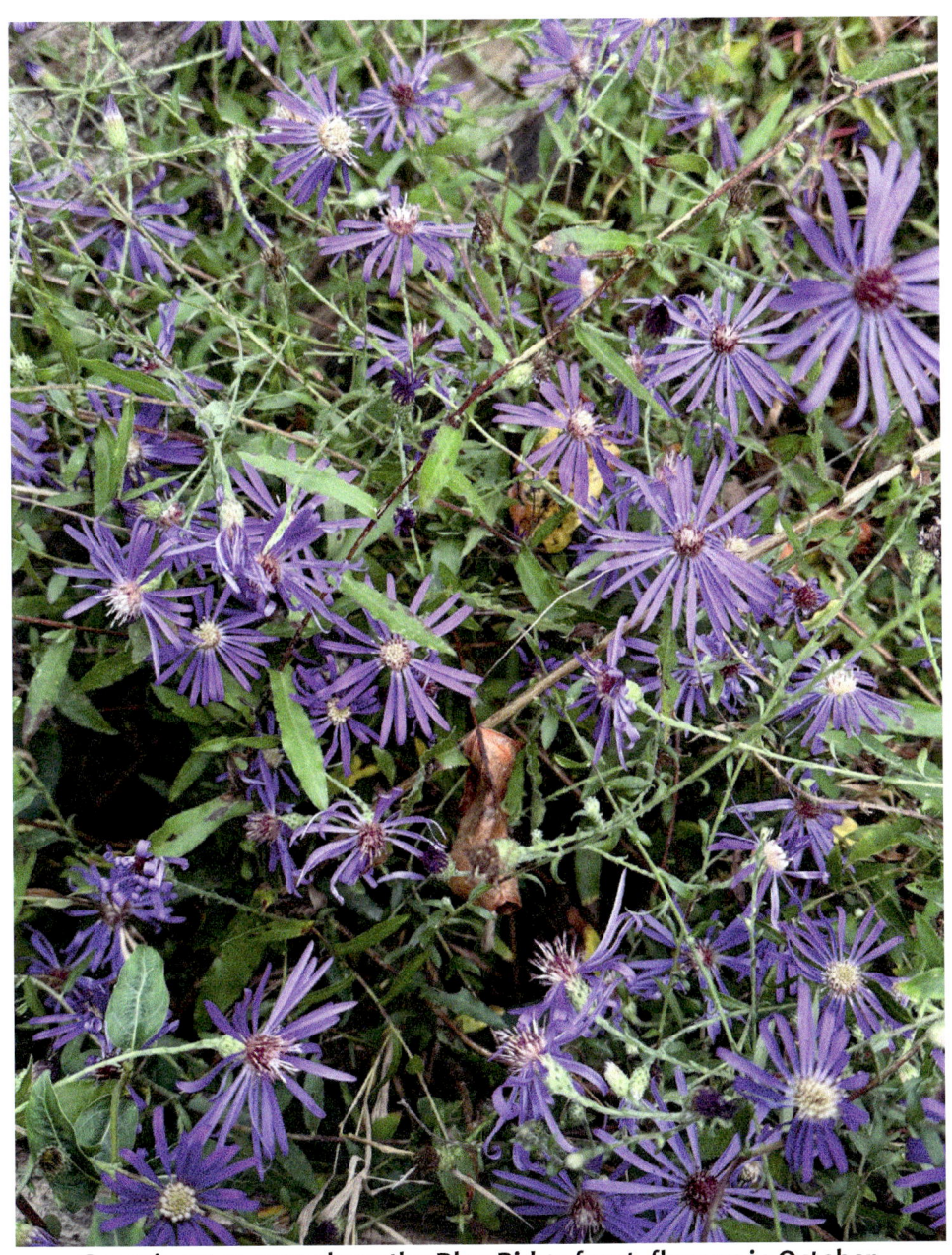
Georgia aster, rare along the Blue Ridge front, flowers in October.

Radford's sedge, with its white-green leaves, is found only along the Blue Ridge front.

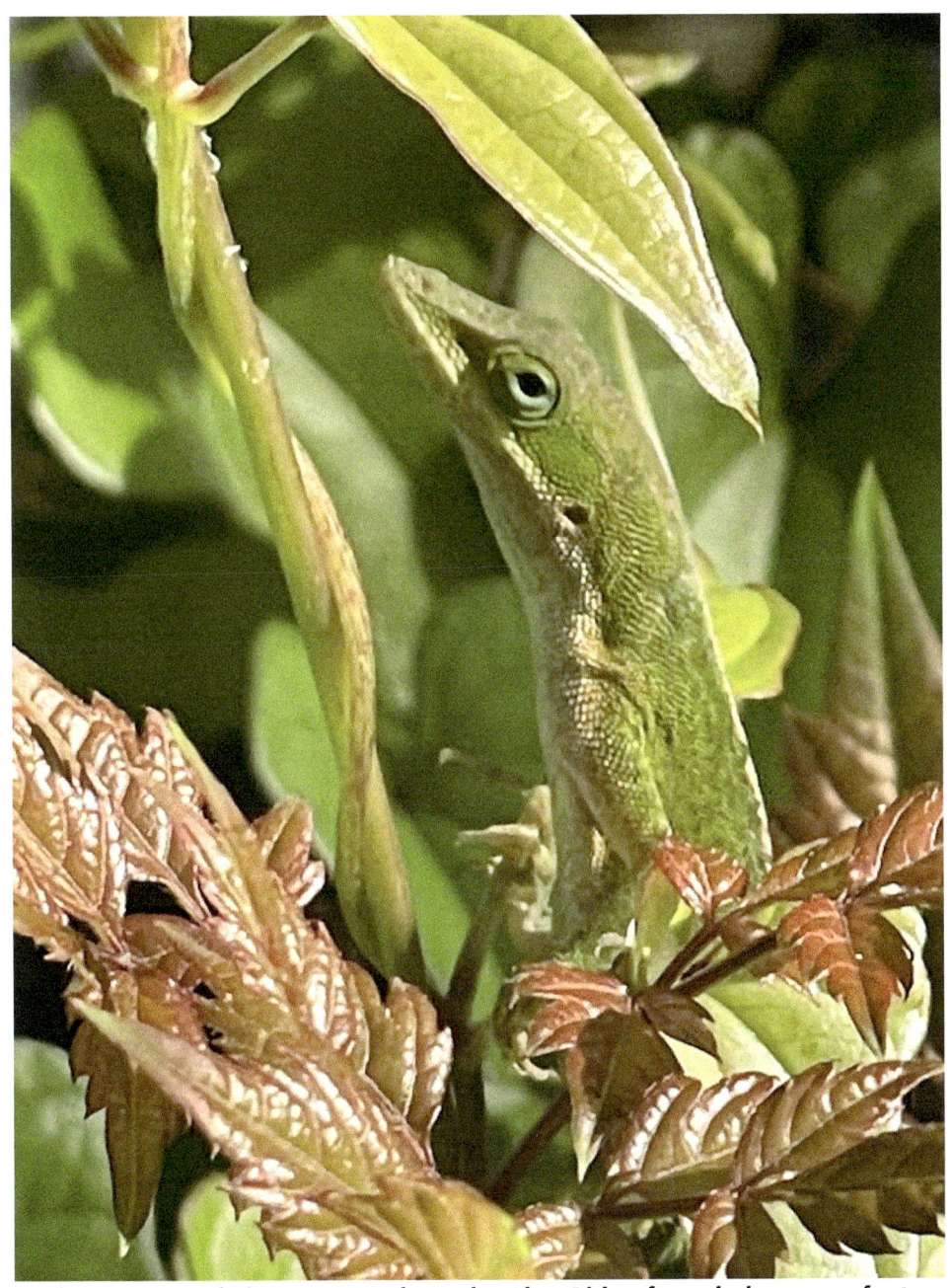
The green anole is common along the Blue Ridge front below 2000 feet.

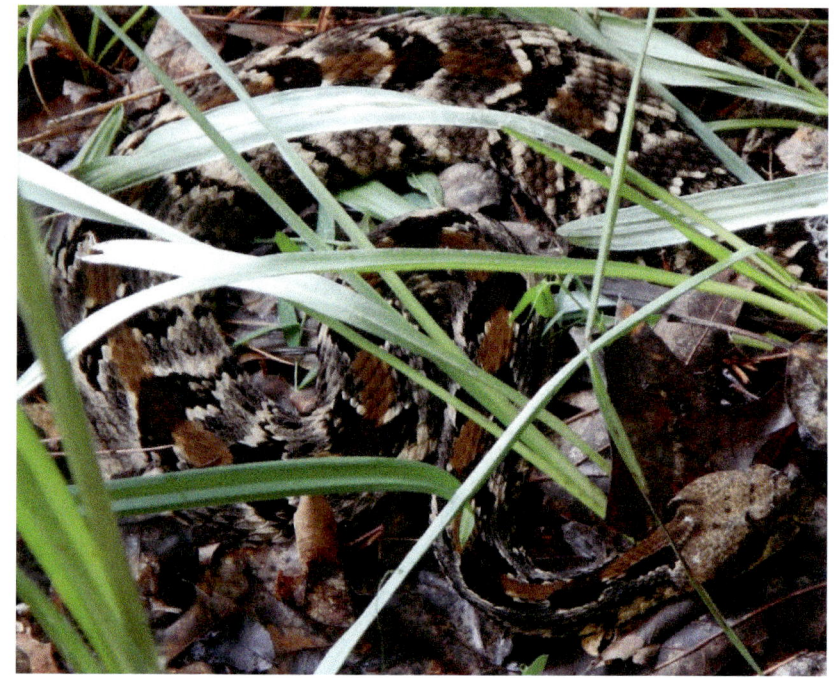

A small timber rattlesnake shedding skin.

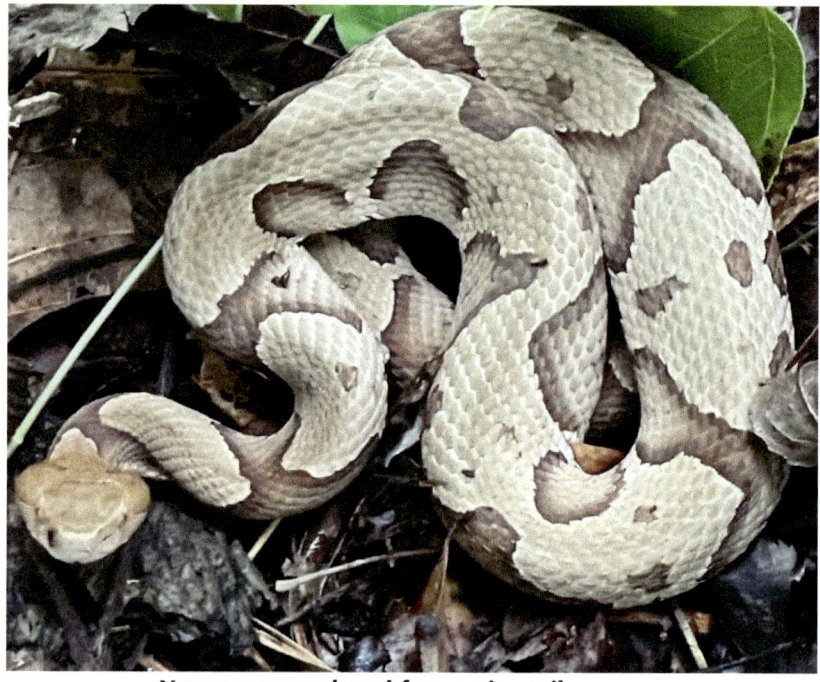

Young copperhead frozen in strike pose.

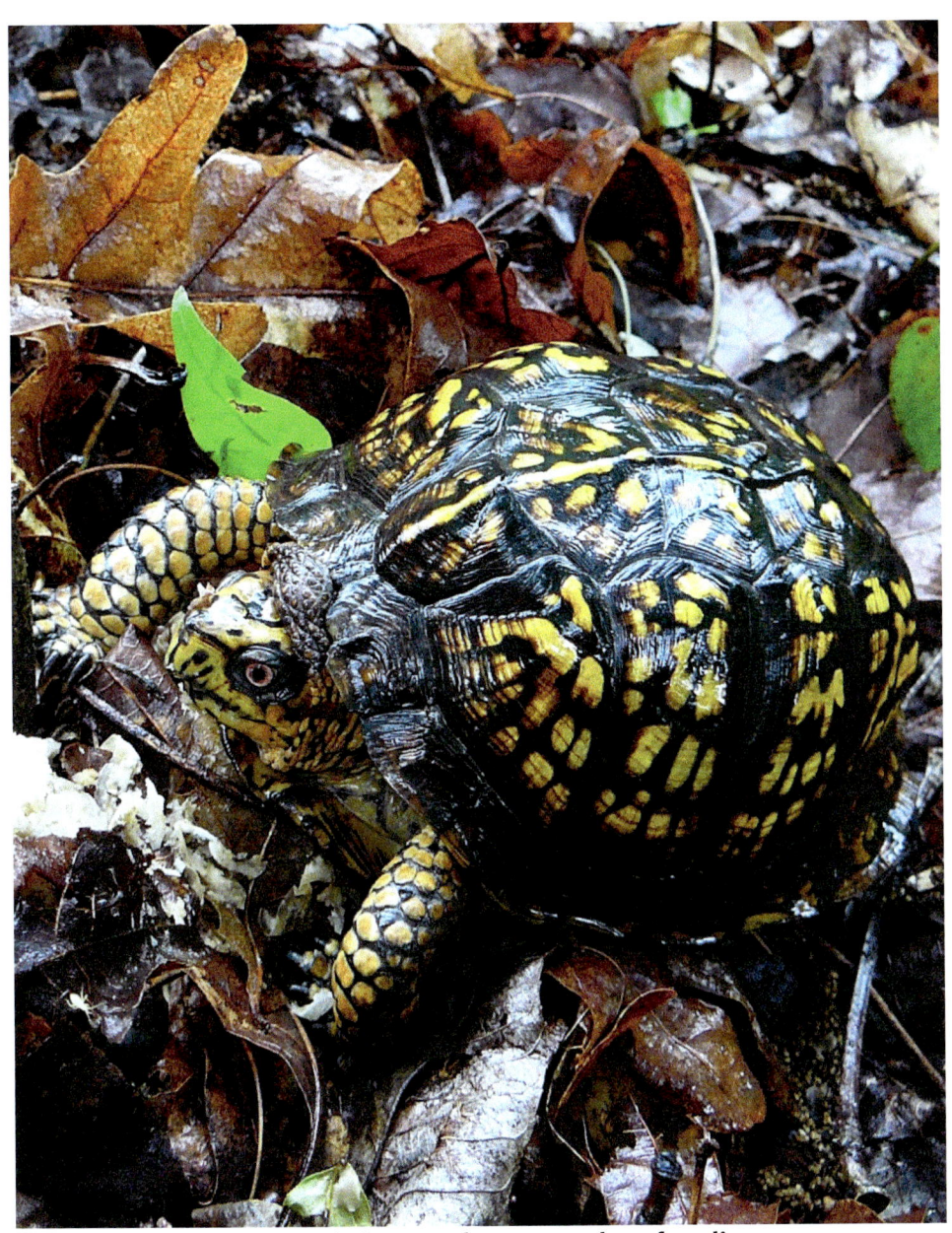
A bright mature male box turtle. Box turtles often live 50 years.

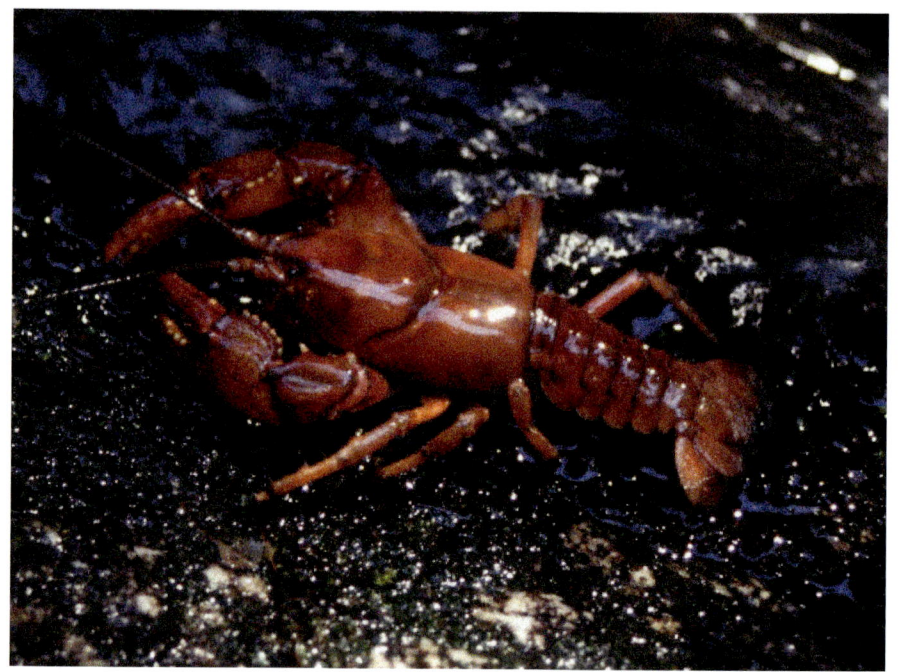
Crayfish on rocks on Cane Creek.

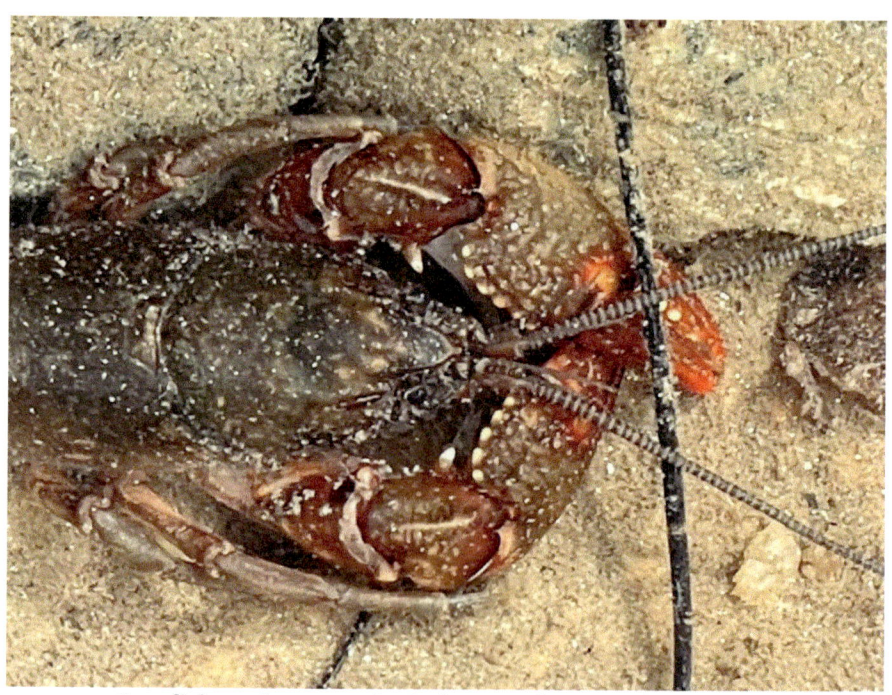
Crayfish underwater in Cedar Creek Gorge in Georgia.

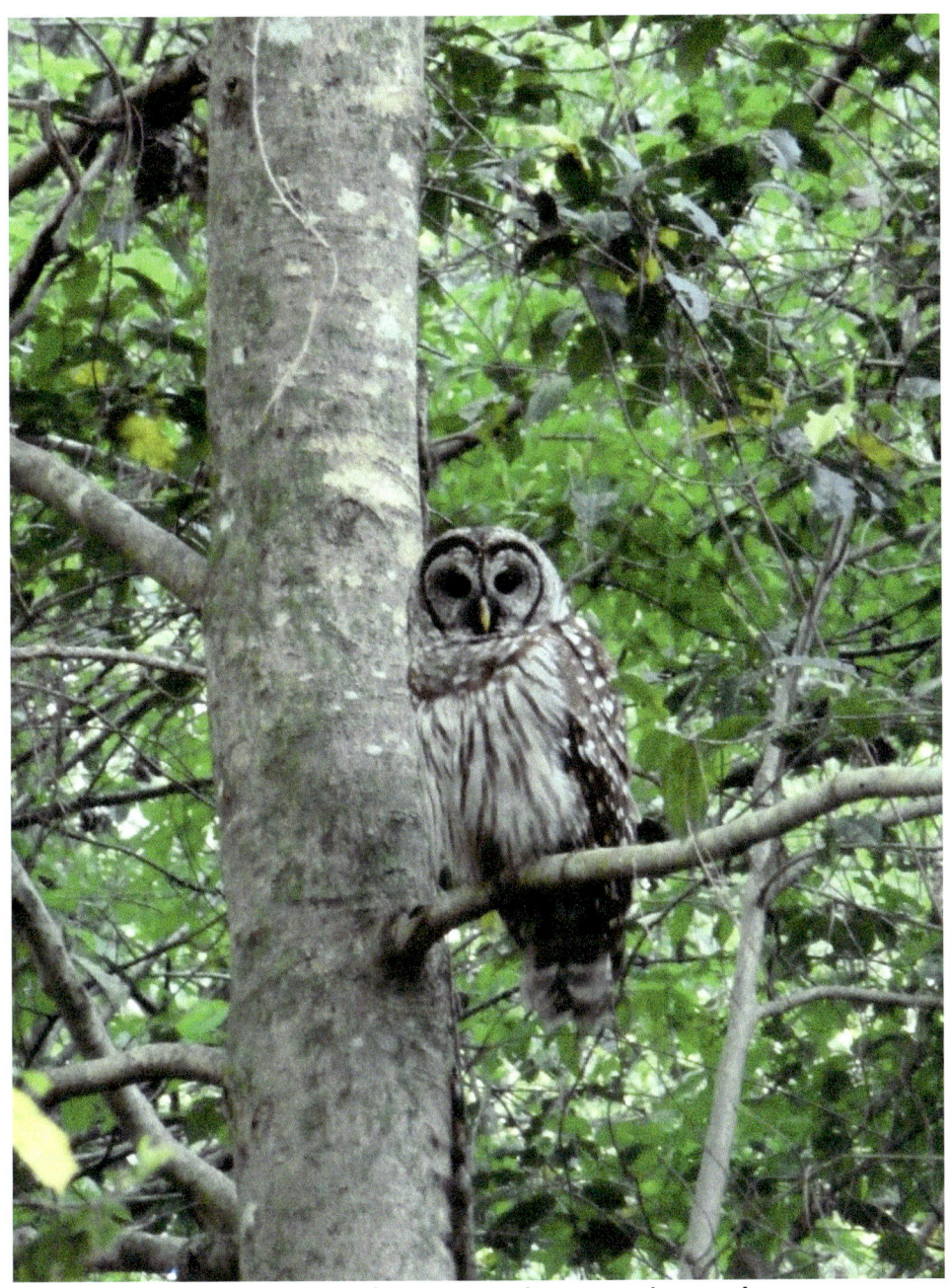

The barred owl is common in mountain woods.

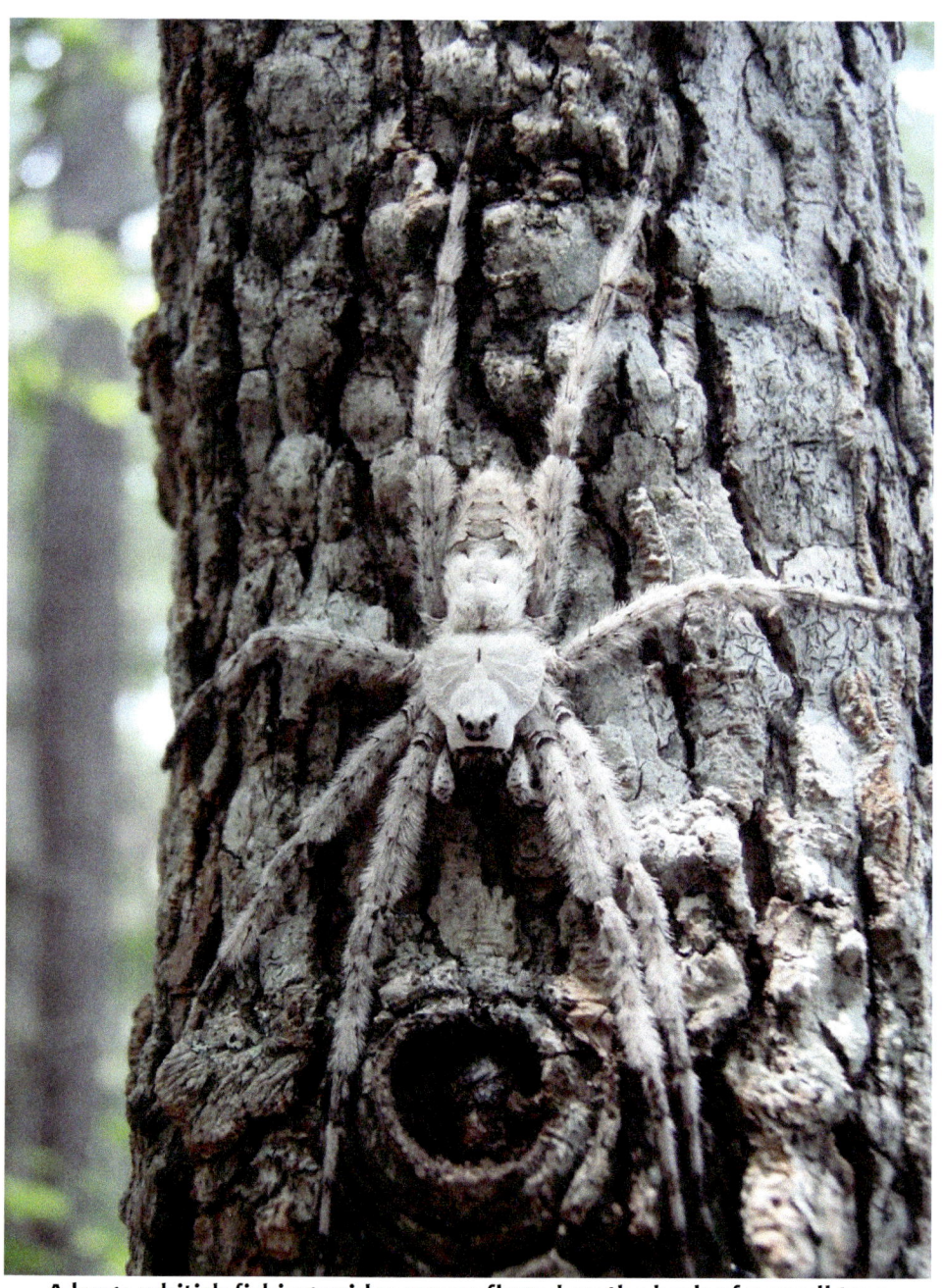

A large whitish fishing spider camouflaged on the bark of a small tree (B. Merle Shepard).

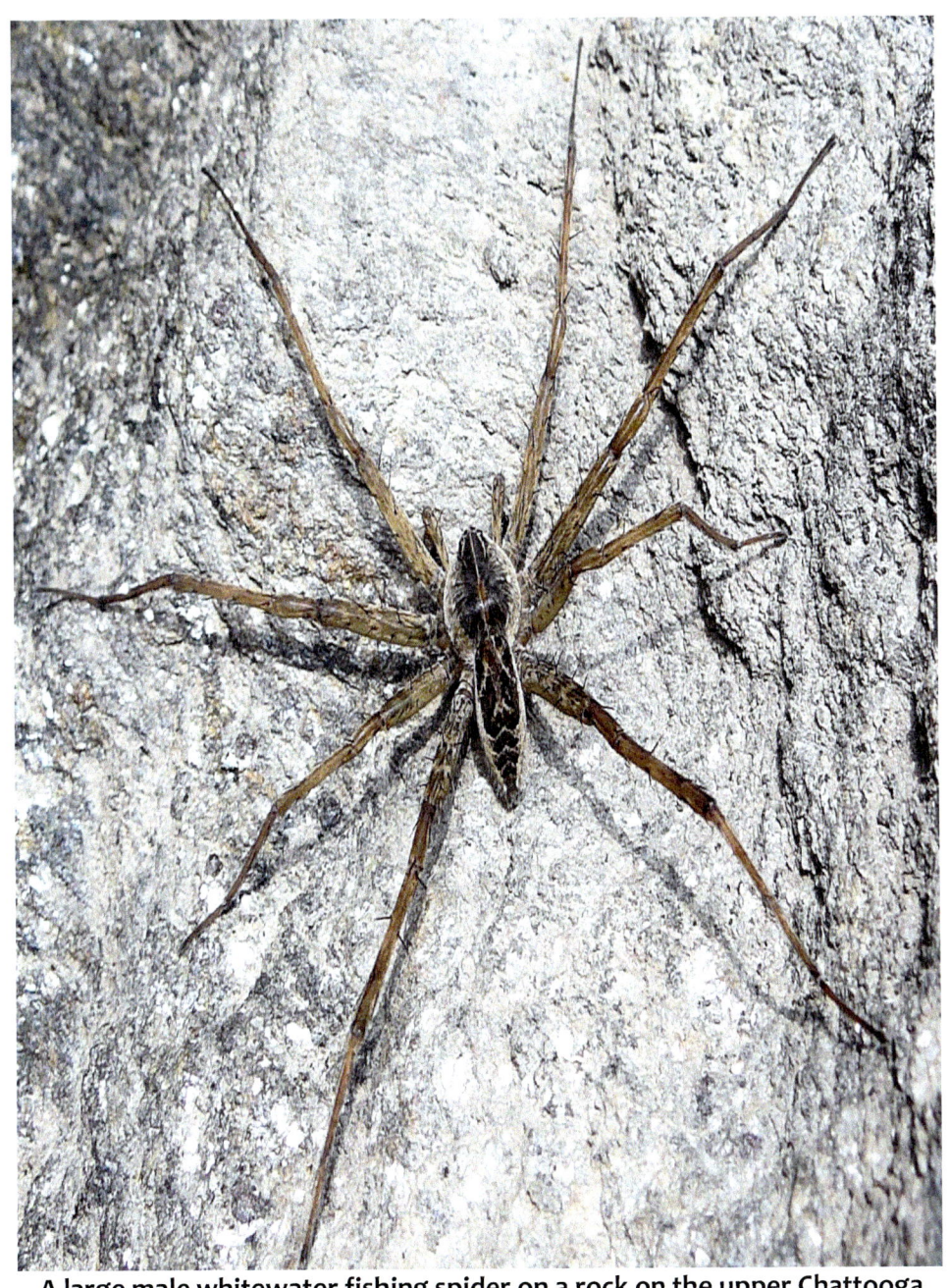
A large male whitewater fishing spider on a rock on the upper Chattooga River

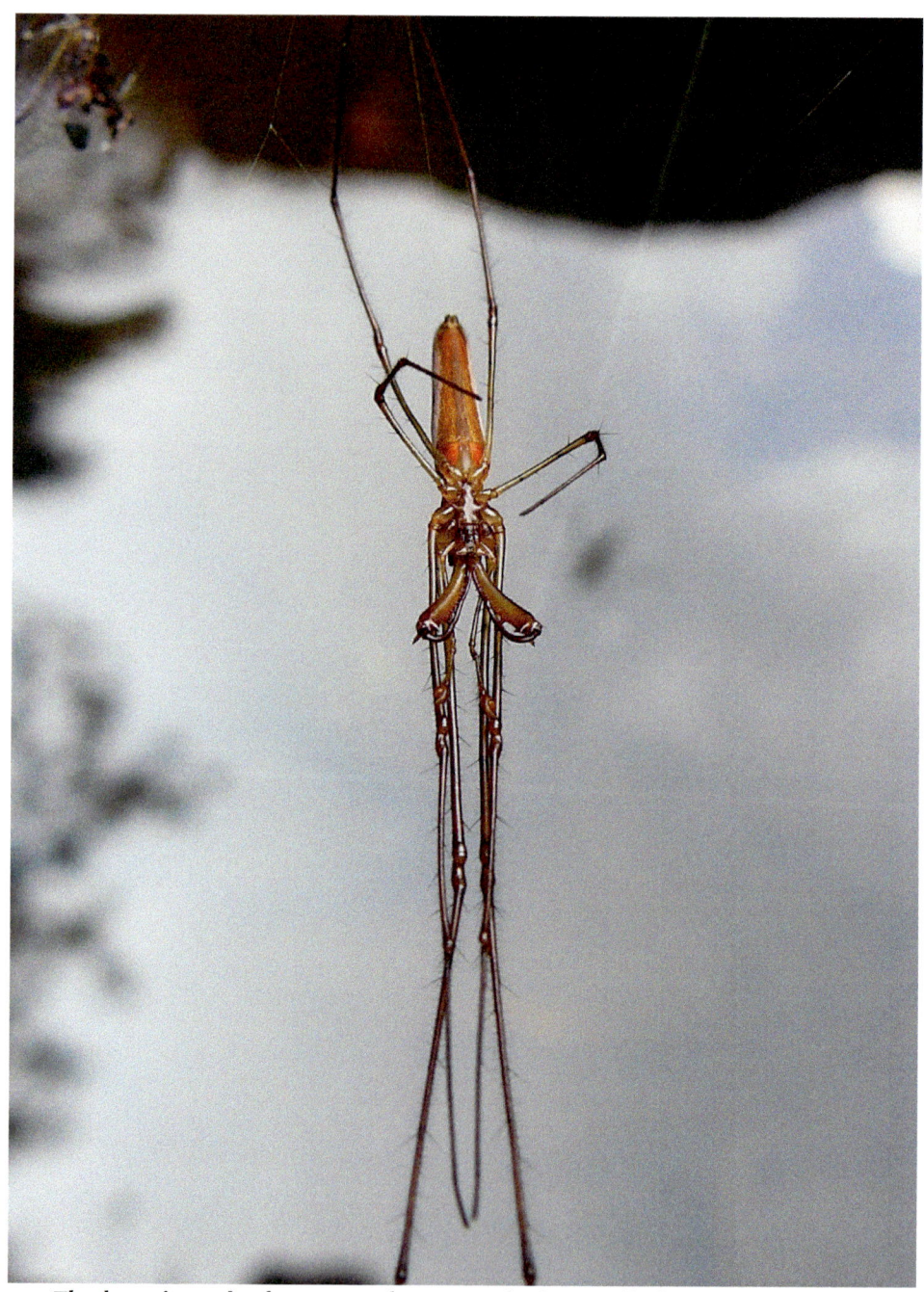
The long-jawed orb weaver, here a male, is usually found near water.

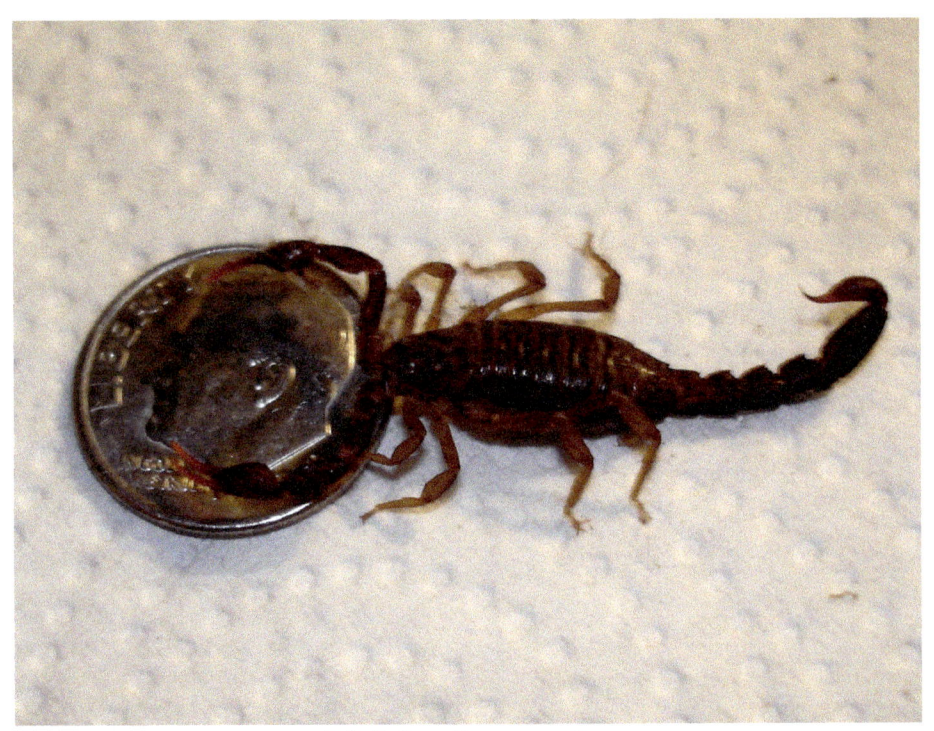
Adult Carolina scorpion.

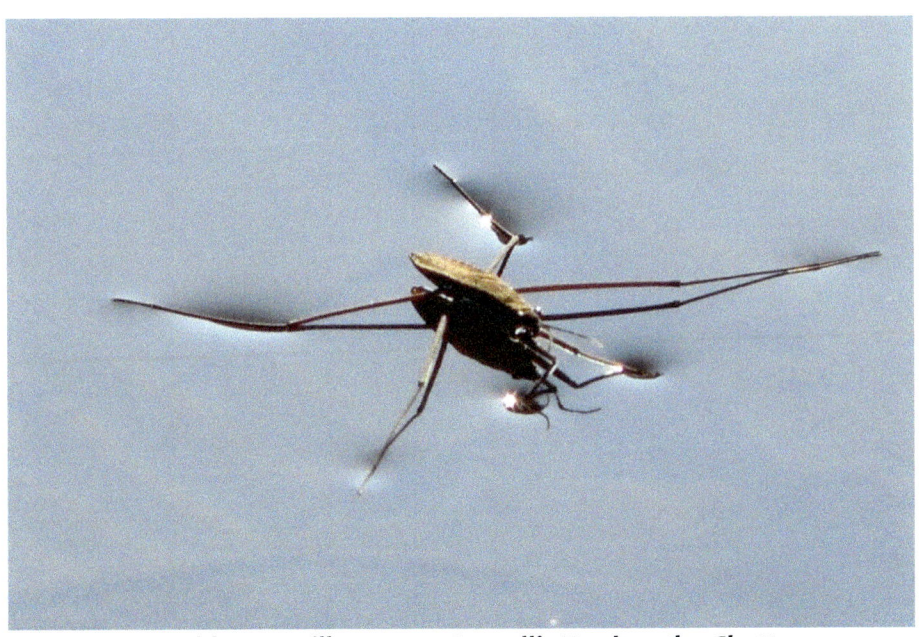
Water strider on still water at Burrell's Ford on the Chattooga.

SELECTED REFERENCES

Anderson, L. E. 1954. **A new species of *Mnium* from the southern Appalachians.** The Bryologist 57:177-188.

Anderson, L.E. and T.T. Bannister. 1952. **An addition to the fern flora of North Carolina.** Journal of the Elisha Mitchell Scientific Society 68: 81-83.

_____ and R. H. Zander. 1973. **The mosses of the southern Blue Ridge Province and their phytogeographical relationships.** Journal of the Elisha Mitchell Scientific Society 89:14-60.

Billings, W.D. and L.E. Anderson. 1966. **Some microclimatic characteristics of habitats of endemic and disjunct bryophytes in the southern Blue Ridge.** The Bryologist 69: 76-95.

Blomquist, H.L. 1948. ***Asplenium monanthes* in South Carolina.** American Fern Journal 38: 171-176.

Chattooga River Native Plant Society. 2025. **Hiker's Guide to the Chattooga River.** 73 p. Available at **decastongrene.com**.

Clay, Butch. 1995. **A guide to the Chattooga River: a comprehensive guide to the river and its natural and human history.** Chattooga River Publishing. 64 p.

Cooper, A. W. and J. W. Hardin. 1970. **Floristics and vegetation of the gorges of the southern Blue Ridge escarpment.** In Vegetational history of the biota of the southern Appalachians, edited by D. C. Holt. Part II: Flora. Blacksburg, VA. 413 p.

Cruse, J. M. 1997. **Vascular flora of Currahee and Soapstone Mountains, Stephens County, Georgia.** Master's Thesis. University of Georgia. Athens.

Davies P. A. 1952. **Geographical variations in *Shortia galacifolia*.** Rhodora 54:121-124

Duncan, W. H., J. F. Garst, and G. A. Neese. 1971. ***Trillium persistens* (Liliaceae), a new pedicellate-flowered species from Georgia and adjacent North [sic]Carolina.** Rhodora 73:244.

Dunn, B. A., and S. M. Jones. 1979. **Geographic distribution of *Shortia galacifolia* in Oconee and Pickens counties, South Carolina.** The Journal of the Elisha Mitchell Scientific Society 95:32-41.

Farrar, D.R. 1998. **The tropical flora of rockhouse cliff formations in the eastern United States.** Journal of the Torrey Botanical Society 125: 91-108.

Gaddy, L. L. 1983. **Notes on the Biltmore sedge (*Carex biltmoreana*).** Bulletin of the Torrey Botanical Club 110:530-532.

_____. 1990. **Glade Fern Ravine, a rich fern site in the Blue Ridge province of South Carolina.** Castanea 55: 282-285.

_____. 1995. ***Carex radfordii*, a new species from the southern Appalachians.** Novon 5:259-261.

_____. 2000. **A naturalist's guide to the southern Blue Ridge front.** University of South Carolina Press, Columbia. 190 p.

_____. 2018. **Moss hunting in the Blue Ridge Escarpment with Lewis E. Anderson.** Evansii 35:58-59.

_____ and M. Nuraliev. 2018. ***Shortia rotata* (Diapensiaceae), a new species from Vietnam.** Wulfenia 24:53-60.

_____ and Shota Sakaguchi. 2024. **The taxonomy, biogeography, and phylogeography of the genus *Shortia* (Diapensiaceae).** Endangered Species Biology 1:1-18.

_____, P.W. Suckling, and V. Meentemeyer. 1984. **The relationship between winter minimum temperatures and spring phenology in a southern Appalachian cove.** Archives for Meteorology, Geophysics, & Bioclimatology, Series B 34: 155-162.

_____, T.H. Carter, B. Ely, S. Sakaguchi, A. Matsuo, and Y. Suyama. 2019. ***Shortia brevistyla* comb. et stat. nov., (Diapensiaceae), A narrow endemic from the headwaters of the Catawba River in North Carolina, U. S. A.** Phytologia 101:113-119.

Garren, L. A. 2013. **The Chattooga River: a natural & cultural history.** Natural History Press. Charleston, S. C. 126 p.

Hatley, J. R. 1977. **Analysis of variation in *Shortia galacifolia*.** M. S. Thesis. North Carolina State University.

Mowbray, T. B. 1966. **Vegetational gradients in the Bearwallow Gorge of the Blue Ridge escarpment.** Journal of the Elisha Mitchell Scientific Society 82:138-149.

_____ and H.J. Oostling. 1968. **Vegetation gradients in relation to environment and phenology in a Blue Ridge gorge.** Ecological Monographs 38: 309-344.

Petranka, J. W. 2010. **Salamanders of the United States and Canada.** Smithsonian Books, Washington, DC.

Pittillo, J.D., R.D. Hatcher, S.W. Buol. 1998. **Introduction to the environment and vegetation of the southern Blue Ridge Province.** Castanea 63: 202-216.

Rodgers. C. L. 1965a. **Survey of the vascular plants of the Bearcamp Watershed.** Castanea 30:133-43.

_____. 1965b. **Vegetation of the Horsepasture Gorge.** Journal of the Elisha Mitchell Scientific Society 81:103-12.

_____. 1969. **Vascular plants of the Horsepasture Gorge.** Castanea 34:374-394.

Sutter, R. D. and A. S. Weakley. 1987. **Inventory of the rare plant species of the embayment gorges and the Highlands Plateau.** Text and map. N. C. Department of Agriculture. Plant Conservation Program. Raleigh. 10p. Fieldwork by L. L. Gaddy and Karin Heiman.

Wagner, W. H., D. R. Farrar, and B. M. McAlpin. 1970. **Pteridology of the Highlands area, southern Appalachians.** Journal of the Elisha Mitchell Scientific Society 86:1-27.

Ware, D. M. E. 1973. **Floristic survey of the Thompson River watershed.** Castanea 38:349-78.

_____. 1984. **Mountain memoirs: botanizing in a Blue Ridge gorge.** ASB Bulletin 31:127-131.

Zartman, C.E. and J.D. Pittillo. 1998. **Spray cliff communities of the Chattooga Basin.** Castanea 63: 217-240.

L. L. "Chick" Gaddy is a naturalist based near Walhalla, SC. Author of numerous books, including *The Natural History of Congaree Swamp* (with John Cely) and *Spiders of the Carolinas*, he holds a Ph. D. in biogeography from the University of Georgia (see www.tibooks.org; above image by Richard White).

INDEX
common name/Scientific name

anole, green/Anolis caroliniana 6, 128
aster, Georgia/Symphyotrichum georgianum 5, 126
azalea, flame/Rhododendron calendulaceum 117
azalea, pink shell/Rhododendron vaseyi 39
bristlefern, Appalachian/Trichomanes boschianum 8
camellia, mountain/Stewartia ovata 56, 106
clubmoss, rock or gorge/Huperzia porophila 56, 71
copperhead/Agkistrodon contortus 6, 8, 129
fern, hay-scented/Dennstaedtia punctuloba 103
fern, narrow-leaved glade/Homalosorus pycnocarpos 28
fern, Tunbridge/Hymenophyllum tunbrigense 4, 8, 11
fern, walking/Asplenium rhizophyllum 43, 111
gay-wings/Polygala paucifolia 107
ginseng/Panax quinquefolius 8, 45, 124
gorgemoss, Carolina/Plagiomnium carolinianum 5, 83
heartleaf, Shuttleworth's/Hexastylis shuttleworthii 122
hemlock, Canada or eastern/Tsuga canadensis 3, 56, 117
hemlock, Carolina/Tsuga caroliniana 3, 117
hepatica, acute-leaved/Hepatica acutiloba 16
horsebalm, whorled/Collinsonia verticillata 5, 78
Indian pink/Spigelia marilandica 15
iris, summer/Iris verna 120
Jack-in-the-Pulpit/Arisaema triphyllum 112
lady's-slipper, pink/Cypripedium acaule 115
lady's-slipper, yellow/Cypripedium calceolus 5, 51, 114
laurel, Carolina or deer-tongued/Rhododendron carolinianum 116
laurel, great/Rhododendron maximum 116
laurel, mountain/Kalmia latifolia 115
lichen, rock gnome/Gymnoderma lineare 5, 61
lily, trout/Erythronium americanum 108
loosestrife, Fraser's/Lysimachia fraseri 5, 78, 119
mandarin, spotted/Prosartes maculata 123
maple, chalk/Acer leucoderme 78
maple, sugar/Acer saccharum 3, 98, 104
mock-orange, cliff/Philadelphus hirsutus 78
Oconee bells/Shortia galacifolia 4, 8, 17, 18, 22
orchid, orange-fringed/Platanthera ciliaris 113
orchid, showy/Galearis spectabilis 51, 109
orchid, small whorled pogonia/Isotria medeoloides 4, 67

orchid, white fringeless/Platanthera integrifolia 5, 96
owl, barred/Strix varia 132
pachysandra/Pachysandra procumbens 16
plantain, Great Indian/Arnoglossum reniforme 8
ramps/Allium tricoccum 98
rattlesnake, timber/Crotalus horridus 6, 129
salamander, green/Aneides aeneus 6, 8, 96
salamander, Jordan's/Plethodon jordani 6
scorpion, Carolina/Vejovis carolinensis 136
sedge, Radford's/Carex radfordii 127
shortia/Shortia galacifolia 4, 8, 17, 18, 22
snake, Northern water/Nerodia sipedon 6
spider, long-jawed orb-weaver/Tetragnatha elongata 135
spider, whitewater fishing/Dolomedes vittatus 134
spider, whitish fishing/Dolomedes albineus 133
spleenwort, black-stemmed/Asplenium resiliens 5, 43
spleenwort, maidenhair/Asplenium trichomanes 79
spleenwort, single-sorus/Asplenium monanthes 5, 8, 34
sumac, poison/Rhus vernix 89
trillium, bent/Trillium flexipes 8
trillium, faded/Trillium discolor 4, 8, 14
trillium, painted/Trillium undulatum 106
trillium, persistent or Edna's/Trillium persistens 4, 89, 97, 105
trillium, southern nodding/Trillium rugelii 82
trillium, sweet white/Trillium simile 45
trillium, Vasey's/Trillium vaseyi 78, 87
turtle, box/Terrapene carolina 8, 130
violet, Canada/Viola canadensis 110
violet, Labrador/Viola labradorica 80
violet, tripartite/Viola tripartita 5